CONDÉ NAST TRAVELER

ROOM WITH A VIEW

© 2010 Assouline Publishing
601 West 26th Street, 18th floor
New York, NY 10001 USA
Tel.: 212 989-6810 Fax: 212 647-0005
www.assouline.com

ISBN: 978 2 7594 0447 6

Color separation: Luc A.C. Retouching
Printed in Singapore.

CONDÉ NAST TRAVELER
ROOM WITH A VIEW

Edited by Klara Glowczewska

Introduction by André Aciman

ASSOULINE

TABLE OF CONTENTS

FOREWORD

Klara Glowczewska
Editor in Chief, *Condé Nast Traveler*

Just as a small piece of glass can intensify the rays of the sun passing through it to the point of setting fields of grass on fire, so do perfectly positioned windows augment and sear into our memory the beauties of the vistas beyond them. They bring them home, make them ours.

Forget for a moment a hotel or resort's more predictable aspects—pools, spas, food, service, and so on. The most memorable, moving, surprising, and, yes, sexy thing when we are first shown to our room—that "aah" moment at the start of a trip—is, if we're lucky (or have done our homework), the stunning view. It's that perfect, ecstatic marriage of the grand (the vista) and the intimate (our own private perch and perspective on it). The Great Pyramid of Giza will never look as miraculous as when observed full on from a room at the Mena House Oberoi. Bora Bora's waters will never appear as improbably, embraceably turquoise—the Platonic form of the color blue—as when framed by the balustrade of a bungalow at the Hotel Kia Ora. Gustave Eiffel's iron tower will never soar as weightlessly and near at hand over the rooftops of Paris as it does from the vantage point of a suite at the Hôtel Plaza Athénée.

I've often imagined a trip around the world during which one would hop, as when crossing a stream from stone to stone, from one room with a view to the next. What a journey that would be. The "Room with a View" feature has occupied the last page of every issue of *Condé Nast Traveler* since the magazine's debut in September 1987. At press time, that's 270 stops and counting—77 more than there are countries in the world. In the interest of portability, we've included 140 in this volume, the date after each marking the month and year of original publication. Here is plenty of inspiration for a lifetime of travel without risking the unwieldy heft of those illuminated medieval manuscripts.

But, like those medieval tomes, this book, too, is crammed with the world's wonders—natural and man-made, spiritual and sensual. In each image, our photographers have captured transporting views, presented the perfect spots to observe still horizons, glittering urban skylines, and, truly, everything in between.

If, as has been said, the frame is pimp to the painting, so too is the windowsill to the landscape. You can go ahead and book these rooms (and suites, cabanas, bungalows, and tents—just turn to page 226). Or you can simply sit back and enjoy the view. Either way, bon voyage.

INTRODUCTION

André Aciman

About the view, they may have been quite wrong, the Old Masters. Veronese painted Venus and Adonis slouching by a tree; Caravaggio, Abraham holding down Isaac, dagger in hand; Rubens, Paris handing Aphrodite an apple because she's the fairest of the three, not knowing yet that this apple will unavoidably lead to the start of the Trojan War and that the gathering clouds foreshadow the burning citadel. In the background, as in so many Renaissance paintings, you'll find the usual scatter of sheep, sometimes sailboats, birds, goatherds, plowmen, a distant castle—just about anything, really. The background merely fills the dots, doesn't really count—no one cares about backgrounds. What matters is the eternal lounging in the nude as Venus and Adonis relish their *pique-nique sur l'herbe*. In the Old Masters, there is hardly a frame outside of the story, certainly no stuff lying about on the margins—not the artist's own jug of water standing next to his easel, or the dirty rag soaked in turpentine, or the scrofulous lapdog minding its own business in the corner. The subject will always be timeless splendor in the woods—not shepherds, not meadows, or the old hag spinning away as she minds the canvas when the artist steps out on an errand.

Old Masters paint the story and the view. They seldom paint the windowsill, too.

New Masters love the view, but they have a passion for the windowsill. Matisse and Dufy: No other painters have loved their windows and their French doors as these two. Sometimes they'll leave the balcony door slightly ajar, sometimes the slats will obstruct the view of the bay, sometimes the windows will be shut altogether. Matisse and Dufy love balustrades, as well—especially those lining a Juliet balcony looking out onto the Promenade des Anglais and farther out to the Baie des Anges. It's always a summer's day, with just a suggestion of wind. If you actually are in the Hôtel Negresco in Nice, you fling open the windows in the morning and it's all there: the sea, the world, infinity itself. This, you tell yourself, is where searching, where time, where everything stops. All you have to decide, if you happen to think of the New Masters then, is whether it is the view itself that matters or whether it's the fact that simply having a view from the Negresco invites you to do something most of us haven't the foggiest notion how to do: luxuriate. You remember visiting the hotel online for a virtual tour, and sure enough the rooms, with their partial view of balusters overlooking the bay, did indeed resemble fussy reproductions of Matisse. Now, as you open the windows, you have finally stepped into a Matisse. Time always stops when you fall in with great artists.

This is also why you argued with the reservations clerk when you called weeks, sometimes months, earlier from at least a continent away. When booking a hotel room in a city renowned for its stunning vistas, the first thing you'll ask for is the proverbial room with a view. I cannot count the number of times when, after making a hotel reservation over the telephone, I've finally brought myself to ask, almost as an afterthought, "And does the room have a view?" "Yes, sir, it does." The answer comes so quickly that you find yourself suspecting perfunctory yessing or, worse, bad faith. "Yes, but which side does the room face?" "The water," replies the clerk, as if to say, What else could it possibly face? But long experience leads me to sense a catch. Keep asking, because soon enough you'll find out that the side facing the beach could yield spectacular views but that the noise from the pool makes napping impossible. Or you could end up facing the ocean but your floor might be too low, so you're given a fantastic view of the trees lining the hotel grounds but never once the ocean beyond them. Worst of all is realizing that the shimmering view of water at a grand resort hotel is not available to you and that your room, as you feared but weren't bold enough to pester the clerk about, faces the back—the garage, the delivery trucks, the row of raucous restaurants hawking tourist menus by sunset—to say nothing of the perpetual drone of the elevator shaft, inaudible by day, deafening by night.

And yet who can forget the scene in Luchino Visconti's *Death in Venice* when the maître d'hôtel walks Von Aschenbach to his room and, after the bellhop has deposited the professor's luggage, carefully opens the large window and then suddenly throws wide the shutters to let in a view that is meant to take anyone's breath away—and, along with it, of course, all doubts about the overpriced room?

This is the dream come true. Postcards will be sent within the hour—unless you take out your camera, turn on your laptop, and right away send everyone you love the view from your suite in real time. That same day, you'll purchase a bunch of postcards with breathtaking panoramas, sit in a café, and begin jotting down words you don't need to rehearse. If you're lucky, you'll want to tell everyone that this very view is but a few steps away from your hotel room, just as the café where you're writing all this is but a hop, skip, and a jump from the water. "From where I'm sitting, I can hear the surf."

If you're like me, though, it's not just the view that you want your friends to see. You want to show a bit of the room before the camera lens picks out the king's palace or the grand cathedral beyond. The Duomo is here, over there the Baptistry, and this here is our terrace where we sit every morning and read the paper over coffee. (No one visits Florence for its hotel breakfasts, but morning on the balcony is a stolen moment in paradise.) You want to frame and anchor the shot in something as totally time-bound as the terrace in order to magnify the timelessness of the view itself. Otherwise

the view is postcard material—no more eloquent than Mozart Muzak. You want your picture to say: "Place de l'Opéra, with its roof glistening in the morning light, is what we wake up to every morning"; or, "At night, we like to leave the shades up so the floodlit coast of Amalfi beams right into the bedroom"; or, "At dawn, when you step out onto the balcony, there they are, the windmills of Corfu."

Views are the stuff of Old Masters. Views through windows, like those of a steeple through foliage or through medieval bric-a-brac, are suddenly less abstract—not the stuff of wall calendars but intimate and accessible because they have acquired a human dimension, feel like home, are almost ours. "If you run down the stairs leading away from this balcony," says the snapshot, "your toes will touch the shore." "If you stick your hand out far enough, you'll feel the breeze off the *grands boulevards*." "Strain your neck out this very window and you can smell the scented breeze." A room with a window is not about the view but about having the view and knowing you have it. A picture of the same without the window is a still life, what the French call a *nature morte*—dead to the senses.

And that, in the end, is what is so magical about a room with a view that shows us the room and the view. It is not dead. It is not timeless. It is here and now. Just walk onto this balcony, says the picture, and you're suddenly there. You can bask and luxuriate in its magic all you want precisely because it is so real to the touch. But because it is so real to the touch, it is also very provisional—because it is clearly not your room, because it's a borrowed room, and in borrowed rooms your days are always numbered—which is why the picture of the room with the window looking out to the world speaks of packed excitement, of time-bound bliss that is given to you for just a few days and then, as suddenly, is offered to the next guest. The French doors stay open as fleetingly as candelabra at a fairy-tale ball stay lit: till checkout time and not a minute longer.

The picture with the window is the ultimate trompe l'oeil. By playing with the illusion of instant access to wonders barely a stone's throw away, it stirs the illusion of permanence and makes you forget how transitory everything really is. Florence and Nice, it turns out, are not within our grasp; they are forever a fingertip away, never closer than just that.

But then all you need is the faintest flutter of a sheer curtain, just an impression of a draft, or the slightest movement of a French door, and despite all doubts and all this talk of illusion . . . you're suddenly there.

Hotel Imperial, Room 506

"The streets of Vienna," wrote the Austrian satirist Karl Kraus, "are paved with culture." He wasn't kidding. Directly outside your recently redone fifth-floor suite is the Musikverein, the famed 1863 Greek Renaissance concert hall. Just beyond is the ornate 1715 Karlskirche, with its Baroque dome and its two shafts modeled after Trajan's Column. The history of your neo-Renaissance hotel is no less august. Built in the 1860s as the palace of the Duke of Württemberg, it was converted into a hotel at the time of the 1873 World's Fair. Except for stints as the German Foreign Ministry offices during World War II and the Russian headquarters during the Allied occupation, it has been one of Vienna's premier hotels ever since, welcoming official state visitors from Prince Otto von Bismarck to Queen Elizabeth. *November 2005*

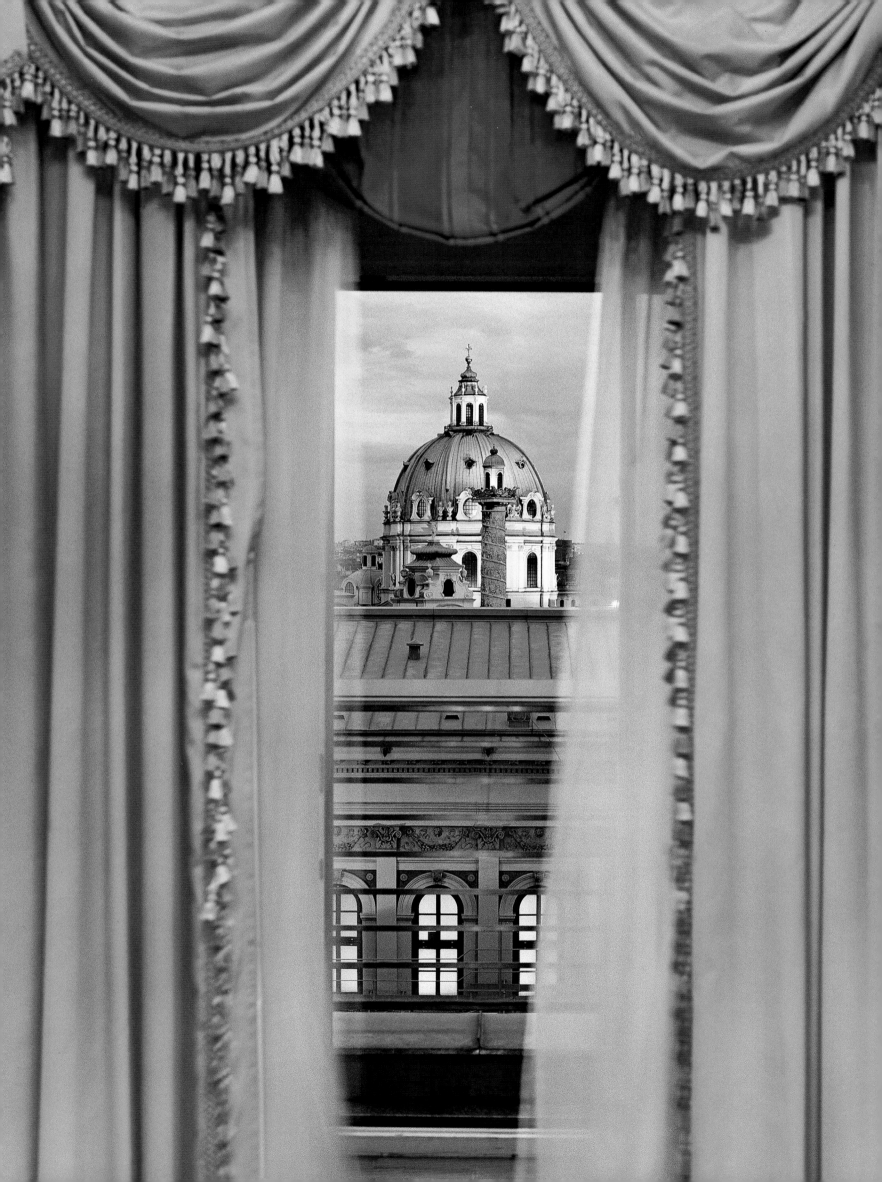

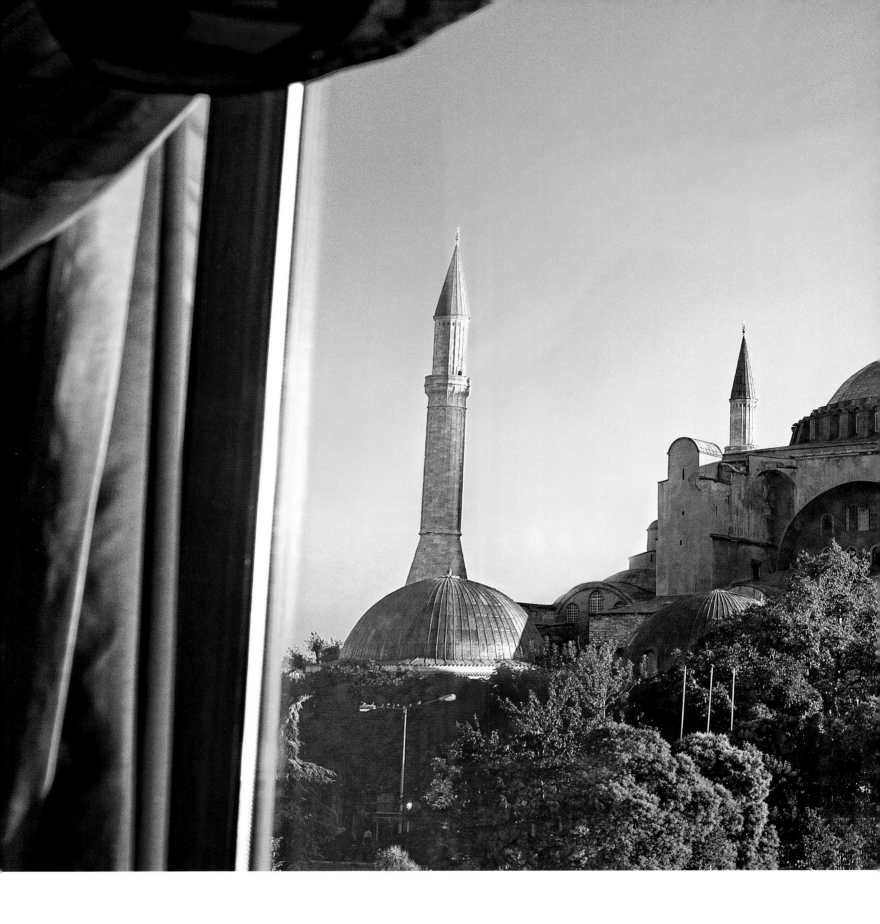

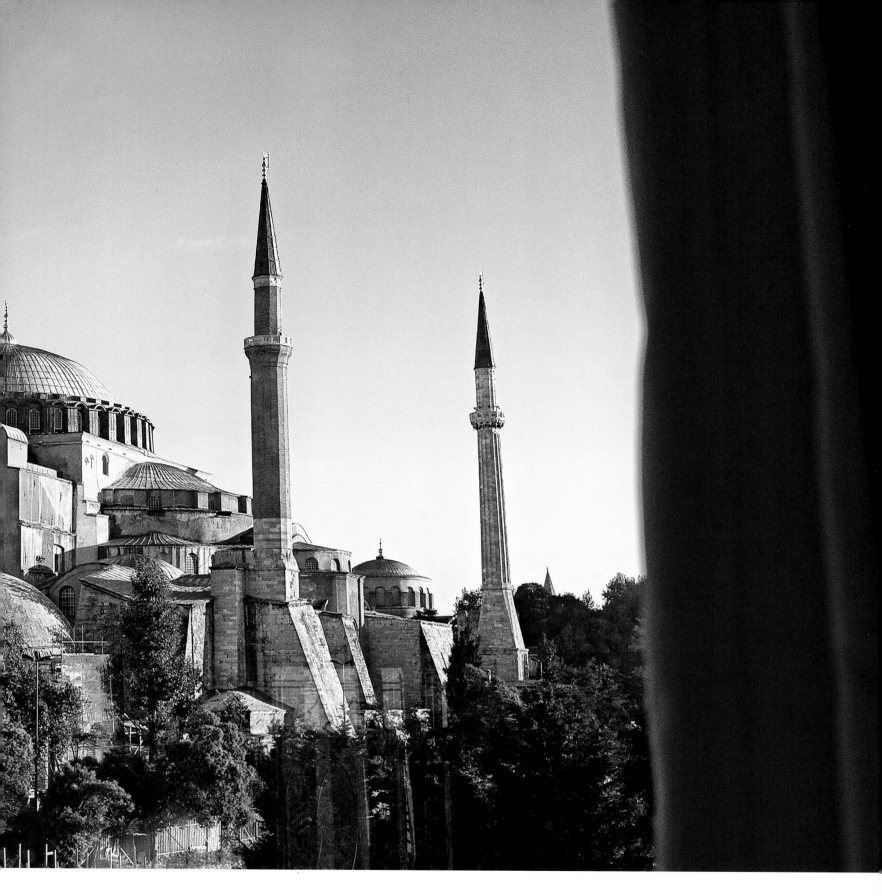

ISTANBUL, TURKEY

Seven Hills Hotel, Room 402

Waking up with this view, you might feel as though you've gone back in time—to the year A.D. 537, to be exact. Ancient Constantinople was a stronghold of the sprawling Roman Empire, and Emperor Justinian I had just completed Hagia Sophia: the Church of the Divine Wisdom. The amber complex would be the seat and symbol of Byzantine Orthodoxy for the next 900 years—until 1453, when Sultan Mehmet II overtook Constantinople and converted Hagia Sophia into a mosque. Luckily, your hotel is positioned for direct access to the mosque's checkered history. Although the silence is overwhelming inside the Church of the Divine Wisdom, outside it's a different story. Sultanahmet, Istanbul's old town, is a cacophony of street vendors and tourists. But late at night, you'll find yourself gazing through the windows of your oak-paneled suite to see Hagia Sophia work her magic under the stars. *November 2007*

Chongwe River House, Upstairs Bedroom

Is the African wilderness truly a wilderness when it comes with designer furniture, Wi-Fi, and the services of a butler, a chef, and a nanny? Chongwe River House, on the riverine border of Lower Zambezi National Park, confronts this dilemma head-on. Lest guests feel cocooned from nature, game guide turned architect Neil Rocher created undulating whitewashed ferro walls and hewn-wood furniture to echo caves and fallen branches. Waterfalls take the place of showers, and decorative prongs at either end of the house recall the horns of a rhinoceros beetle. There is a full staff, to be sure—including armed guides for bush walks to see four of the Big Five and more than 400 bird species—but thankfully no screens to impede the views. Your upstairs bedroom looks out over a crocodile-filled river and untamed land stretching toward the Muchinga Escarpment, the natural boundary for the region's hundreds-strong elephant herds. Talk about call of the wild. *March 2008*

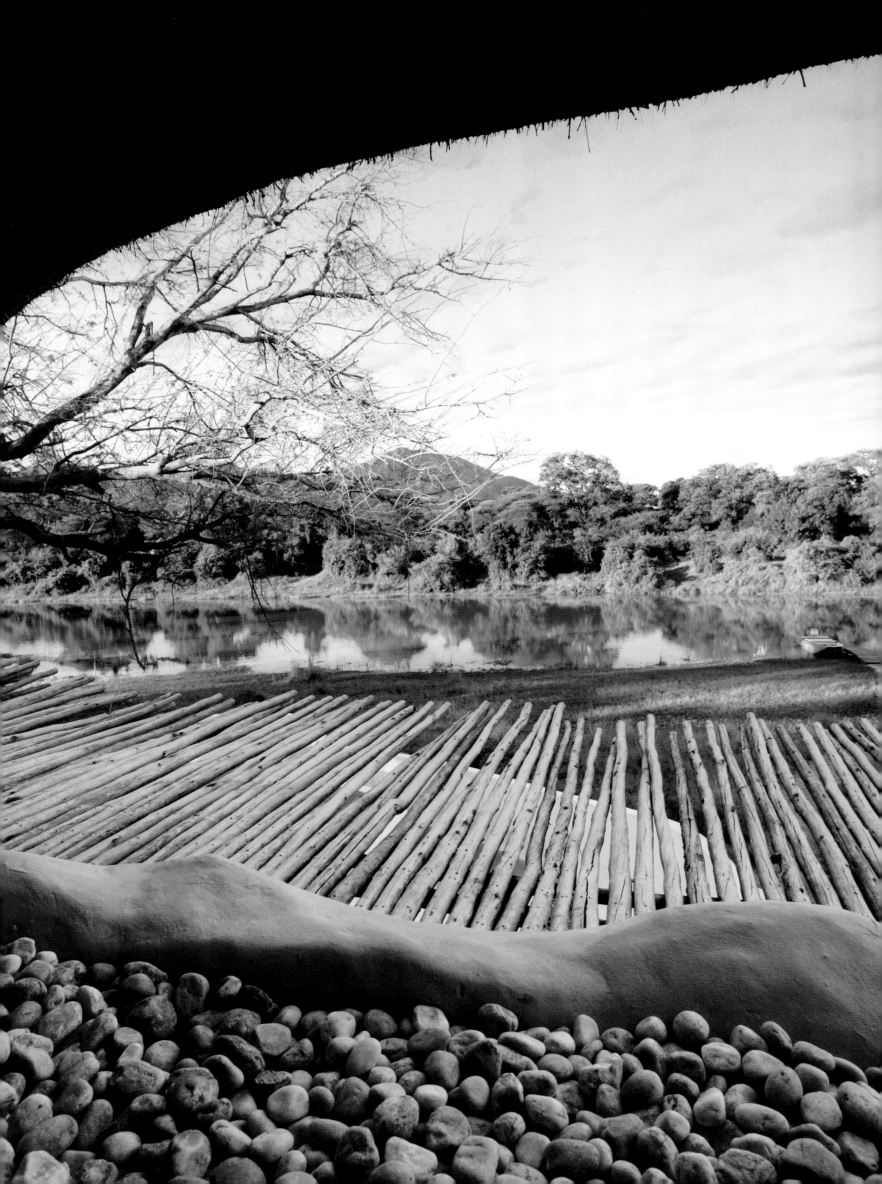

Mandarin Oriental San Francisco, Room 4804

Rudolph Nureyev, we imagine, saluted this view with a neat entrechat trois. He stayed in the 158-room hotel soon after its opening. Other guests can reflect on the long-stay establishment visible in the bay, whose guests included Al Capone, Machine Gun Kelly, and Bird-Man Robert Stroud. Alcatraz, in the distance, was abandoned as our tightest prison in 1963 and is now a tour site, but the emaciated pyramid in the foreground represents money and risk in a different way. It's the home of the financial and insurance corporation Transamerica. And befogged in the distance, there is the iconic Golden Gate Bridge. *December 1987*

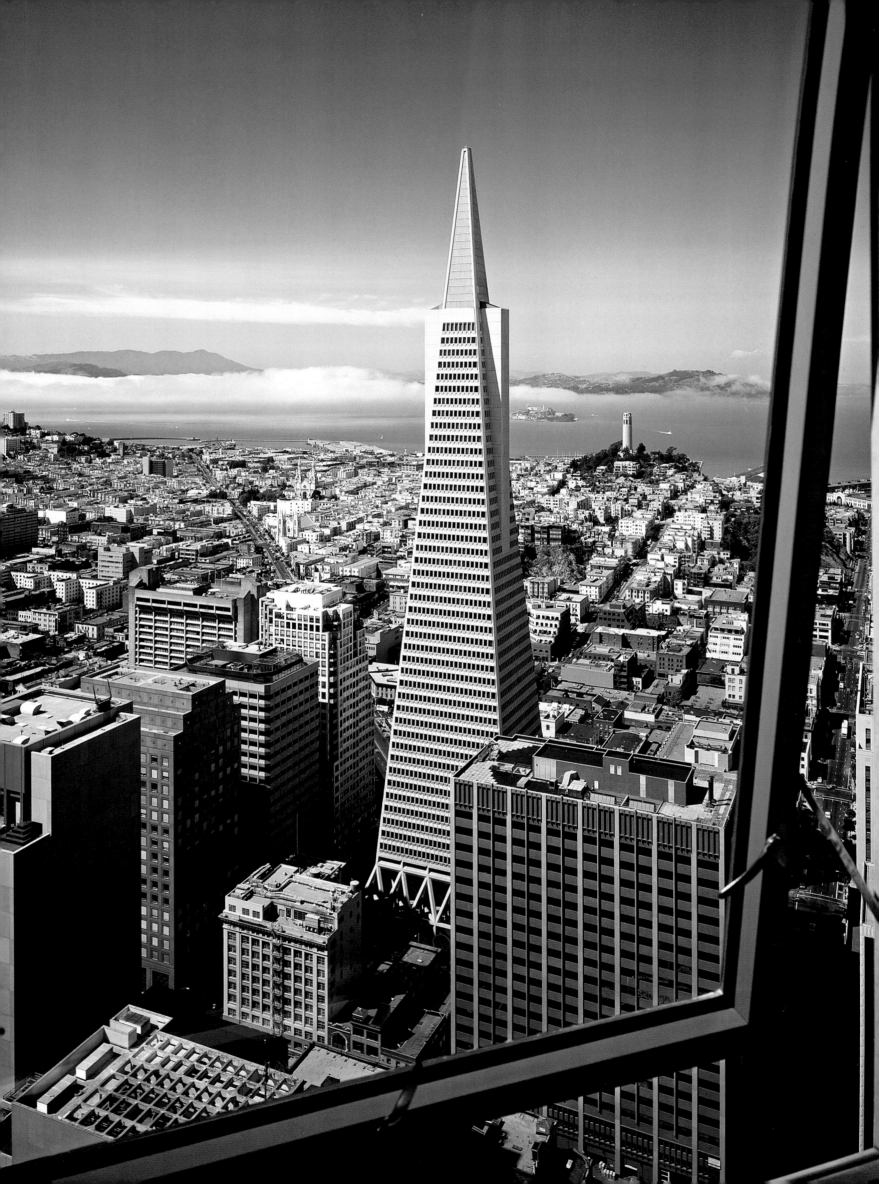

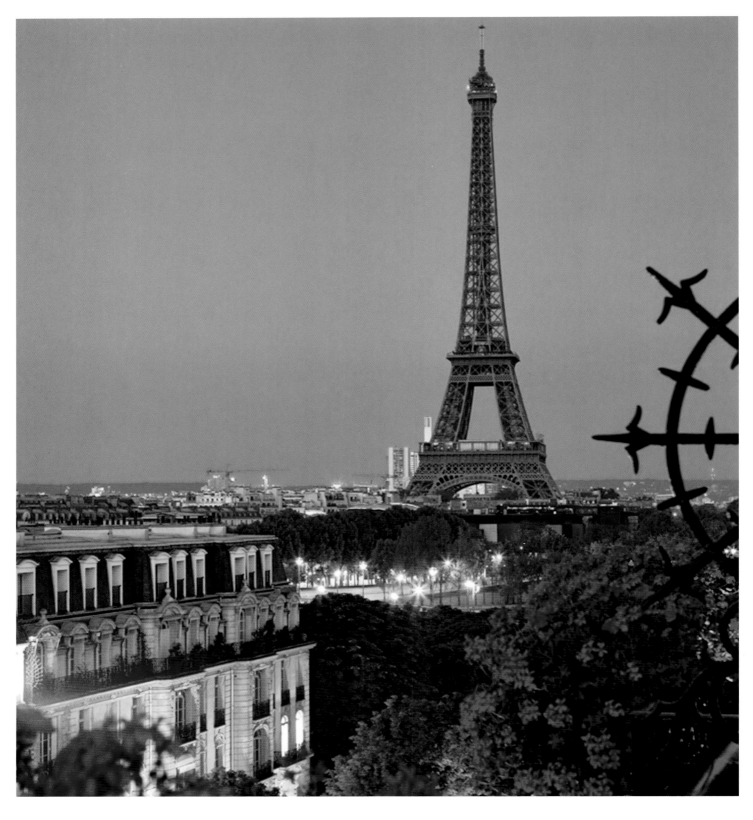

Hôtel Plaza Athénée Paris, Room 604-605

"Spreading across the whole city, a city shimmering with the genius of many centuries, we shall see, like an ink stain, the odious shadow of this odious column of bolted metal." This protest in *Le Temps* newspaper was not quite what Gustave Eiffel had hoped for when he proposed the construction of an iron tower for the 1889 World's Fair. Sadly, the Parisian arbiters of taste were nearly unanimous in their hatred of the design. Of course, a lot has changed. In fact, more than six million visitors come to Paris each year to glimpse the iconic sight. But only a privileged few get to see it as its creators intended: as a beacon at the heart of Paris itself. All *you* need to do, however, is step onto the balcony of your sixth-floor suite, perched above the fashionable avenue Montaigne, and you'll be greeted with this dazzling view of Eiffel's "stupefying folly." *November 2008*

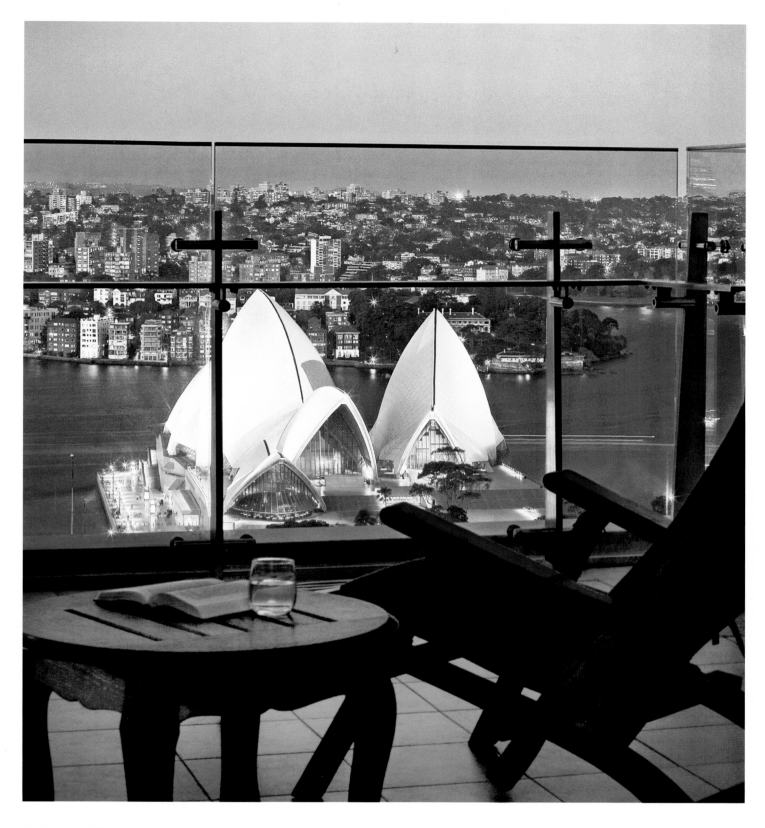

SYDNEY, AUSTRALIA

InterContinental Sydney, Australia Suite

"I dream a house," said the late Danish architect Jørn Utzon, "and then I see it in my head." There's no telling what thoughts will dance through your head in the Australia Suite of the InterContinental Sydney, but you certainly won't tire of the view. Here, the windows reveal panoramas of the harbor and Utzon's modern icon, the Sydney Opera House (the architect thought his building looked best from above). If you can tear yourself away from the vista, you'll find other national treasures in your suite, including a gallery's worth of contemporary Australian art. Behind the InterContinental's neoclassical facade, you'll spy remnants of the 1851 Treasury Building (like the tax office that is now a bar) integrated into the hotel complex. Outside, the diversions of The Rocks—once a slum, now a hip restaurant district—and the Opera House itself are just minutes away. A dream location indeed. *June 2009*

Fontainebleau Miami Beach, Room 1124

Not content to merely be part of the background, this icon and its knockout curves almost overshadow the view. And with good reason. After its opening in 1954, the Fontainebleau became a paragon of Miami Beach style, and its architect, Morris Lapidus, an instant legend—despite purists' dismissal of the half-moon structure as "Bronx Baroque." Frank Sinatra and his Rat Pack arrived to pal around by the pool, Elvis Presley drew legions of fainting fans, and films like *Goldfinger* put the hotel on the silver screen. Today, after a billion-dollar overhaul, the Fontainebleau is poised to become Miami's must-stop once more. In addition to the fabled sand and surf, there are 11 restaurants, 10 pools, and the glamour of hotel nights past to keep you entertained. *May 2009*

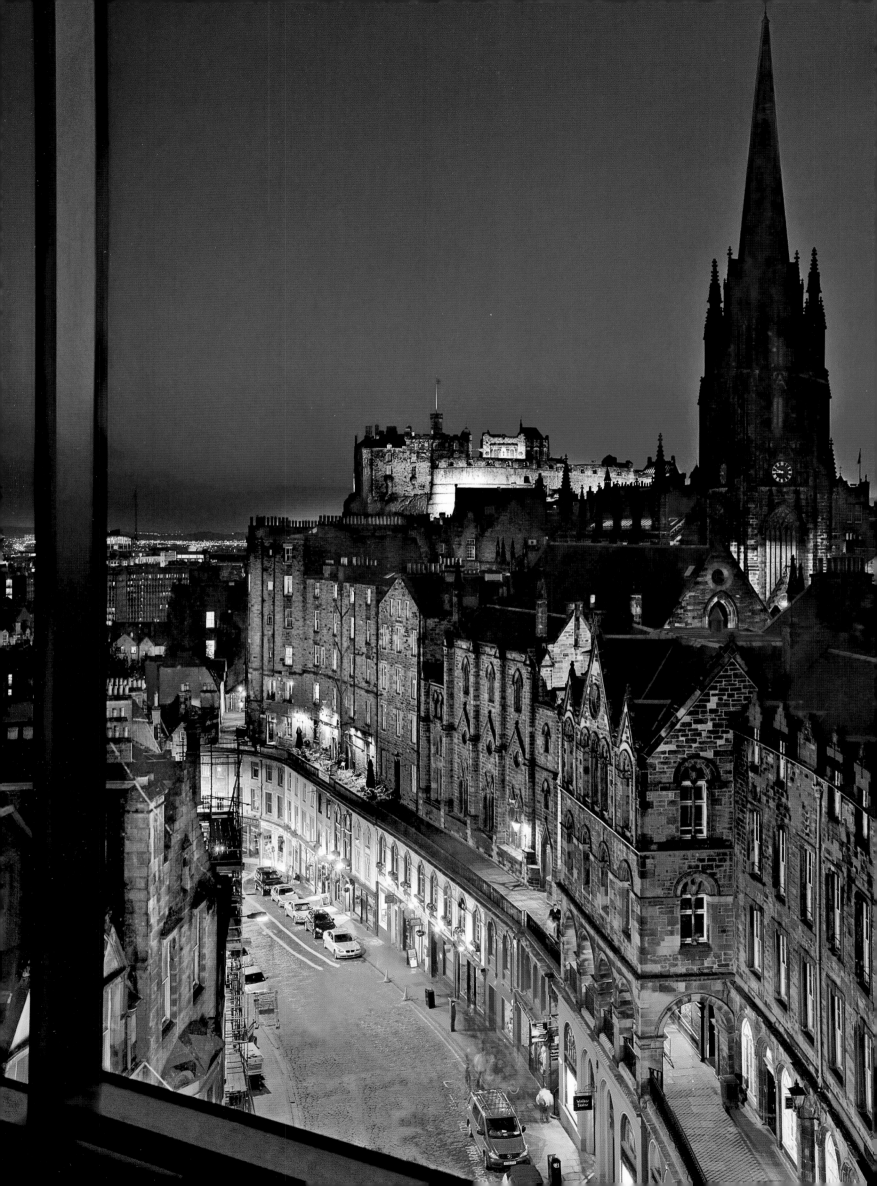

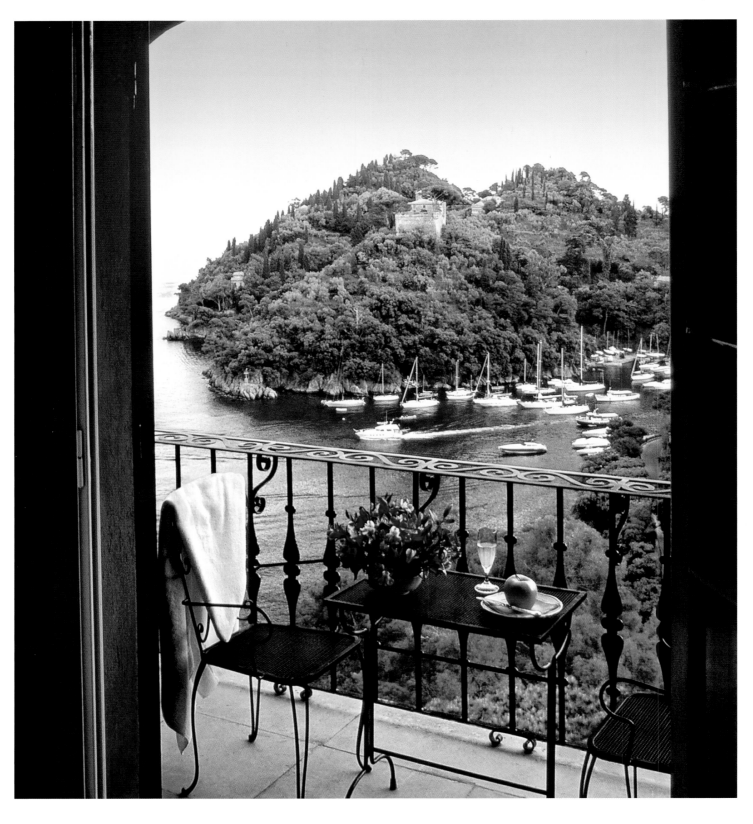

PORTOFINO, ITALY

Hotel Splendido, Room 472

Queen Elizabeth slept here—well, Hollywood's Queen Elizabeth. In 1976 Elizabeth Taylor took Room 472, and also the connecting suite 471, with Richard Burton. Liza Minnelli and Leslie Bricusse are among the others who've enjoyed the view and the hillside's scent of lime and pine. Room 471 is a corner suite with windows on two sides. Both living room and bedroom (white walls, crystal chandelier) open onto a terrace private enough for superegos but also suitable for monitoring goings-on at the pool and noting whose yachts are dancing cheek to cheek in the harbor. *October 1987*

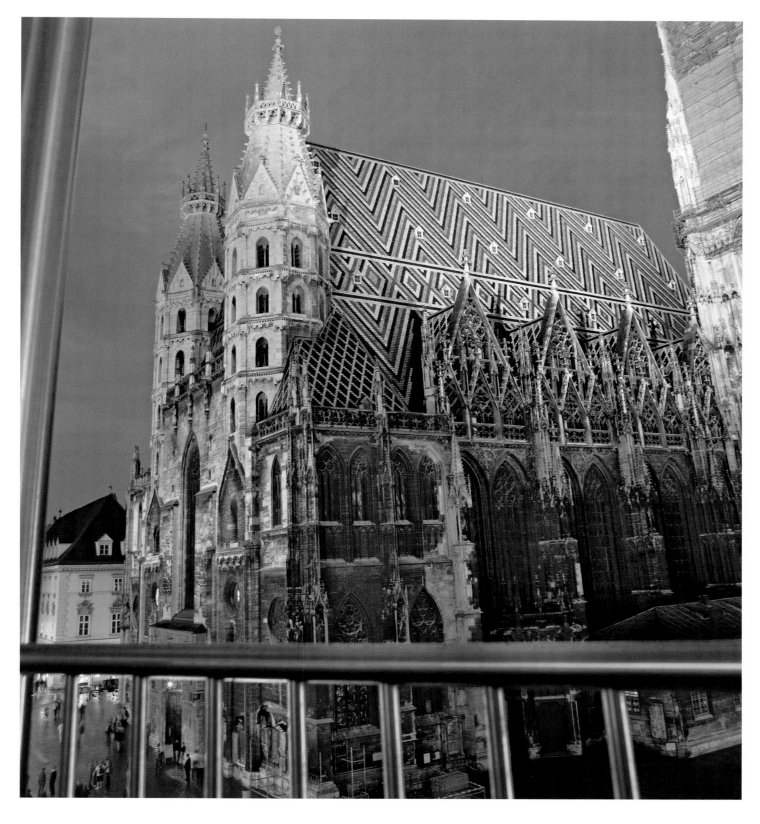

VIENNA, AUSTRIA

DO & CO Hotel, Room 300

St. Stephen's Cathedral is just a stone's throw from your floor-to-ceiling windows, and yet nearly nine centuries separate it from the DO & CO Hotel. Welcome to Vienna, where the old is always smack up against the new. This twelfth-century church at the end of the Kärntnerstrasse—a pedestrian stretch of shops selling everything from sandwiches to shoes—marks the very heart of the imperial city. Speaking of shoes, you'll want a stylish but sturdy pair, because this is a walking city. You're within strolling distance of the opera house, the vast Kunsthistorisches Museum, the increasingly lively banks of the Danube, and the busy outdoor Naschmarkt, with its dozens of cafés and shops. Do give your feet a rest at least one evening, though, by ascending to the formal restaurant atop your hotel, where you'll find an even better view of that heavenly roof. *April 2007*

CHICAGO, ILLINOIS, USA

Hotel 71, Room 1203

This stretch of the Chicago River is where the building boom began. When the city was incorporated in 1837, it was the nexus of urban life—until the Great Fire of 1871 made it a blank architectural canvas again, one which gradually filled up with the gallery of high-rises outside your window that make up today's business district. The elegant Donnelley (1992) is the fourth building on your left, and just out of view behind it rises the pencil-like Lincoln Tower (1928). On your right hulk the 1959 Marina City towers, better known as the "corncobs," and beyond them, though out of view, the mammoth 1931 Merchandise Mart, still the world's largest commercial building. In more recent years, office space isn't all that's been on the rise: With the appearance of new hotels, restaurants, and shops along the revitalized riverside boulevard, the neighborhood is, more than ever, mixing business with pleasure. *March 2003*

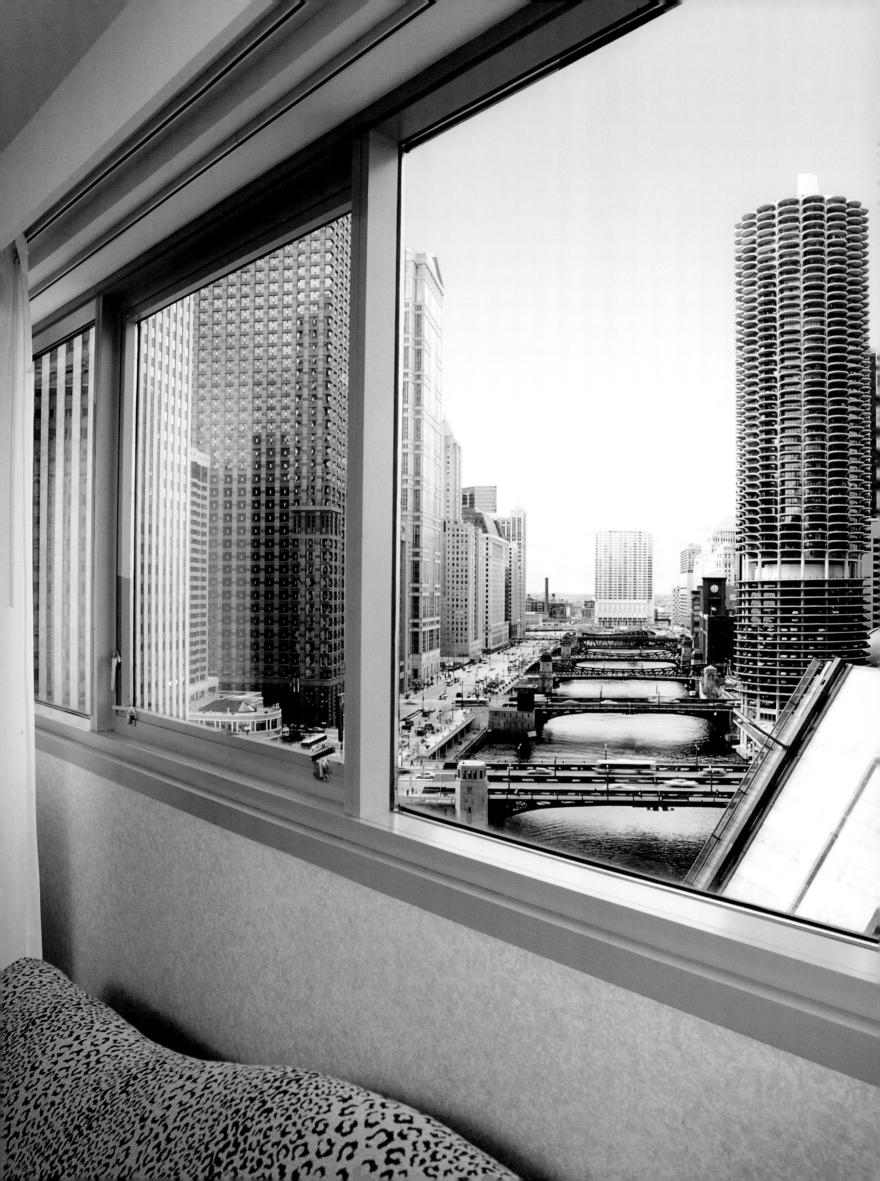

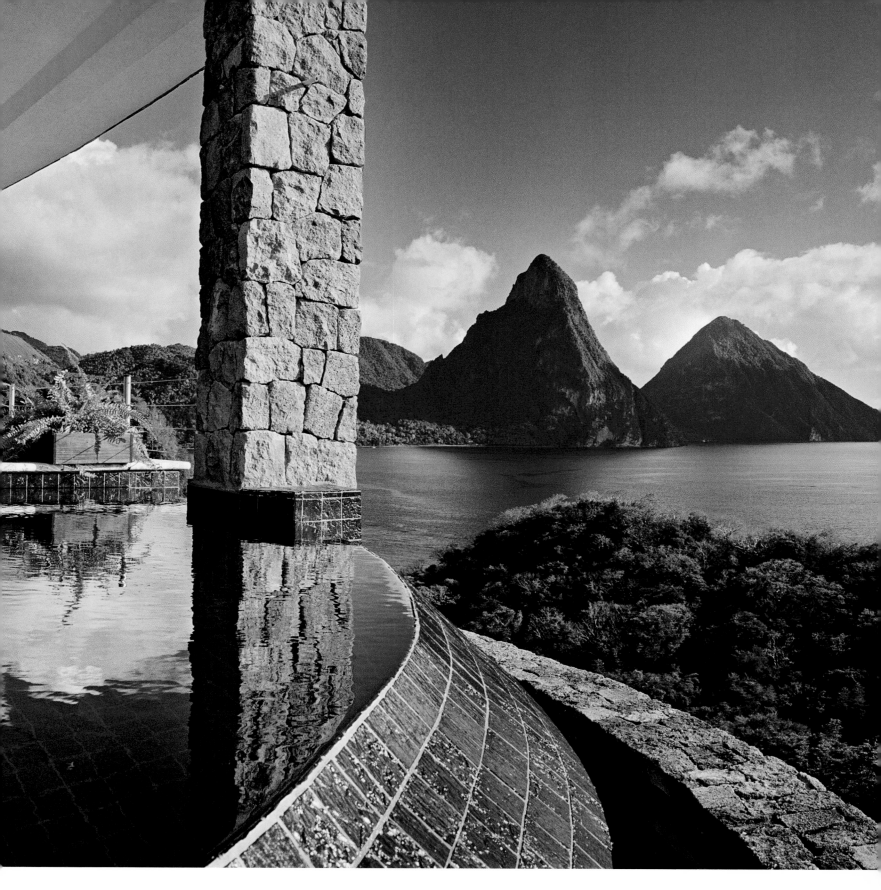

SOUFRIÈRE, ST. LUCIA

Jade Mountain, The Sun Suite

St. Lucia may have a lot of rocks and hard places, but what a place to be caught. For starters, you've got some enviable decisions to make. That swimming pool is not only enormous, but it's yours alone, so where's your bathing suit? Those peaks on the horizon are the famous Pitons; two of the most photographed mountains in the hemisphere, they are a UNESCO World Heritage Site. So where's your camera? That natural body of water is the Caribbean, and 190 feet below your room it meets not one but two beaches—more decisions. The fluttering wings you hear could be from Jade Mountain's resident hummingbirds or bananaquits. Where are your binoculars? You'll want them after sunset, too, because this far removed from light pollution, the Milky Way is dazzling. The choices are enough to exhaust you. Did we mention the open-air beds? All soft landings should be so hard-earned. *September 2007*

Mena House Oberoi, Room 802, The Carter Suite

"From the summit of these monuments, 40 centuries look upon you," bellowed Napoleon before leading his soldiers into battle against Egyptian forces near here in 1798. (He won.) You can ponder the general's words from this suite (named after President Jimmy Carter, who stayed in it in 1979 while negotiating a peace between Egypt and Israel). Rising before you, the Great Pyramid of Cheops, the largest in Giza, was built by thousands of workers in the twenty-sixth century B.C. Composed of 2.3 million limestone blocks, each weighing 2.5 tons on average, it served as the tomb for the pharaoh and is the sole Ancient Wonder of the World still in existence. Though not quite as storied, Mena House has come a long way from its genesis as a nineteenth-century royal hunting lodge. Surrounded by 40 acres of jasmine-scented grounds, it has antiques-filled rooms, a golf course—and views that have stood the test of time. *April 2009*

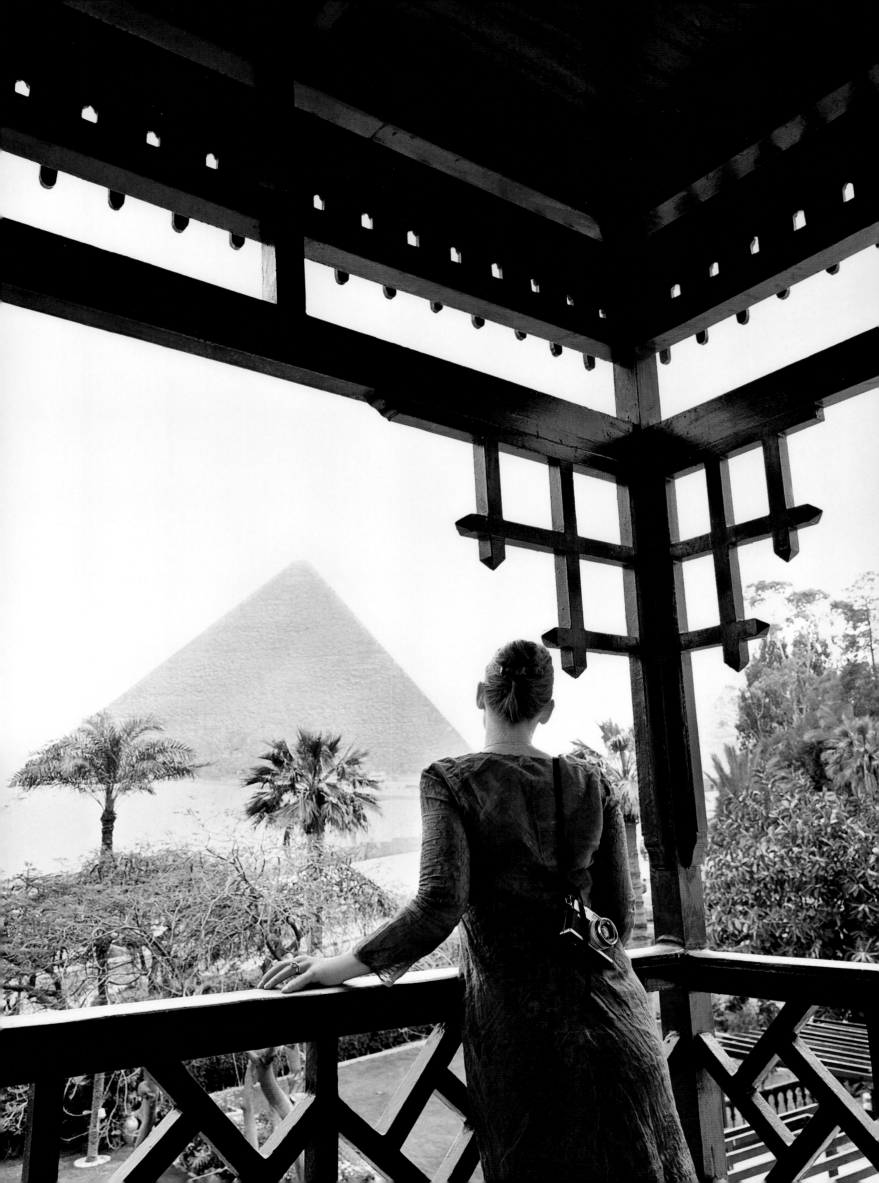

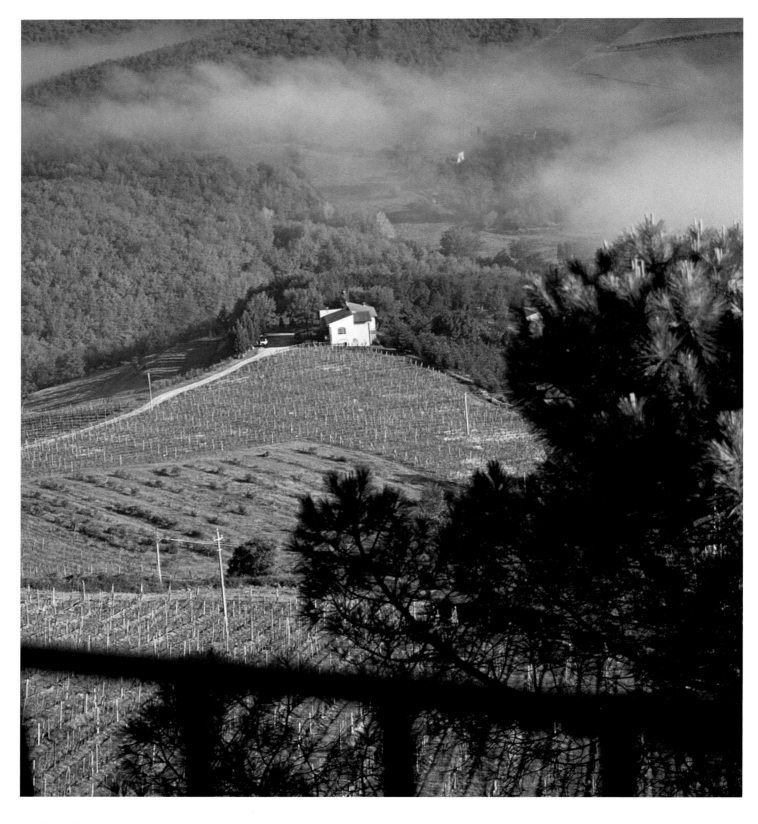

RADDA IN CHIANTI, ITALY

Relais Vignale, Room 64

Early October is harvest time in the hills below the Relais Vignale, a 300-year-old manor nestled in Tuscany's Chianti Classico region. These vines produce sangiovese grapes, the basis of the celebrated, robust wines that carry the region's name. What looks like an age-old landscape is actually a staging ground for innovation and industry. Thanks to recent developments that keep yields low and quality high, Chianti wine has shed its rusticity (for the best Chianti Classicos, look for a black rooster on the label). And although your view might seem consummately Italian—surely you've seen it painted sfumato-style, framing the shoulder of a Renaissance lord—there's a touch of Merchant-Ivory about it; the area is often dubbed Chiantishire, due to the many British residents who find the food, the sunshine, and the vinos of Tuscany a welcome tonic. You too can imbibe freely, for the Relais Vignale offers daily wine tastings. *Salute! October 2002*

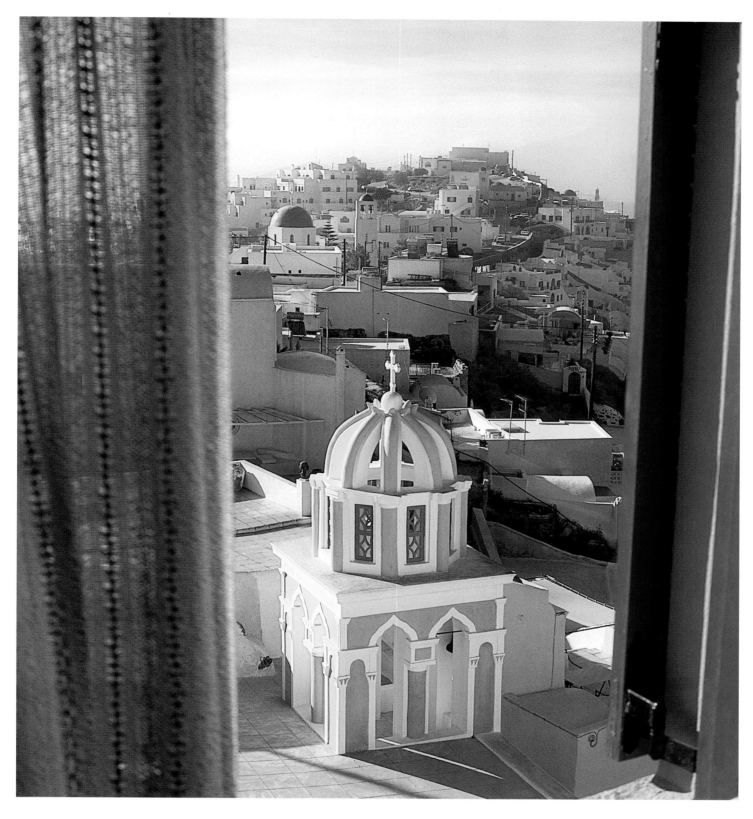

SANTORINI, GREECE

Villa Rose Hotel, Apartment 3

You'll ascend some 580 steps (skirting donkey droppings en route) to reach Fira, a town clinging to the cliffs of Santorini. The island's famous vistas of whitewashed buildings against the blue Mediterranean—and the effort required to get to them—could only be eclipsed by the myth of what once was here. A volcanic explosion in 1550 B.C. sank the center of Santorini beneath the sea, and with it, many believe, the legendary city of Atlantis. For the contemporary citizenry, the focal point is somewhat different: religion. Throughout the year, the chiming of church bells like those outside your window marks the onset of a Greek Orthodox celebration. February 2 will ring in the feast of Candlemas, and a few months later will commence the pre-Lenten revelry culminating in Easter, the year's largest event. Even on non-holy days, however, you'll find reason to give thanks—as your view proves. *February 2002*

Kapawi Ecolodge & Reserve, Room 19

Brush aside the mosquito netting, roll out of bed, and step onto the terrace, and you'll receive a boisterous greeting from a brown jacamar, an egret, or another of the 500-odd bird species residing in this pocket of the biodiverse Amazon jungle near the Peruvian border. Perched on stilts above the Capahuari River, Ecuador's remote Kapawi Ecolodge—two planes and a boat ride from Quito—isn't just environmentally conscious, it's downright reverent. Solar panels power the lodge, and the 19 thatched-roof cabanas are built of palm and mahogany without a single nail, following the methods of the indigenous Achuar. After getting your fill of the view, slip on the rubber boots left at your door and head down to the river for a canoe ride. As you float, peer into the sweeping branches of the hundred-foot trees: You might even spot the rarely seen three-toed sloth. *February 2007*

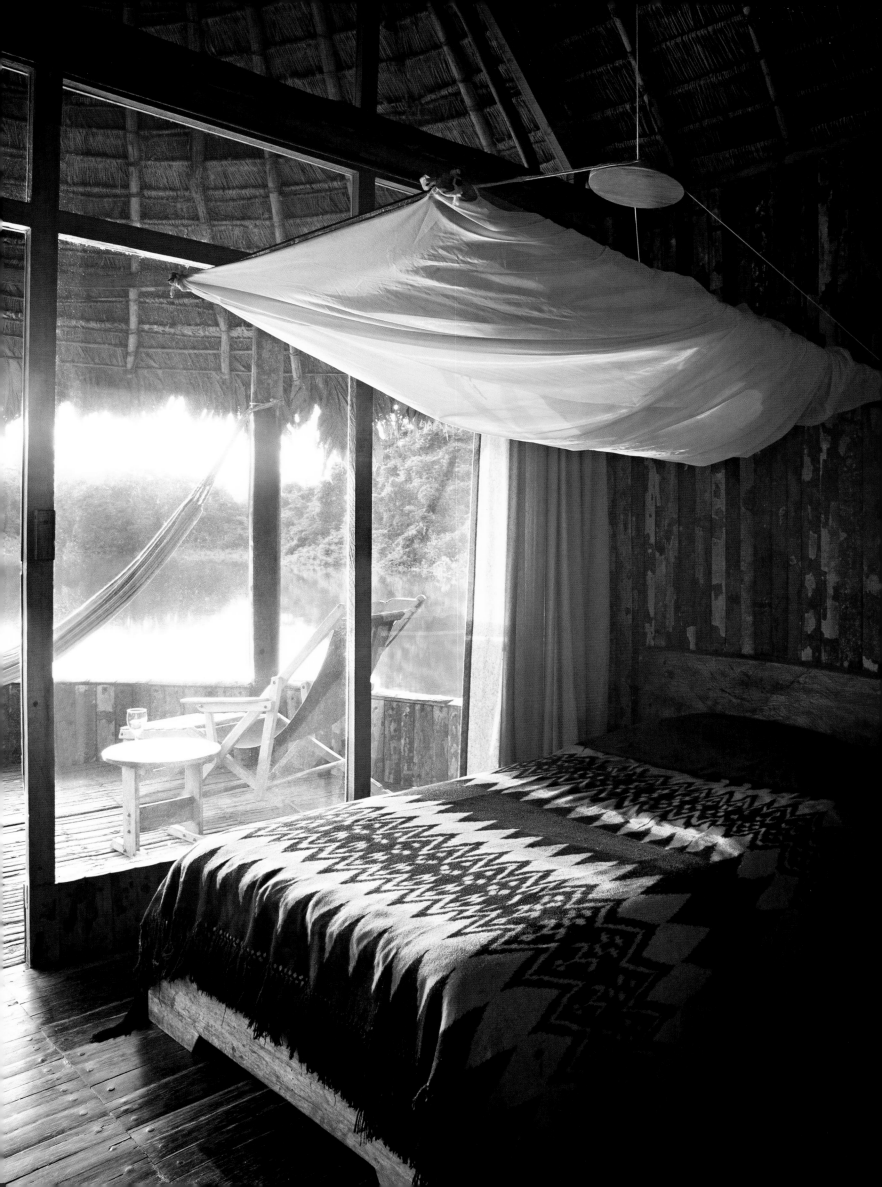

Hogno Han Ger Camp, Ger 2

Your sense of space increases exponentially in Mongolia, where a vast dome of blue sky hovers over seemingly endless stretches of open terrain. Here in the foothills of the Hogno Han Mountains, the country's three main geographic zones—steppe, desert, and forest—converge, creating a dramatic backdrop for this grassy site. Guests arrive by car at the remote Hogno Han Ger Camp, four hours west of the capital, Ulaanbaatar, over one of the region's few paved roads. Like the locals, you're staying in a *ger*, the traditional dwelling of nomadic herders that is prized for its portability and its adaptability to Mongolia's extreme fluctuations in temperature: Its trellis walls are swaddled in layers of felt, which can be added or removed, depending on the elements. A potbellied stove (fired up by an attendant) heats the candlelit room, leaving you to curl up in your wood-frame bed and gaze through the *ger's* oculus at the perfect sky. *June 2004*

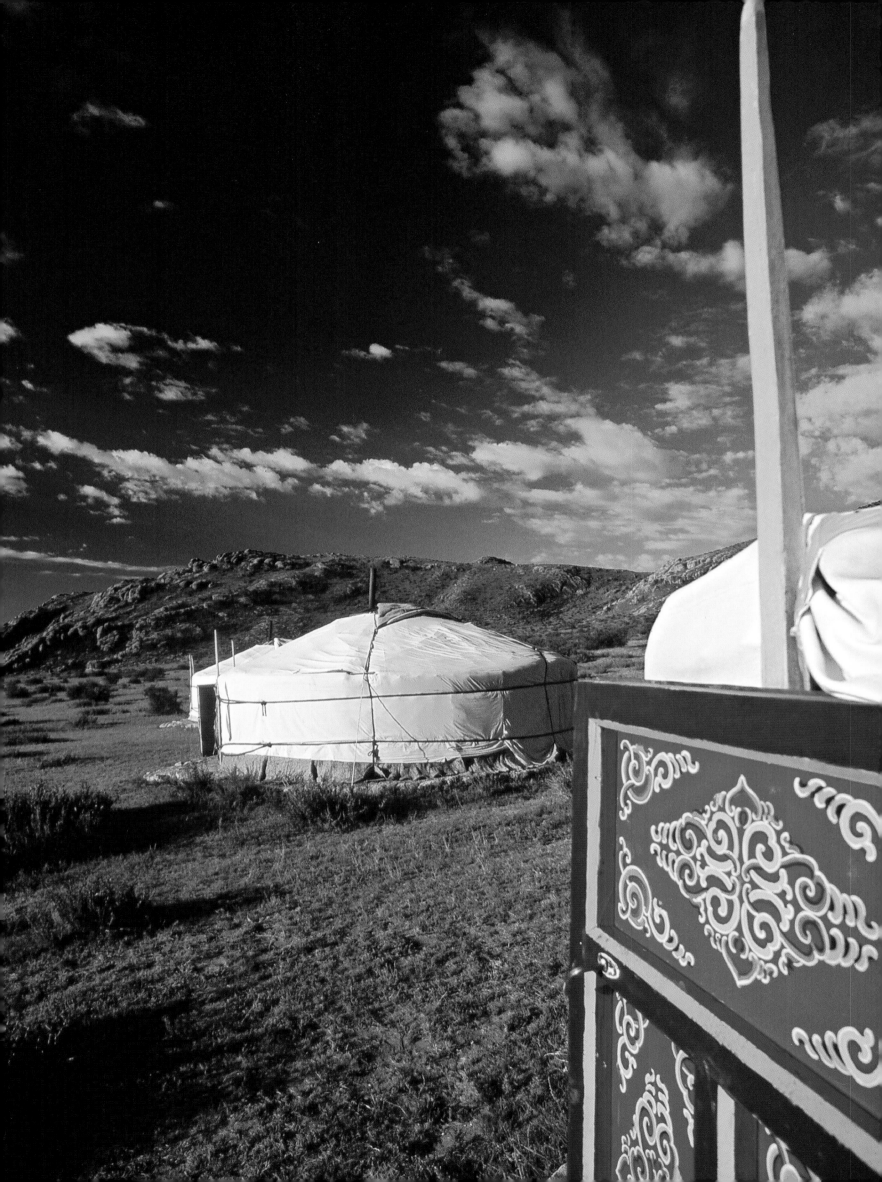

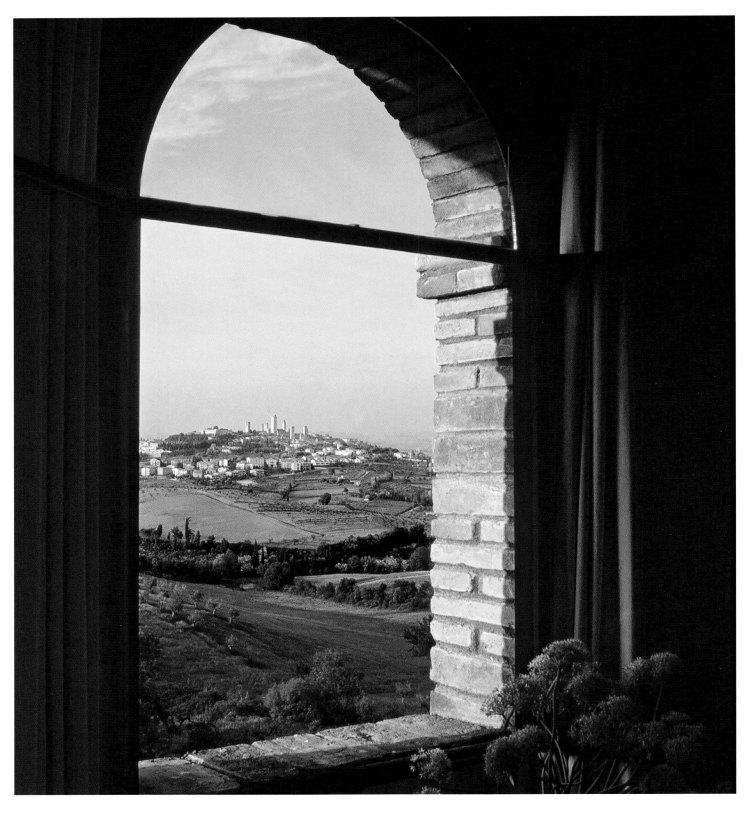

SAN GIMIGNANO, ITALY

Hotel Pescille, Tower Room

Skylines tell a story, as much in Tuscany, perhaps, as in Manhattan. In the Tuscan hill town of San Gimignano the story is in the towers. In the thirteenth century there were more than seventy of them. You might call it the ultimate in fortress mentality: Noble families retreated to the hills and marked their bastions with towers. Little more than a dozen survive now; some of them you can see from the Tower Room of the Hotel Pescille, just as one paranoid noble might have gazed out on the citadels of others. The hotel itself is a survivor: first a castle, then a monastery, then a winery. It sits near the Via Francigena, the old Paris-Rome route. Napoleon happened by in 1812 and turned out the monks. In 1971 the winery became a hotel, amid the vineyards and the olive groves. No monklike asceticism is expected now—the last conquest of Tuscany was by sybarites. *September 1989*

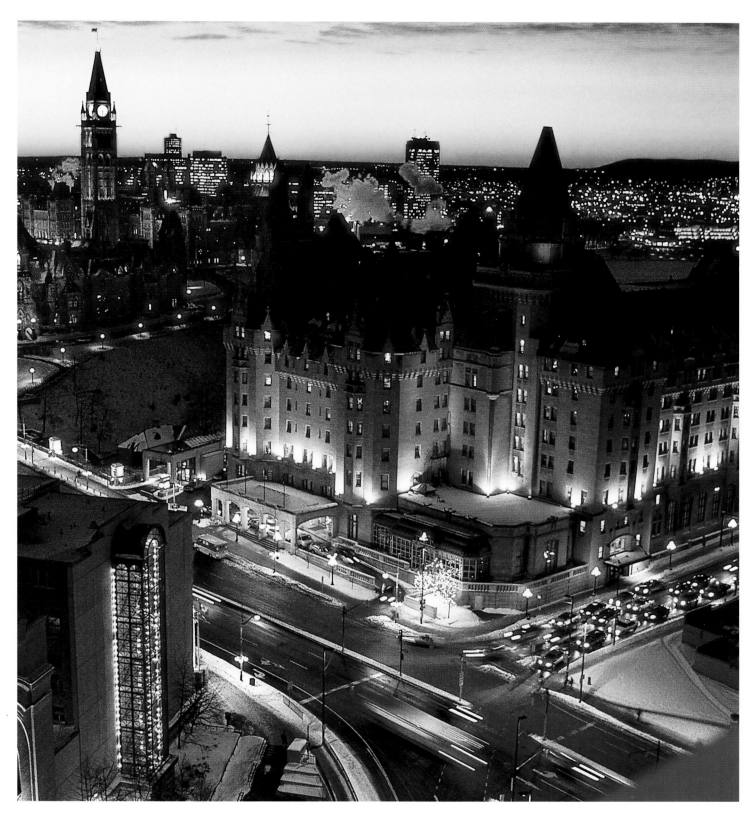

OTTAWA, ONTARIO, CANADA

Westin Ottawa, Room 2318

The limestone of the 1912 Château Laurier, across the way, glows on this winter evening, and you, cozy in your suite at the much more modern Westin, have a sweeping view of the downtown Ottawa scene. Those are perhaps legislators motoring down Rideau Street after a day on Parliament Hill (marked by the Westminsteresque tower in the distance) and hours of *débats chauds*—after all, that's Quebec just across the river. You're in one of the world's chilliest capitals, but even if you're frost-phobic, you won't be frozen out of the action. A brisk walk leads to hundreds of shops and restaurants in the now trendy nineteenth-century ByWard Market district. To beat the cold, take in a heated game of hockey (the Senators play at nearby Scotiabank Place). Or lace up your own skates on the frozen Rideau Canal, visible behind the Laurier. At five miles, it's the world's longest ice rink. *December 2002*

ESCALANTE CANYON, UTAH, USA

Wind River Pack Goats' Escalante Canyon Goatpacking Camp, Tent 3

There's only a thin nylon barrier between you and the rugged, striated Navajo sandstone of Utah's Escalante Canyon, part of Grand Staircase-Escalante National Monument—a 1.7 million–acre expanse of isolated mesas, buttes, valleys, and slender canyons rich with dinosaur and fish fossils. And yes, that's a goat ambling by your tent, but it's not a resident; rather it's your camping gear's means of conveyance. The outfitter Wind River Pack Goats leads an occasional hiking excursion that snakes along the 85-mile Escalante River. With a companionable goat carrying your pack, you're free to shimmy through the cliffs off the seldom-traveled slot canyons, to decode the ancient petroglyphs etched along the canyon walls by the Anasazi, and to be serenaded by some 200 bird species. There's some serious ground to be covered—you'd better start hoofing it. *April 2006*

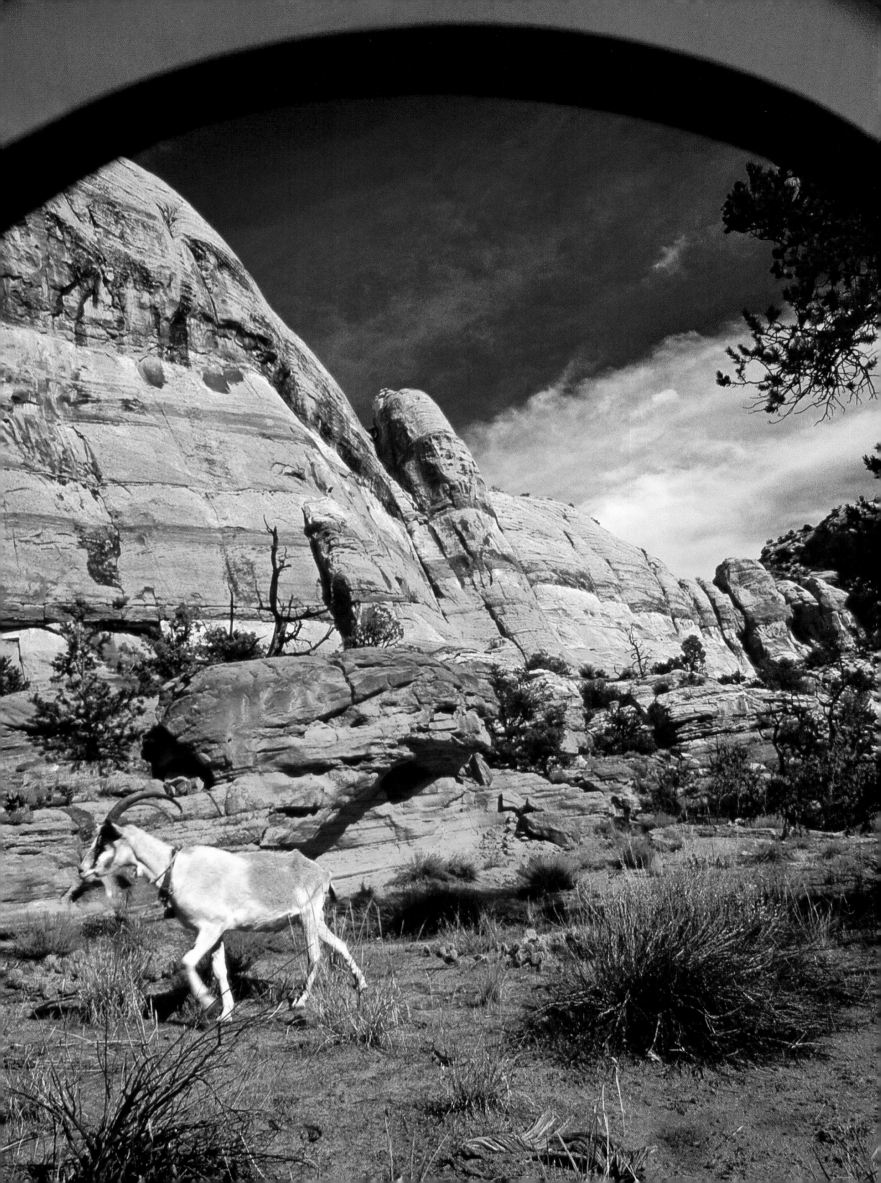

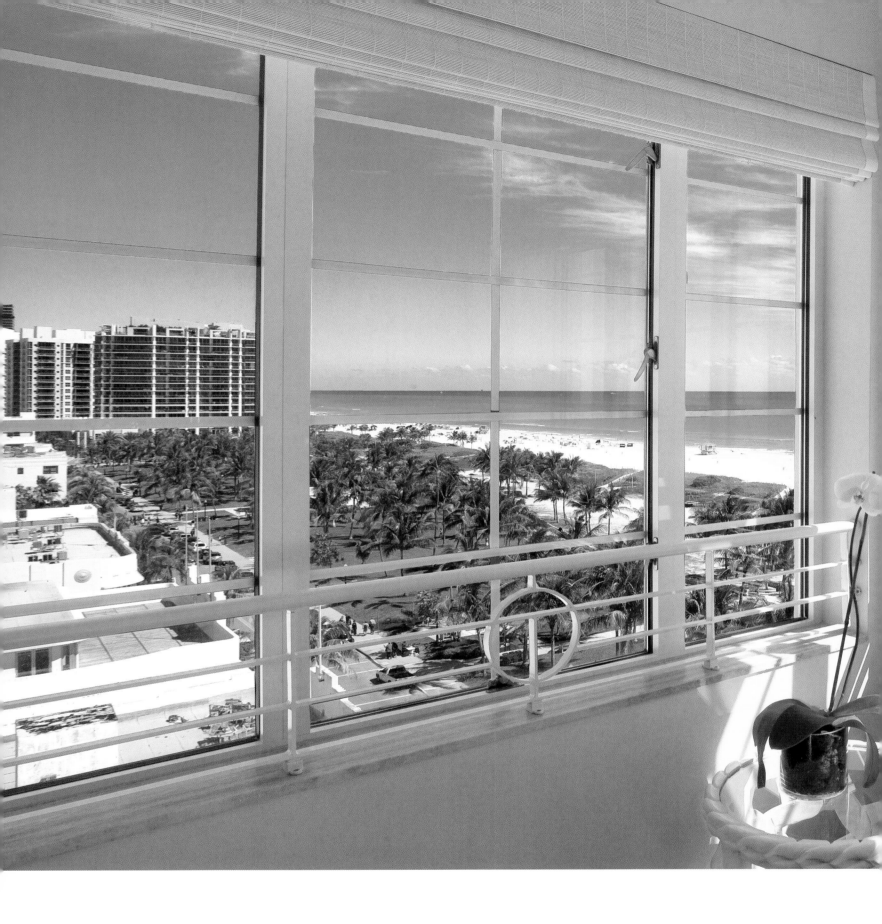

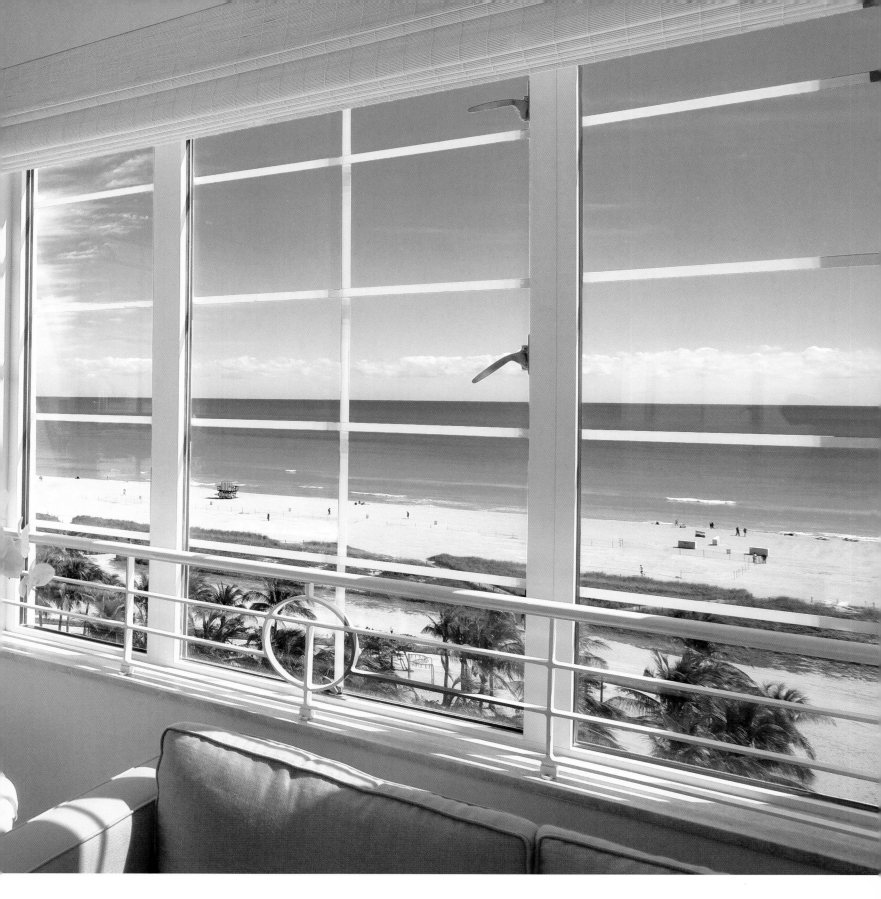

MIAMI BEACH, FLORIDA, USA

The Tides, South Beach, Suite 801

If adaptability were a currency, Miami Beach might be the wealthiest place on earth. Less than a century ago, its high-rises weren't even a glimmer in the imagination. But in 1913, a new bridge connecting the strip to mainland Miami drew the first investors to the oceanfront property. During the South Beach Art Deco boom of the 1930s, the city experienced another reinvention. However, nothing changed it as much as the ascent of Fidel Castro in 1959, when half a million Cubans fled the revolution, injecting Miami Beach with a dose of Latin flavor. More recently, the arrival of the glitterati caused yet another transformation. Even The Tides wasn't spared. Previously an homage to minimalism, the hotel has morphed into a pastiche of textures and styles. Today, you'd be hard-pressed to find remnants of its former persona—your present vantage point notwithstanding. But would you want it any other way? *August 2008*

Giraffe Manor, Master Bedroom

Say hello to six-year-old Lynn and, wandering behind her on the front lawn, seven-year-old Arlene. They're just two of the ten long-legged residents of Giraffe Manor, who every now and then poke their noses into your second-story bedroom window in search of a treat (sans giraffe, your window frames the silhouette of Mount Kilimanjaro). Since 1974, when the owners of this 120-acre estate turned it into a sanctuary for five baby Rothschild giraffes—endangered at the time—these graceful animals have flourished in Langata South, a suburb of Nairobi. And over the years, many of the offspring have been moved next door, to Nairobi National Park. The manor's current brood, ranging from a two-ton, 19-foot bull to the three-month-old female calf he sired, pretty much have the run of the place. But when you're greeted with a face as irresistible as Lynn's, how could you mind? *June 2003*

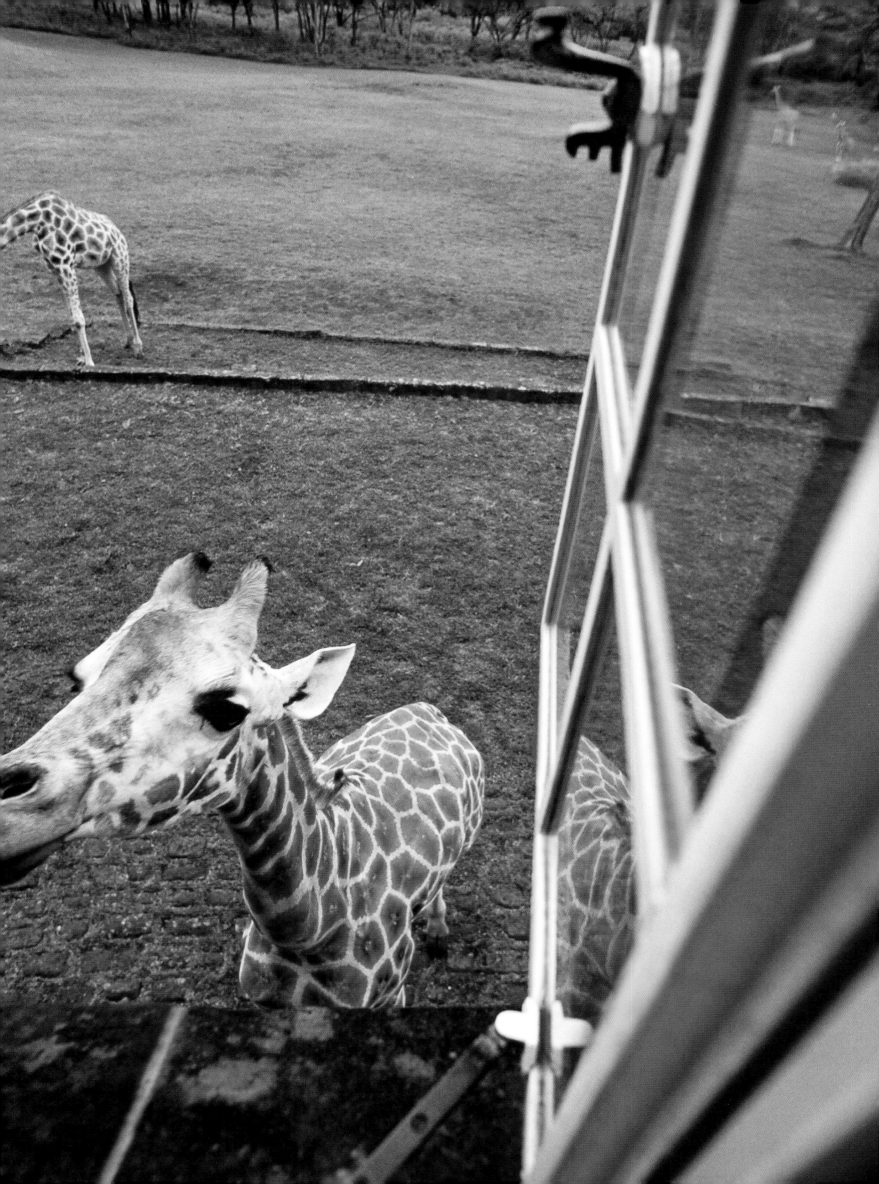

Bauer Il Palazzo, Royal Suite

In a city where nearly every view is frame-worthy, this balcony at the Bauer Il Palazzo delivers big-time. You're above Venice's great intersection, where the Grand Canal meets the lagoon. Gondolas and vaporetti pass into the web of canals, out toward other islands and the Lido, and across to Dorsoduro and the Church of Santa Maria della Salute. The Baroque basilica is impressive enough from this distance, with its great domes and more than 120 statues, but there are more treasures inside, including Titians and a Tintoretto. To get there, climb into a *traghetto* (a shared gondola) and go native, if you dare: Venetians, like the gondoliers who propel the asymmetrical craft, stand during the crossing. After all, if Lord Byron could swim to the Lido, you can swim to shore. *July 2007*

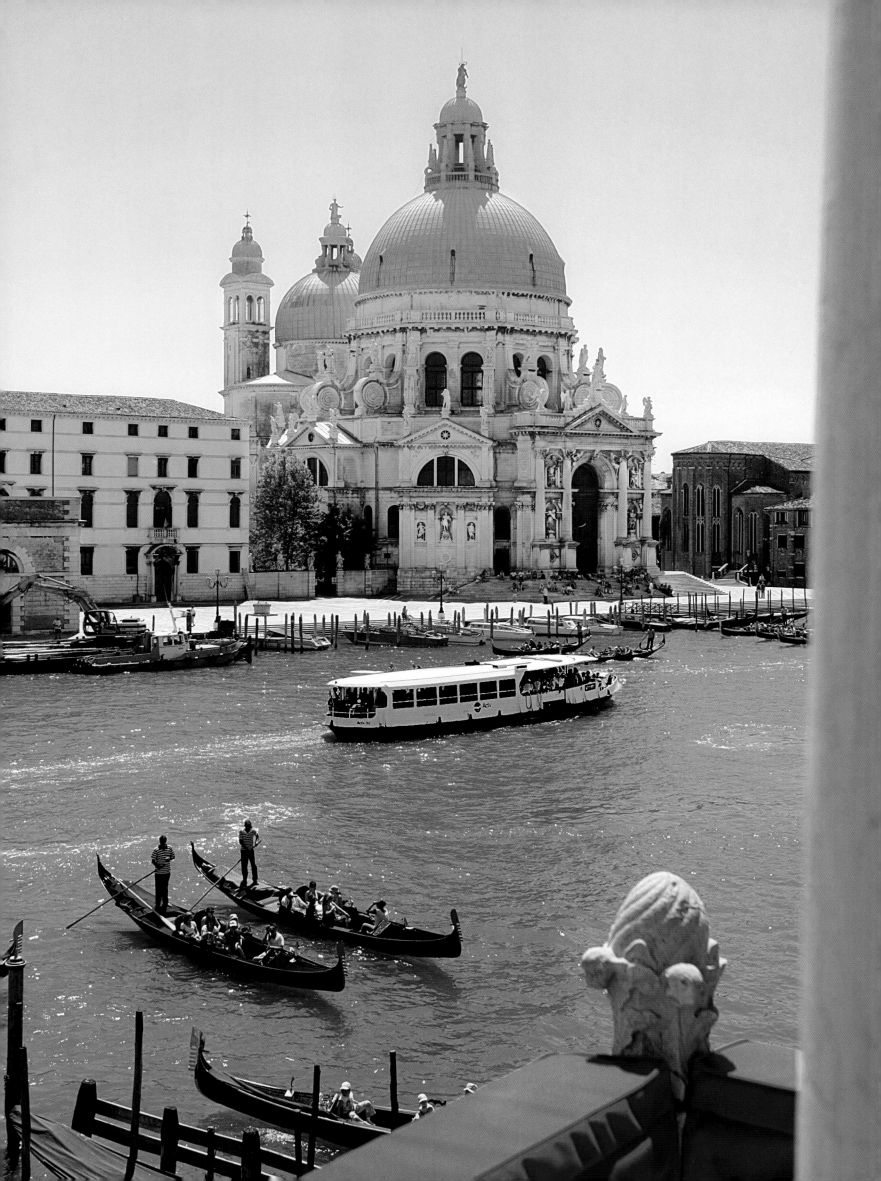

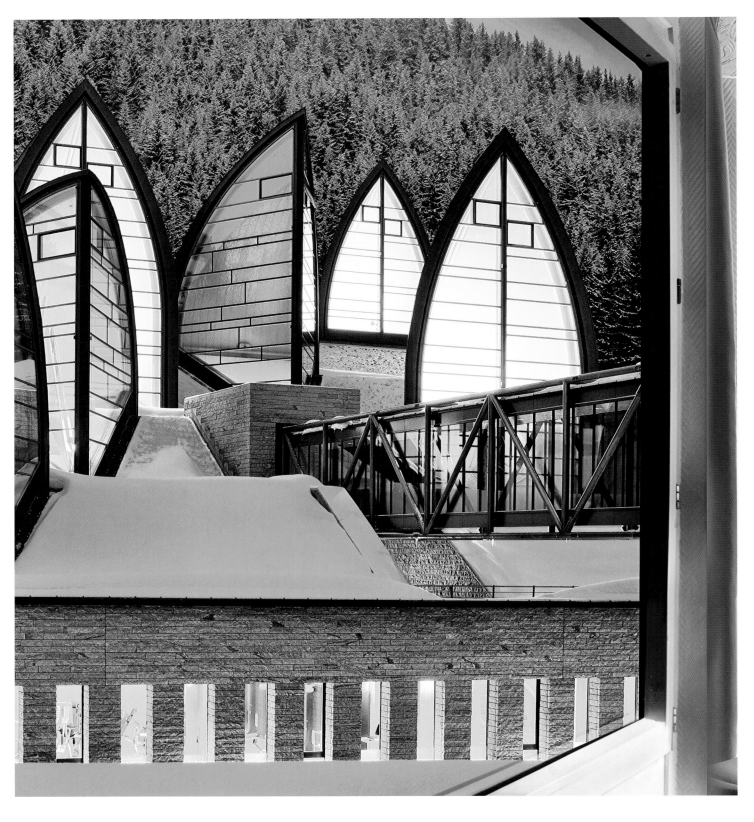

AROSA, SWITZERLAND

Tschuggen Grand Hotel, Room 116

Is that the aurora borealis outside your window? Not quite, though these man-made northern lights are just as magnetic. Perched atop Tschuggen Grand Hotel's Bergoase Spa, the nine sail-shaped dormers illuminate the 43,000-square-foot minimalist facility. Since opening in 1929, the Tschuggen Grand has been one of Switzerland's preeminent winter retreats, luring skiers and snowboarders to Arosa's 37 miles of trails. However, few ventured here during the milder months (May through November), when the hotel was traditionally shuttered. That changed in 2006 with the opening of Swiss architect Mario Botta's modernist Bergoase Spa, which ushered in the Tschuggen Grand's first ever summer season. Now, besides skis, golf clubs are the must-have accessory in Arosa, where you can tackle Europe's highest-altitude 18-hole golf course, a challenge at 6,560 feet. But after hitting the links, there's nothing like a nighttime view of those northern lights. *December 2008*

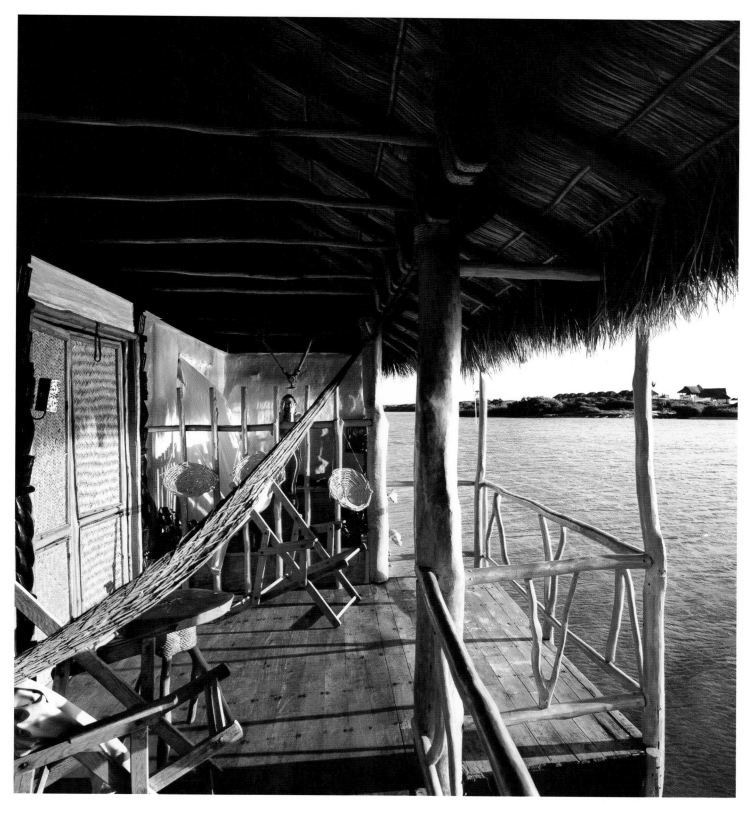

JALISCO, MEXICO

Hotelito Desconocido, El Venado Suite

Absent electricity and beyond the reach of cell phones, your shady, thatched-roof *palafito*, propped on stilts over a lagoon that's part of a wetland habitat rich in sea turtles and birds, is a respite from the everyday world. On Mexico's sleepy Costa Alegre, south of Puerto Vallarta, the Hotelito Desconocido, or "Little Unknown Hotel," belies its humble name: The eco-resort is at once pamperingly luxurious and utterly simple, operating only by solar energy, with candles for illumination come nightfall. The resort's gray water is purified before being returned to the environment, and at both restaurants, all meals are prepared from local organic ingredients. While dining, you'll be serenaded by representatives of the 150 bird species here, in one of the country's most significant reserves. *February 2005*

Mandarin Oriental Dhara Dhevi, Villa 3

To look out from the second-story terrace of your villa at the Mandarin Oriental Dhara Dhevi is to see the old ways of Chiang Mai artfully interwoven with the new. The buildings on the grounds of this resort are set amid rice paddies, palm trees, and banyan trees, and were designed to replicate traditional Northern Thai, Shan, and Burmese architectural styles. Within their walls you'll find modern amenities, including a yoga studio, a Thai cooking school, and even 24-hour room service. What you won't find on your porcelain dinner plate, however, is the rice that is harvested from the paddies beyond your terrace. All of the crops cultivated on the resort's 52 acres are donated to nearby Wat Don Jan, which uses the fruits of the Mandarin Oriental's land to feed hundreds of underprivileged children. *August 2006*

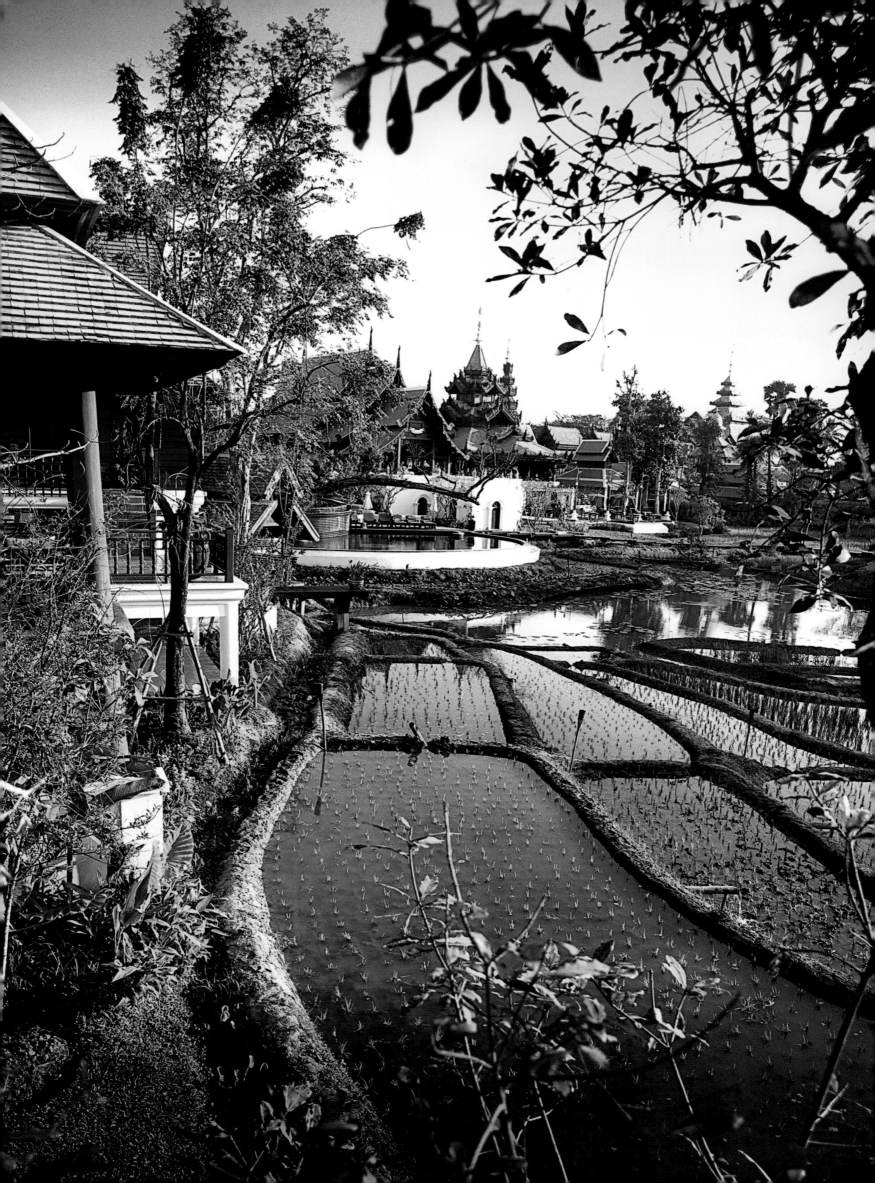

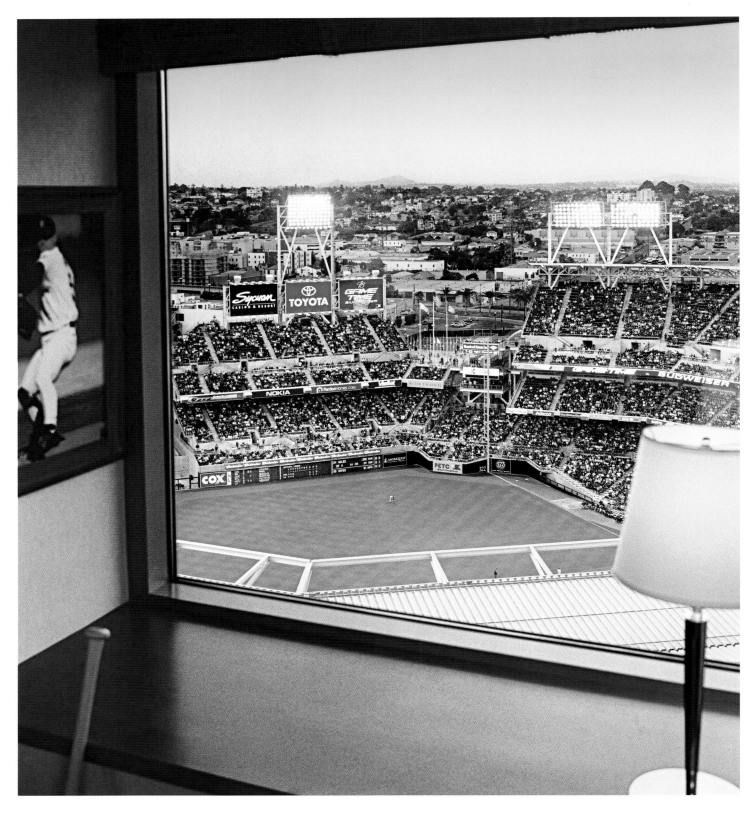

SAN DIEGO, CALIFORNIA, USA

Omni San Diego Hotel, Room 1933

Now, going back to your room to catch the game's progress is a real-time thrill. The Omni opened its doors to coincide with the first pitch at Petco Park, the San Diego Padres' sparkling $294 million baseball stadium and the newest jewel in the city's revitalized downtown. As if hosting heavy hitters Barry Bonds, Dave Winfield, and Steve Garvey weren't evidence enough, the hotel displays its commitment to baseball greatness inside: Joe DiMaggio's cleats are in the lobby, Babe Ruth's 1932 contract with the Yankees is in the Presidential Suite, and a broken bat autographed by Willie Mays in 1962 is in the fifth-floor hallway. Your own room comes stocked with peanuts and Cracker Jack (in the minibar). And should you want to get closer to the action on the field, a skybridge links the 32-story hotel to the park. *September 2004*

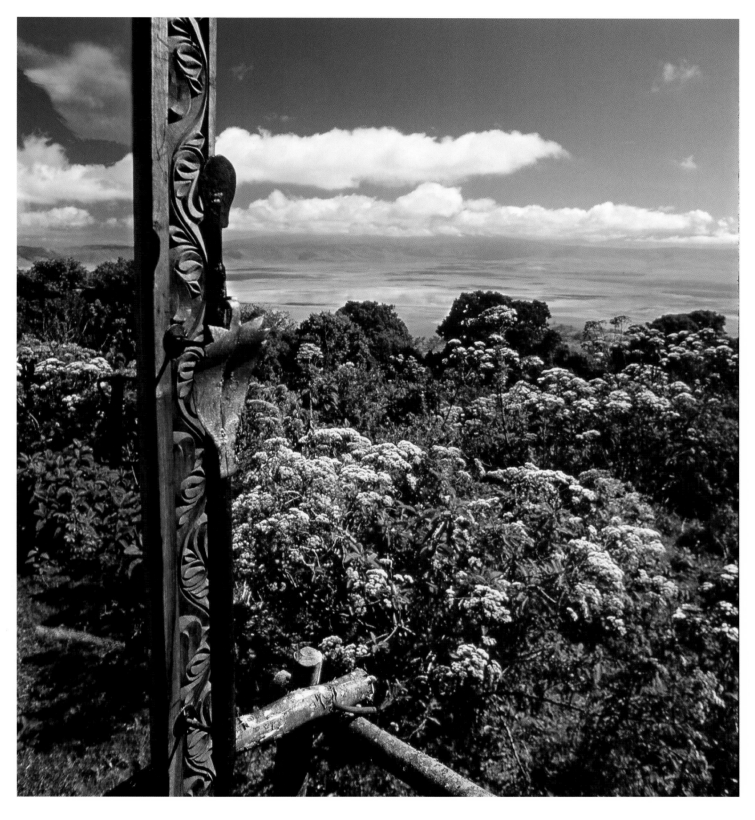

NGORONGORO CONSERVATION AREA, TANZANIA

Ngorongoro Crater Lodge, Suite 12

Beyond the foliage burgeoning before your balcony lies the Ngorongoro Crater, the vast caldera that is a highlight of northern Tanzania's safari circuit. You've likely just returned from a morning game drive into the crater 1,640 feet below, where you mingled with the more than 25,000 large mammals that inhabit it, among them lions, elephants, rhinos, zebras, and wildebeests. Flamingos congregate on Lake Magadi, whose silvery outline is visible in the distance. With such a bountiful landscape of forest, grassland, swamp, and lakeshore, the wildlife hardly need a more fulfilling environment than that within the 12-mile-wide crater. For you, too, the habitat is lush, as creature comforts here come in various forms, including champagne, four-poster beds, and butler service. *January 2004*

Yokohama Royal Park Hotel, Room 6716

For those who like to combine sightseeing and indolence, it would be hard to beat this spectacle—a bathtub vista from the Royal Park's sixty-seventh-floor Urban Spa room in the 971-foot-high Yokohama Landmark Tower. The tallest inhabited building in Japan overlooks Yokohama Bay, where the Minato Mirai 21, or "Harbor of the Future," is taking shape. But things weren't always so prosperous. In the last century, the city was destroyed and rebuilt twice: after the 1923 Great Kanto Earthquake and following U.S. air raids during World War II. Preparations for the one hundred fiftieth anniversary of the port's opening in 2009 have triggered yet another renaissance. Glimpse the progress during a late-night soak and your eye will also fall on the sparkling Yokohama Bay Bridge and the giant Cosmo Clock 21 Ferris wheel rising out of the blue. *October 2007*

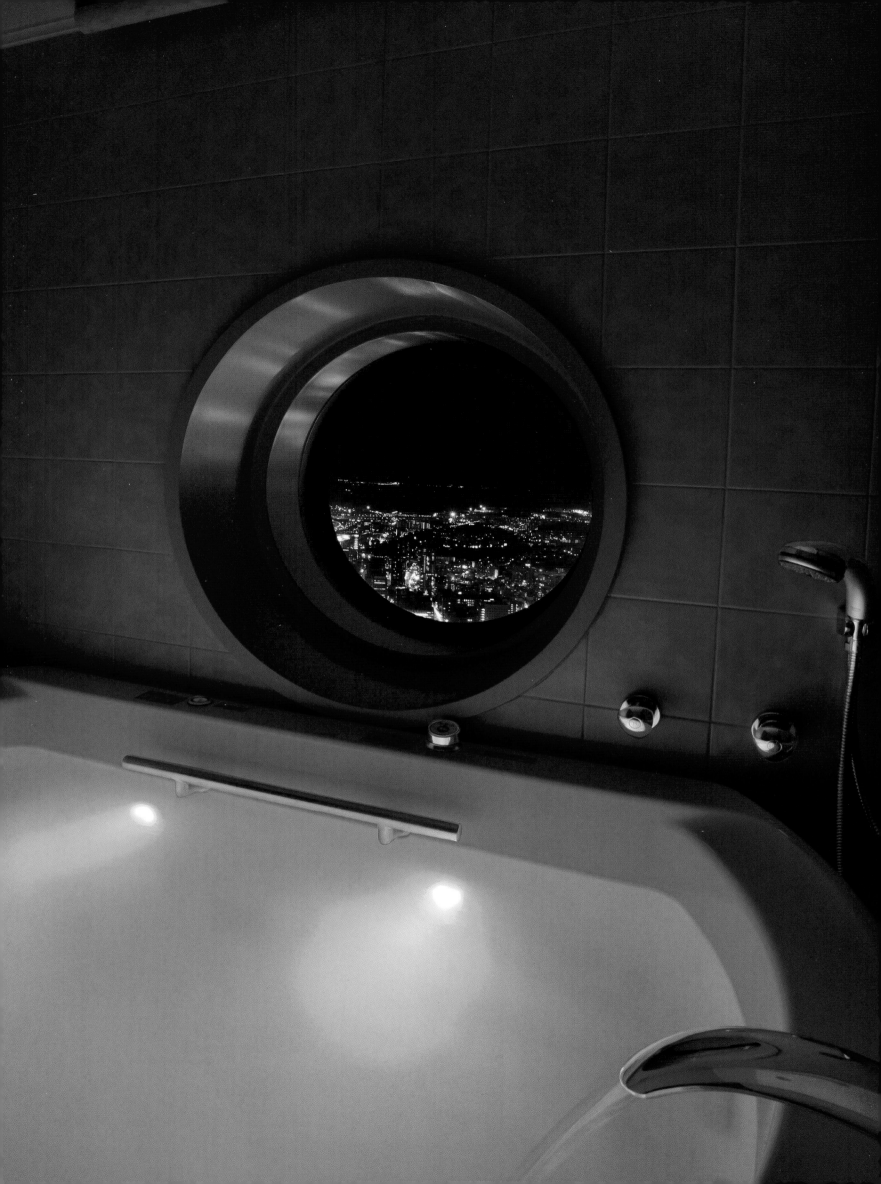

InterContinental Carlton Cannes, Room 329

Some of the world's most recognized faces have been scrubbed clean here, after an evening of either bouquets or boos at film's most publicized festival. Emma Thompson, Clint Eastwood, and Holly Hunter have each retreated to this suite during the annual spring rite, when the Carlton welcomes *le tout* filmdom. One of the Riviera's great Art Nouveau palaces, it has always courted fame, in its early years playing host to czars and sultans. The Italian army occupied it during World War II (to seal off the now-exclusive beach out front), but since Cannes's film festival began in 1946, the hotel has become a star in its own right, cast by Hitchcock in *To Catch a Thief* and co-starring with Meg Ryan in *French Kiss*. *September 2000*

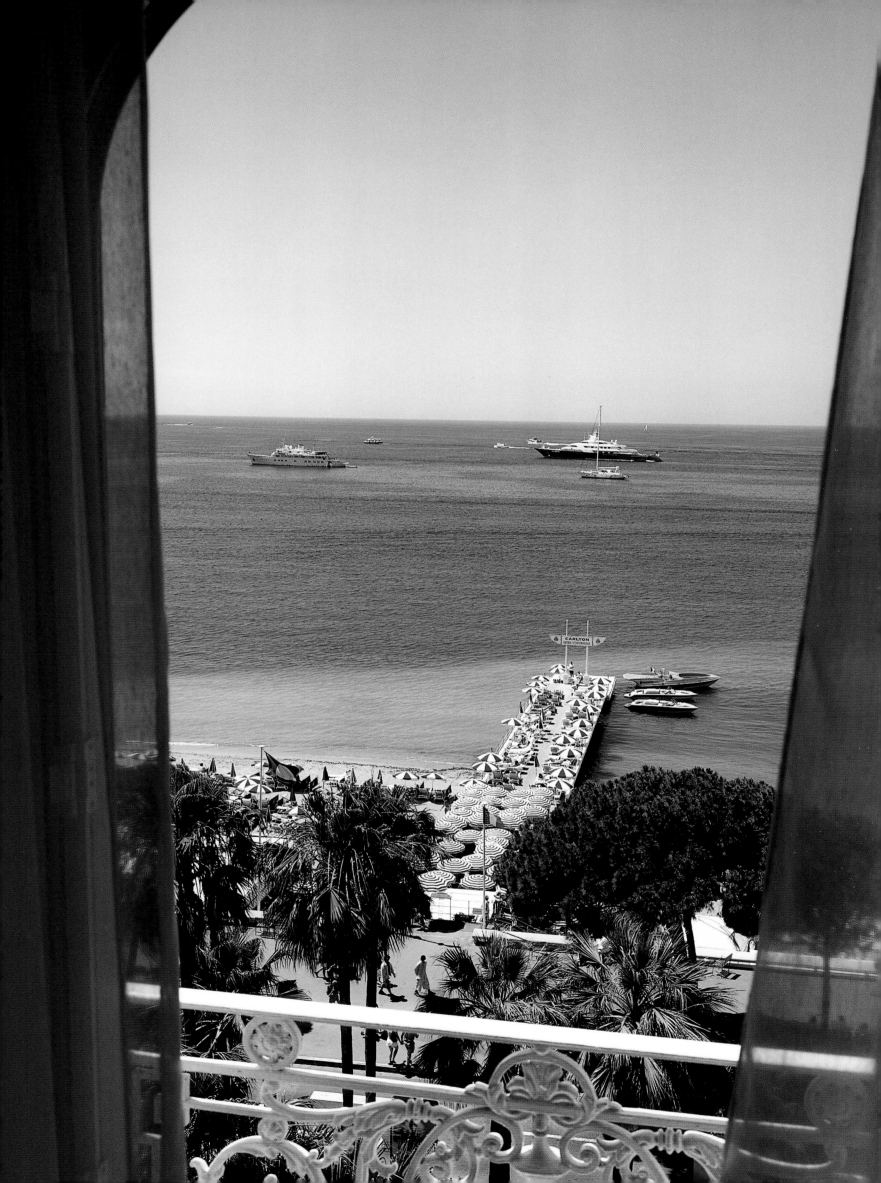

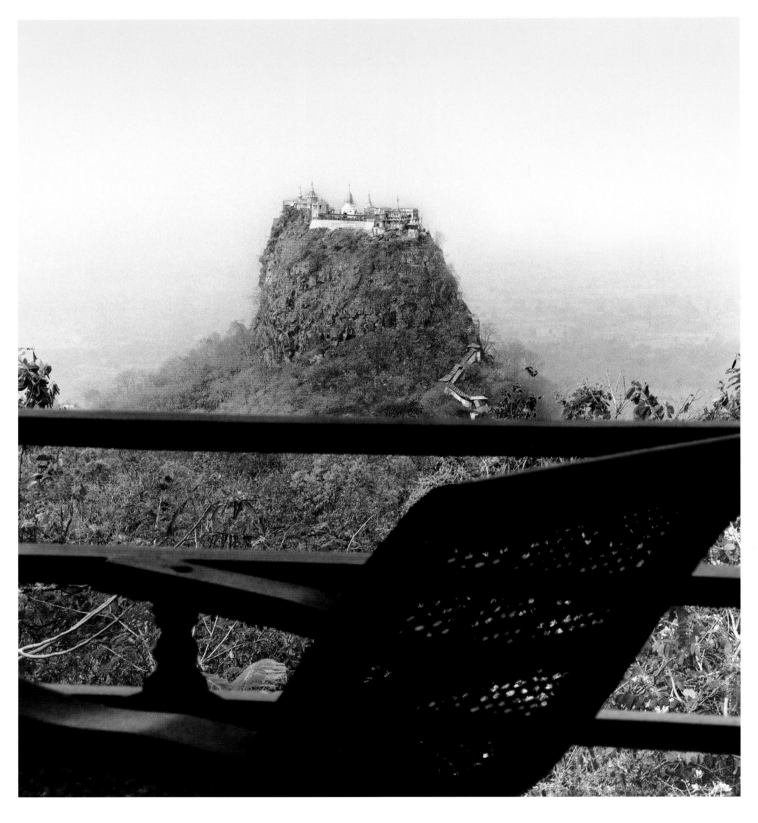

MOUNT POPA, KYAUK PADAUNG TOWNSHIP, MYANMAR

Popa Mountain Resort, Room 805

Reaching the improbably situated monastery in the distance requires a 777-stair climb up the conical mass—actually a volcanic plug—on which it regally perches. The trip is a half-day excursion from your similarly high-altitude lodgings at the Popa Mountain Resort on neighboring Mount Popa, which has been dubbed Myanmar's Mount Olympus. A hundred miles from the ancient city of Bagan, Mount Popa is one of the most revered sites in this deeply religious country. It is the traditional home of *nats*, Burmese spirits—some with oddball names, such as Mr. Handsome and Bandy Legs—that have been worshipped since before the arrival of Buddhism. During the annual Popa Festival (held in May every year), a multitude of travelers ascend the mountain to pay their respects at the numerous *nat* shrines that dot the winding trail to this hotel, itself a welcome nirvana for weary pilgrims from many lands. *October 2005*

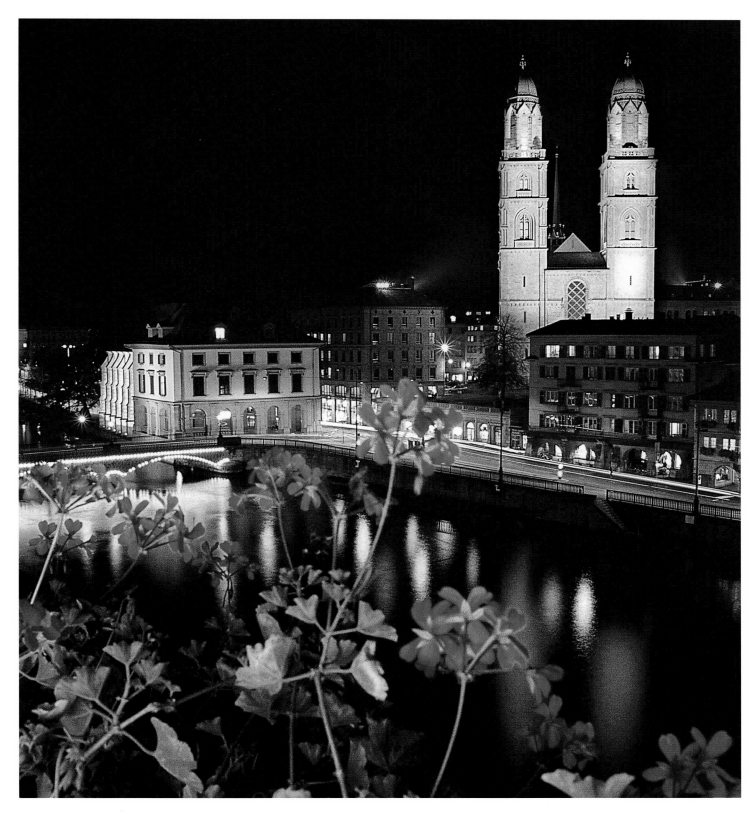

ZURICH, SWITZERLAND

Hotel Zum Storchen, Room 521

The shop-filled guildhalls that line the Limmat River signal modern adaptation, but it's the twin-spired cathedral that's more telling of Zurich today. The Grossmünster, which predates the 600-year-old Hotel Zum Storchen by three centuries, sprang from the ruins of a church erected by Charlemagne, who built it on the burial palace of sibling martyrs Felix and Regula. Legend has it that the two carried their severed heads across the Limmat, expiring at the site of today's cathedral. Another type of religious zealot, Ulrich Zwingli, arrived in 1519 preaching Reformation from the Grossmünster's pulpit. His sermons, rhapsodizing on hard work, had a long-lasting impact. Despite Zurich's modest size and quaint architecture, it is today Switzerland's cash cow—the banking and insurance capital of the country. If the rewards of a strong work ethic look as they do from the balcony of Room 521, surely even Zwingli would approve. *November 2000*

Ritz Paris, Imperial Suite

Pity poor Gustave Courbet. In 1871, the painter denounced Napoleon's memorial in the Place Vendôme as a tribute to "war and conquest . . . devoid of all artistic value." It was duly dismantled, only to be rebuilt under the Third Republic at a present-day cost of $65,000 and billed to Courbet. That price seems paltry now, purchasing just five nights of this view, but it drove Courbet into exile and gave the emperor he detested a permanent monument. Even Napoleon might envy guests in the Imperial Suite—a realm of privilege that has welcomed Winston Churchill, Grand Duke Nicholas, and Princess Diana and Dodi Al-Fayed, whose last hours were spent, happily no doubt, in its silk salons. *March 2007*

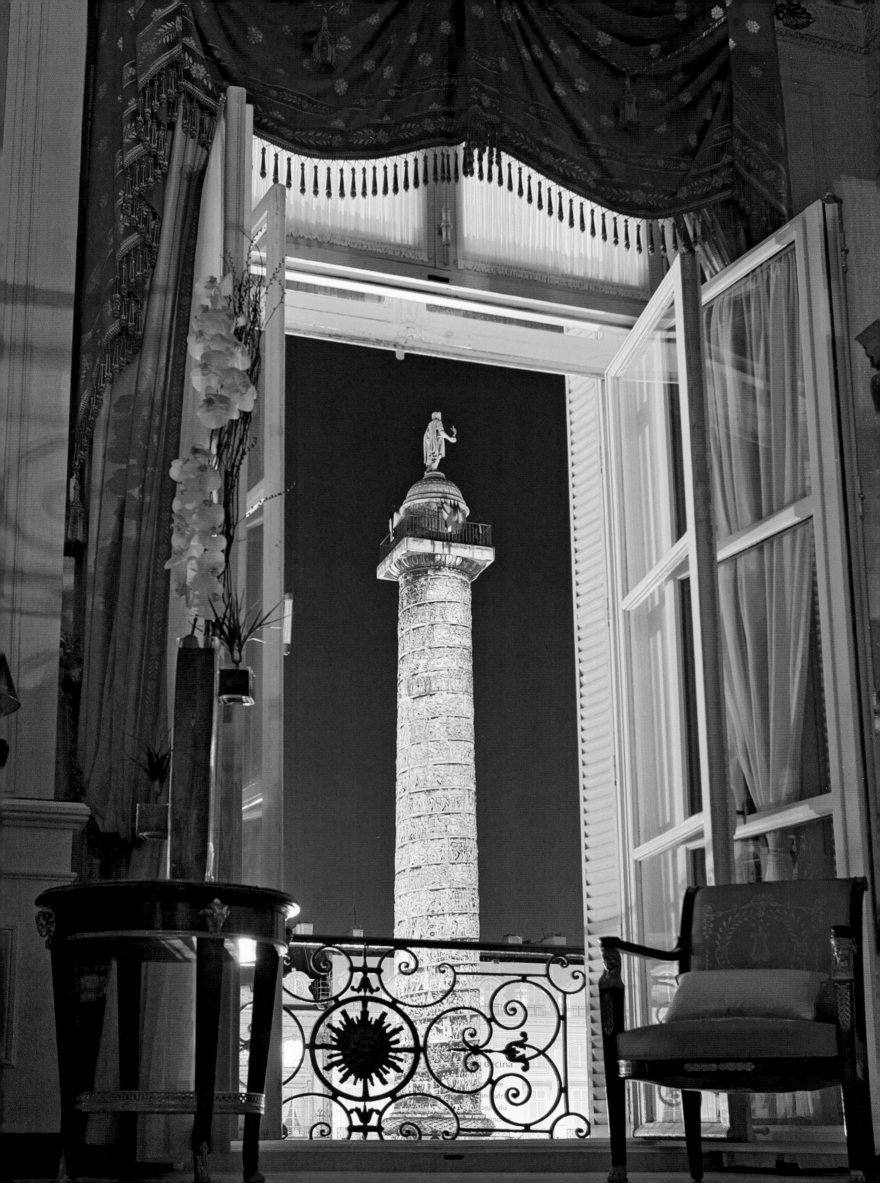

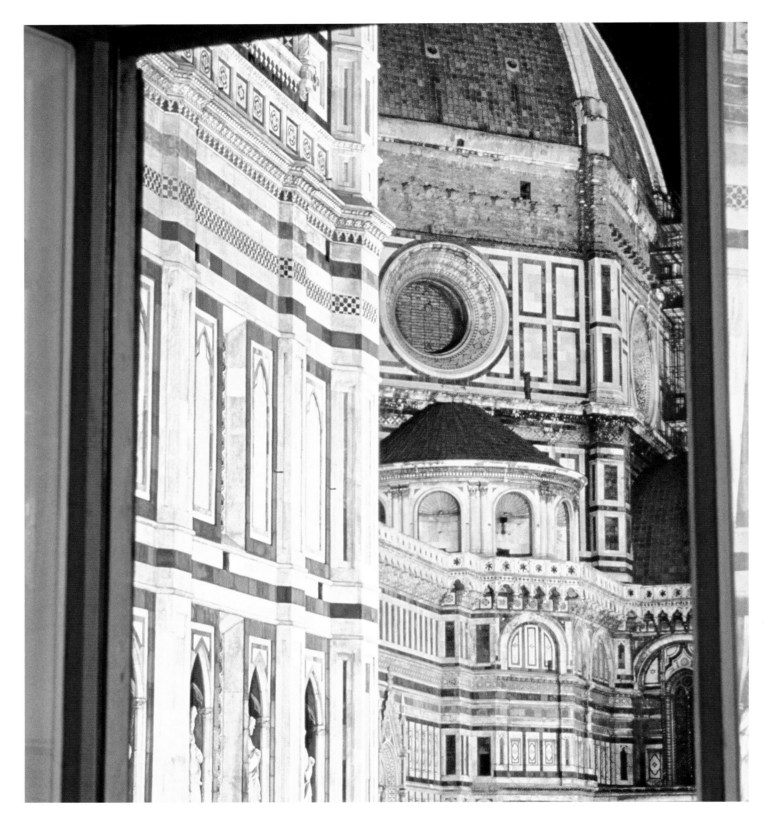

FLORENCE, ITALY

Hotel Bigallo, Room 306

Life beats in the heart of Florence as the clip-clop of horse-drawn carriages and the lilting chatter of evening strollers drift though Room 306 of the Hotel Bigallo. Brunelleschi's cupola atop the Duomo's ornate marble facade, and Giotto's fourteenth-century Campanile glowing green under spotlights, lie practically within reach. Should this symphony of sights and sounds cause you to swoon, blame it on Stendhal's syndrome—named after the nineteenth-century novelist who nearly fainted from an overexposure to Florentine art. For a momentary respite, visit the Duomo's unadorned interior, where Savonarola preached against sinful extravagance and inspired penitents to build a vast "Bonfire of Vanities." But there's no harm in looking, so surrender to the view and share Elizabeth Browning's wonder when she effused, "The [cathedral's] mountainous marble masses overcome us as we look up—we feel the weight of them on the soul." *January 1996*

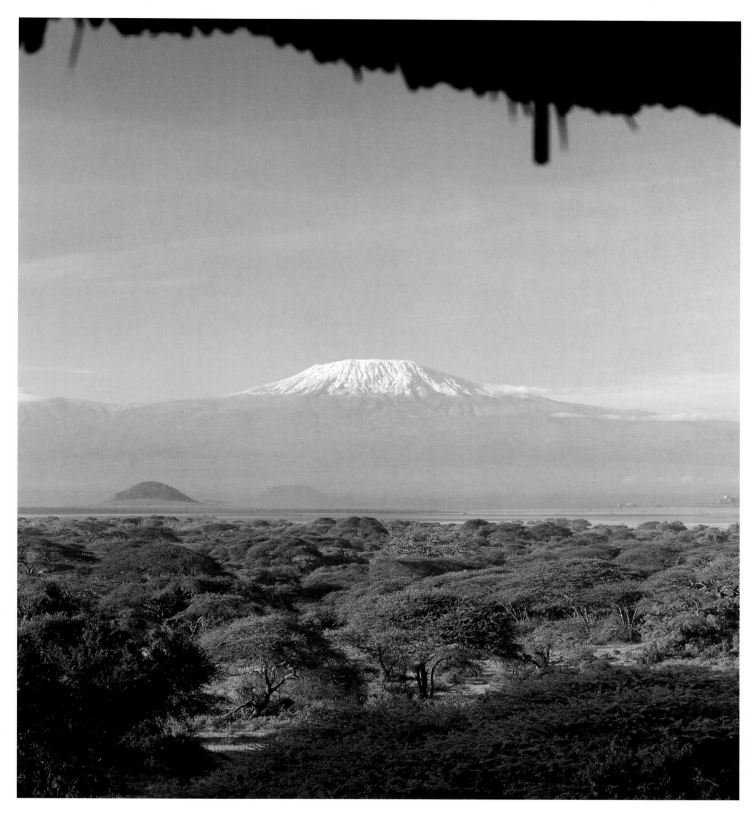

CHYULU HILLS, KENYA

Ol Donyo Wuas Lodge, Mpya Cottage

From your bedroom in the foothills of Africa's youngest mountain range, Chyulu Hills, gaze upon its tallest peak. Mpya Cottage's views of snow-topped 19,340-foot Mount Kilimanjaro are unobstructed—by windowpanes or even walls. A short flight from Nairobi via private charter places you among the thatched cottages of Ol Donyo Wuas Lodge, whose name means "Spotted Hills" in the Masai language. The property sits on a 300,000-acre spread, inhabited solely by wildlife and the Masai. The Big Five—elephants, Cape buffalo, rhinos, leopards, and lions—roam the land, along with more than 300 bird species. During the day, you too are free to roam the savanna, visiting local villages and following the animals via horseback or Land Rover. Back at the lodge, a candlelit dinner awaits under the stars, accompanied by the sound track of the African night. *June 2007*

Rio Othon Palace, Room 2612

Few South American cities have lured the glitterati like Rio de Janeiro, and as you admire the sweeping curve of Copacabana Beach from your balcony at the Rio Othon Palace, it's easy to see why. While Fred and Ginger didn't actually dance at the neighboring Copacabana Palace Hotel as depicted in *Flying Down to Rio* (they were on a Hollywood set), countless stars, including Marlene Dietrich, Brigitte Bardot, and Carmen Miranda, the larger-than-life local entertainer who took America by storm in the 1940s, have shared their sparkle with the famous beach below. One of Rio's most recognizable figures is not merely passing through, however: Sugarloaf Mountain, whose conical silhouette is straight ahead, has become a symbol of the glamour capital. Ascend by cable car to its peak for a view of your room with a view. *September 2006*

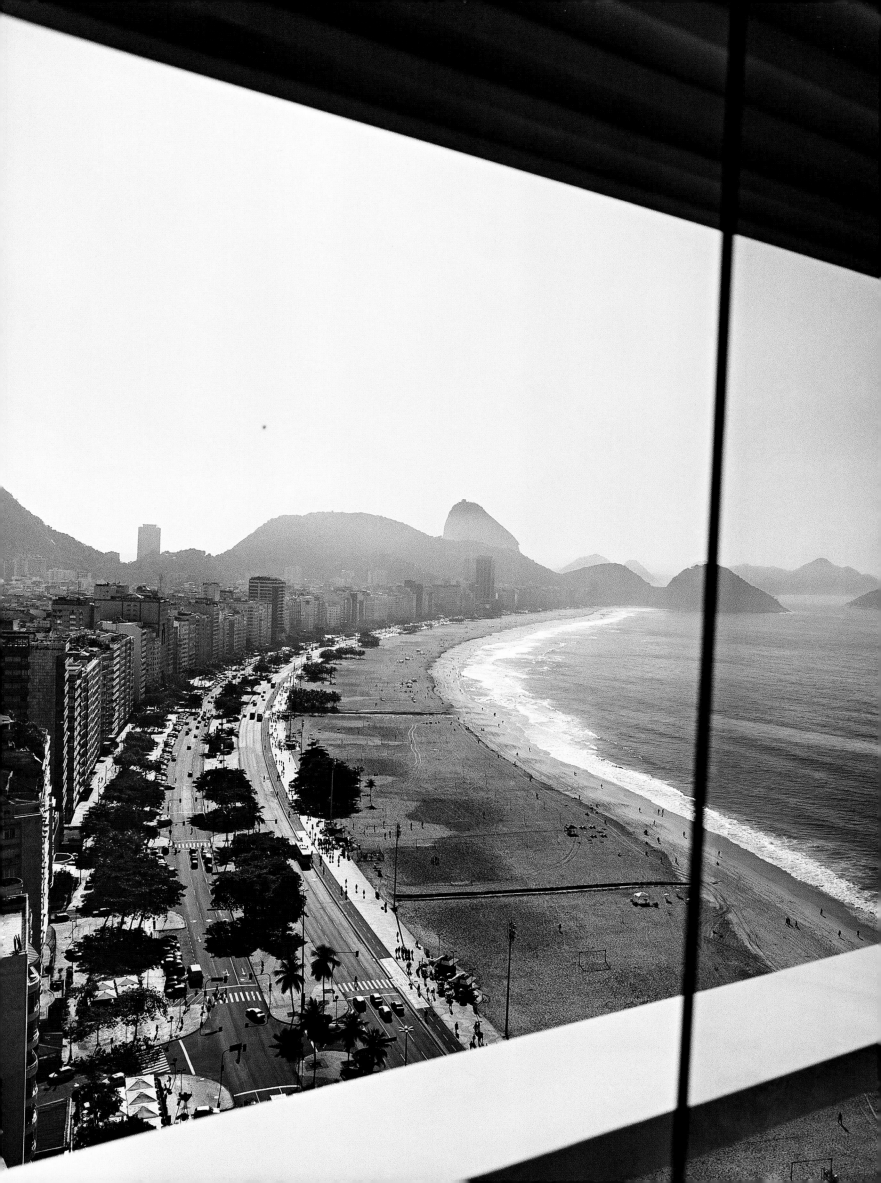

NHA TRANG, VIETNAM

Bao Dai's Villas, The Royal Villa

It is the picture of peace: the still, blue bay; the silent mountains bathed in bright, steady sunlight. Out of sight but perfectly in sync with their surroundings, tourists sip their coconut juice, eat the catch of the day, haggle over shell souvenirs. Par for the course, perhaps, in the Caribbean, but still something of a surprise in Vietnam. From Bao Dai's Villas, some 50 miles north of Cam Ranh, you look out onto Nha Trang Bay. Bao Dai, last of the Nguyen emperors, threw great parties here until he fled to France in 1954. Decades later, the villa became a vacation resort for the Vietcong hierarchy, who reportedly partied as hard as their imperial predecessors. Today, it is a born-again capitalist retreat with boats that whisk you to offshore islands. It may still be a long way from the well-rehearsed elegance of St. Barts or the Côte d'Azur, but it's getting there. *October 1992*

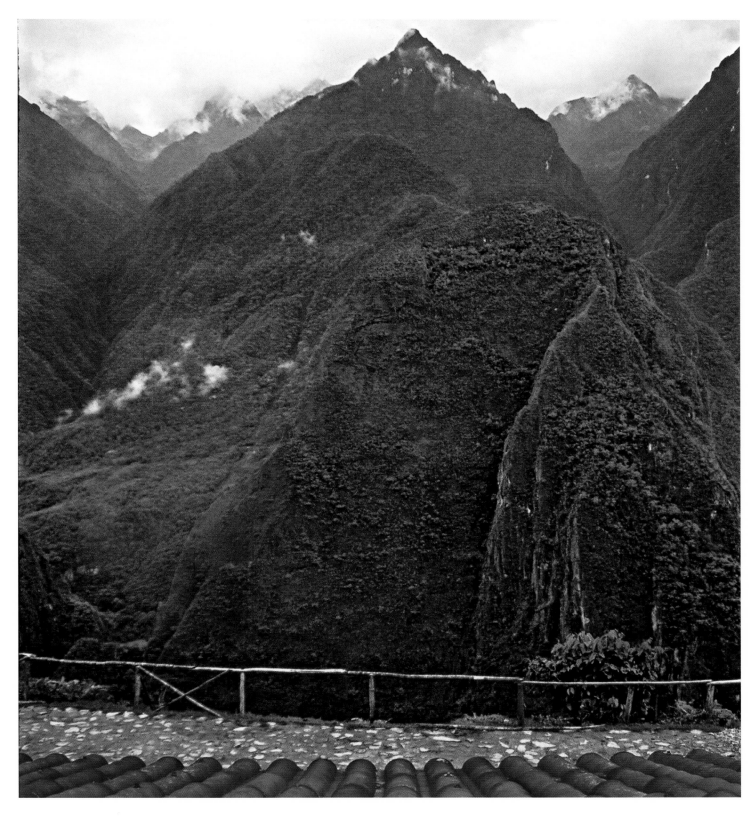

MACHU PICCHU, PERU

Machu Picchu Sanctuary Lodge, Room 40

It's just past dawn here in the historic complex and sanctuary of Machu Picchu, and you can savor your 8,200-foot-high view of Putucusi ("Sacred Mountain") in much the same way that Inca Pachacutec, Machu Picchu's creator, once did. At the height of Pachacutec's rule, between 1438 and 1471, his people built the site's spectacular mountaintop citadel, incorporating agricultural terraces, temples, palaces, workshops, and homes for about a thousand inhabitants, only to abandon the city decades later for reasons still unknown. Carefully concealed from the Spanish conquistadors by the Incas and virtually lost to the world for centuries—until an American scholar, Hiram Bingham, came upon the ruins in 1911—this architectural marvel remains astonishingly well preserved. Indeed, it is now excessively well visited, too: Take advantage of your lodge's location at the entrance to the site to see the city at its early-morning finest. *November 2003*

Mandarin Oriental Hong Kong, Lichfield Suite

After Chris Patten, last British governor of Hong Kong, sailed away and the People's Liberation Army marched across the border, a certain apprehension descended on the residents. After all, many of them had fled China's communism for the freedoms of a British colony. Whispers that the Mandarin Oriental—whose white-gloved doormen and tea with crumpets symbolized crisp British rule—might close, underscored the gloom. They needn't have worried. Ten years later, Hong Kong, and the Mandarin, are born again. China's exports are booming, and the former colony is beaming with confidence, a spirit reflected in the Mandarin's revamped Lichfield Suite, an homage to Patrick Lichfield, the swinging sixties photographer who often stayed here. Lest we forget that Beijing is the real seat of power, I. M. Pei's angular Bank of China Tower makes the point. *February 2008*

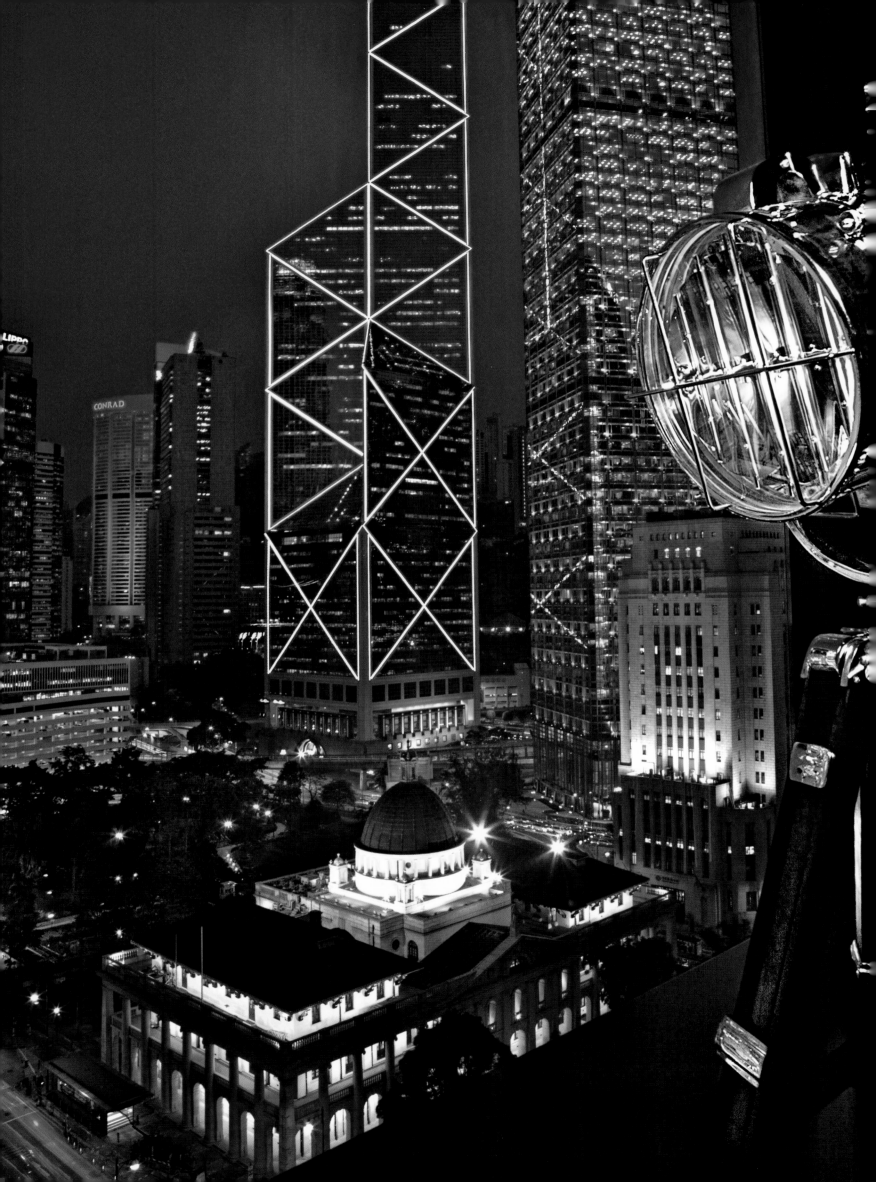

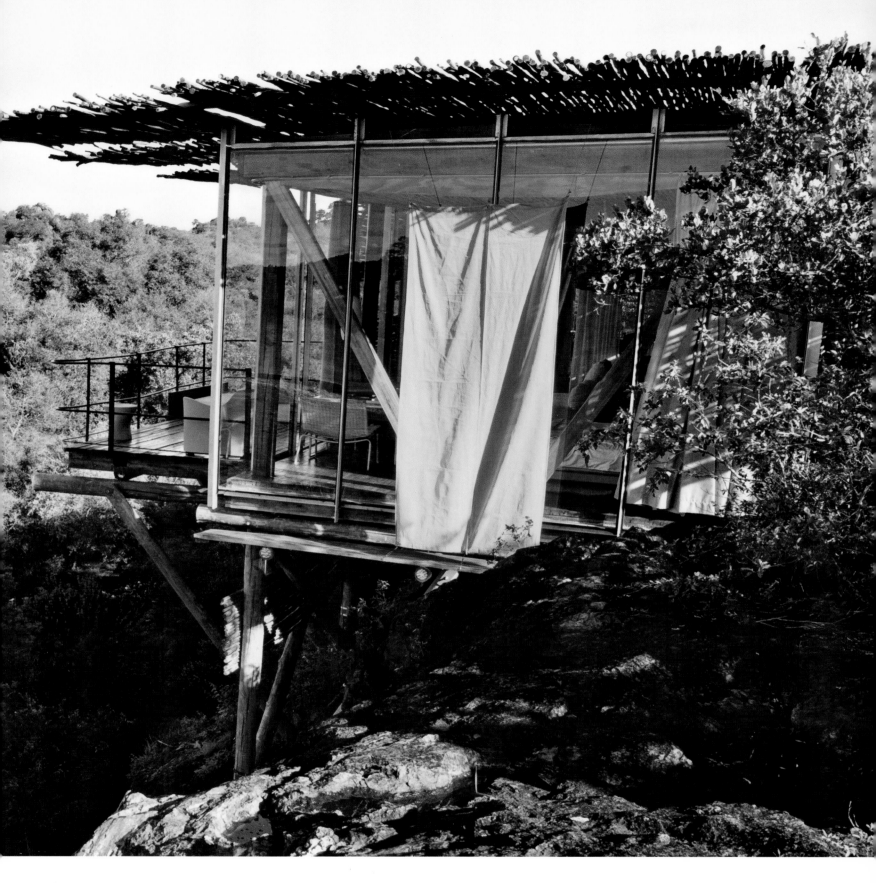

Singita Lebombo Lodge, Suite 6

Your accommodations may seem incongruous: tall panes of glass with a latticed-wood roof jutting out over a precipice on the rugged slopes of the Lebombo Mountains. But as contemporary as it appears on the surface, this safari lodge on the eastern edge of Kruger National Park is far from an eyesore. With their transparent walls, these 15 angular aeries meld design, function, and eco-awareness, embracing the outdoors rather than acting as a retreat from it. And who wouldn't want these wraparound views for wallpaper? The Nwanetsi River below ebbs and flows with the day's rainfall, attracting all sorts of animals that populate this remote bushland, among them giraffes, cheetahs, hippos, and antelope—and there are a whopping 336 species of trees, too. As you relax on your open-air deck, you might spy a lion lounging similarly by the riverbank. Here, big game spottings are, literally, just a walk in the park. *May 2004*

The Omnia, Room P

When the art of skiing was pioneered in Switzerland, it would have been impossible to imagine the level of creature comforts now offered once you leave the piste (after all, it was supposed to be a macho sport). Take, for example, what awaits you here, in Room P of the The Omnia, a mountain lodge in Zermatt. After a few bracing gulps of the air from your balcony, you can retire for a soak in a Japanese cedar bathtub. The lodge itself requires a head for heights—the main entrance, atop a rock in the middle of town, is 5,411 feet above sea level. Zermatt is car-free; however, when you head for the lifts, a horse-drawn sleigh or carriage can take you there. And after that soak in the tub? A fireside drink in the Lounge Bar, perhaps—recalling that, in Latin, *omnia* means "everything." *January 2008*

Trump International Hotel, Room 508

For most of the year, the sight line is clear between your room and Central Park, but on one morning every November, the view is colorfully interrupted. On that day, the procession of giant balloons, floats, and some 5,000 people that is the Macy's Thanksgiving Day Parade travels a two-and-a-half-mile route, making its way down Central Park West and arcing around Columbus Circle (next to this hotel) before continuing south to Herald Square. Clifford the Big Red Dog, whose happy profile presently fills your window, is the current old-timer of the balloon bunch, having made his first appearance in 1990. *November 2004*

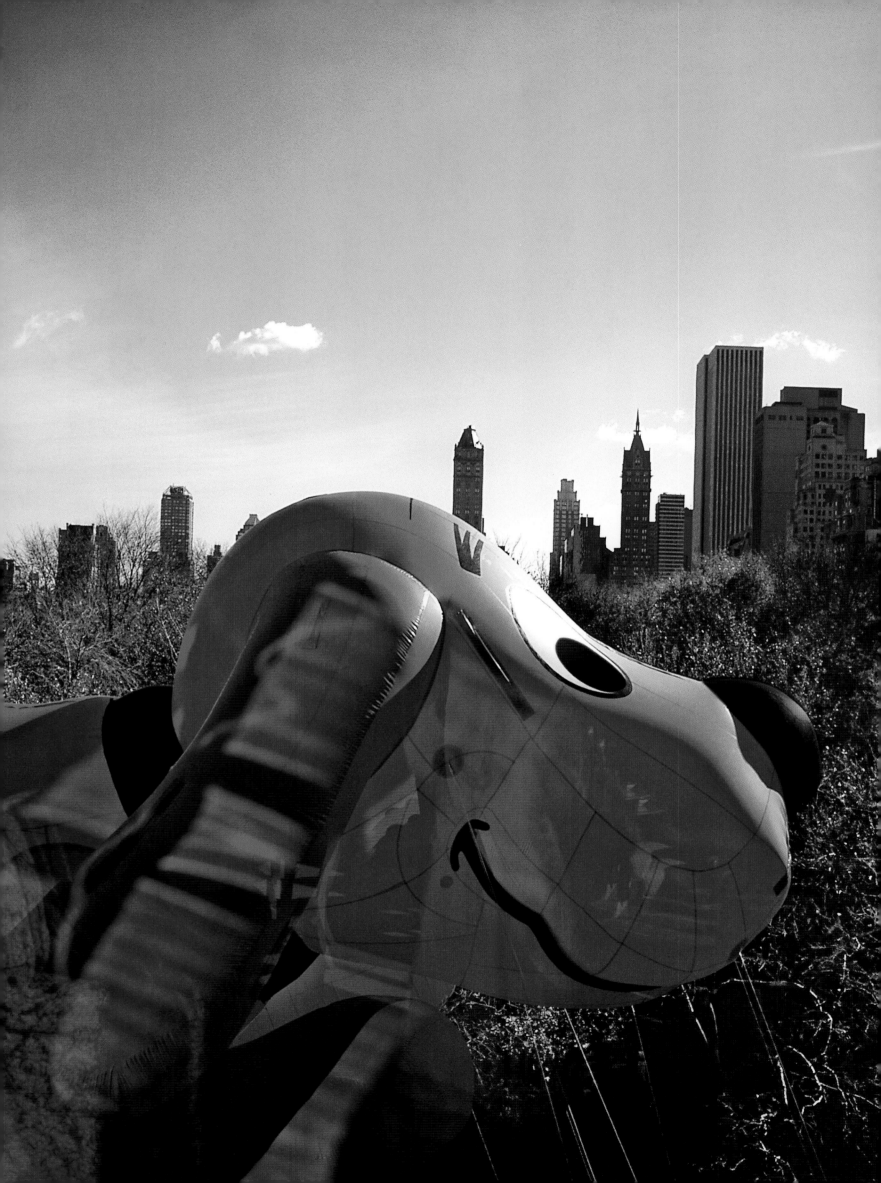

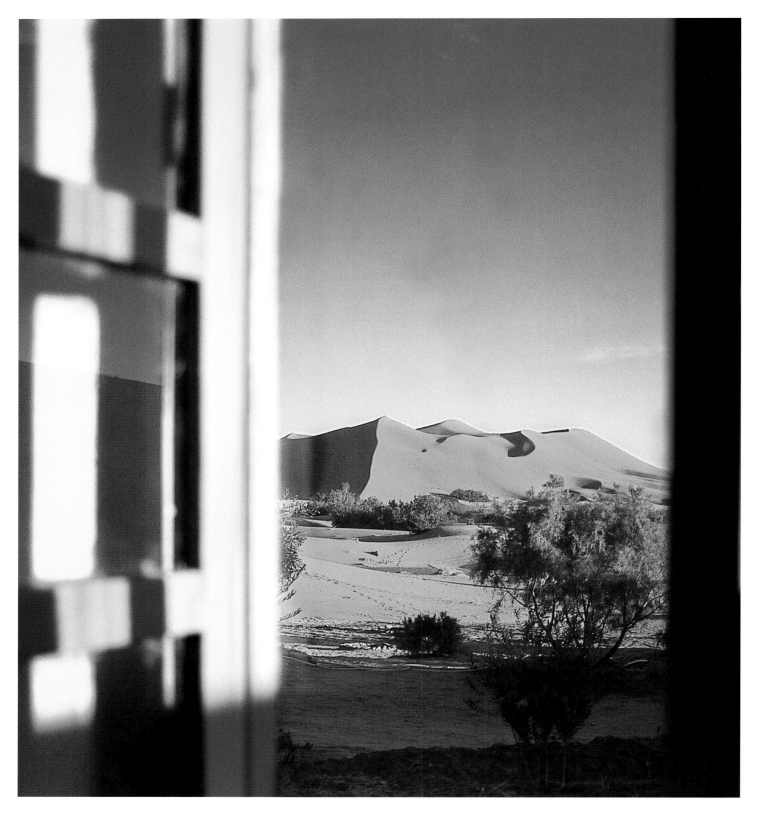

ERFOUD, MOROCCO

Auberge Kasbah Derkaoua, The Dune Suite

Here on the western fringe of the Sahara, what you see is what you get—or is it? Local myth has it that the dunes of Erg Chebbi—which ripple over some 20 miles and can reach a height of 150 feet—are the result of a sandstorm conjured by God to bury the people of Merzouga as punishment for their refusal to shelter a woman and her child during a festival. Present-day visitors to this tiny village, however, can rest easy about securing a place to stay. Like the numerous family-run auberges that dot the surrounding landscape, the Auberge Kasbah Derkaoua (also known locally as Chez Michel, after its owner) can, if overnighters so desire, pitch tents out in the dunes. But there is more than meets the eye: From November through March, a lake gradually forms in the dunes just west of Merzouga, attracting an astonishing 72 species of birds. *October 2001*

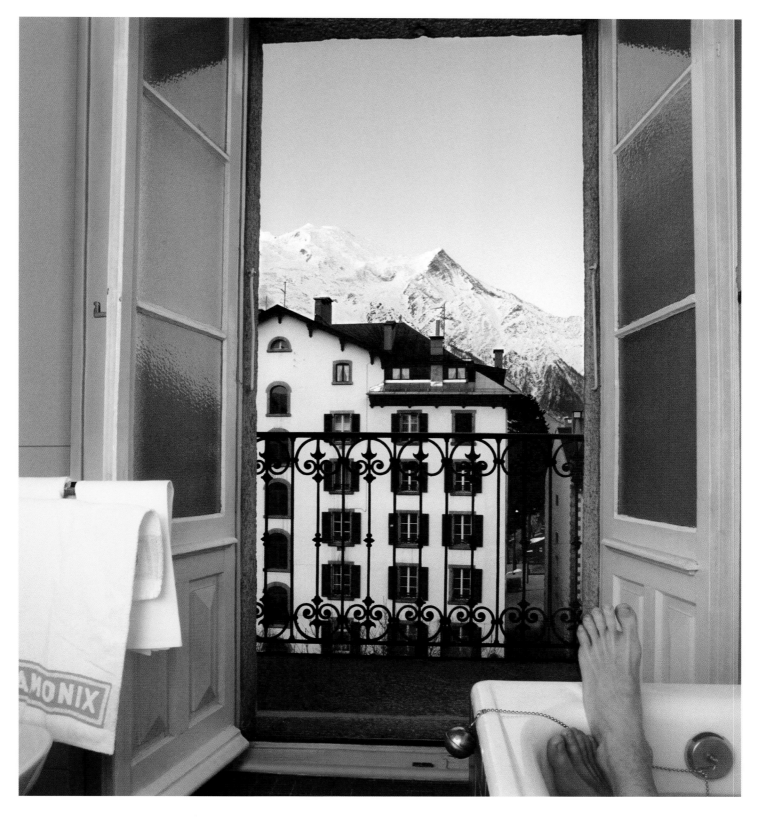

CHAMONIX, FRANCE

Hôtel Croix-Blanche, Room 37

The mountain is the highest in Western Europe, 15,771 feet of it lying across France, Italy, and the plug end of the bath. It is Mont Blanc, and in the evening's hot soak you can relive your summer's hike to the top (truth to tell, some relatively easy routes are marked for Sunday hikers) or your dazzling winter's ski run down the Vallée Blanche's thirteen miles of glaciers. That's a drop of 9,097 feet, the biggest vertical in Europe. You get more than action replay with Room 37. There are two bedrooms and a terrace (three-star *grand confort*, not *grand luxe*) bang in the center of town. *September 1987*

BOSTON, MASSACHUSETTS, USA

Millennium Bostonian Hotel, Room 804

Against this backdrop of glossy high-rises, two gems that add to Boston's historic luster—the redbrick Faneuil Hall, known as the Cradle of Liberty, and the white-columned Quincy Market—glow conspicuously in the heart of downtown. From your suite, the trip to the cobblestoned marketplace outside is an easy one. Get used to the notion of easy, for this part of Beantown is accessible in a broader sense, with the Leonard P. Zakim Bunker Hill Bridge (behind your hotel) providing a direct link to Charlestown, across the river. The bridge is the latest astounding engineering feat to emerge from Boston's 12-years-and-running Central Artery/Tunnel project, dubbed the Big Dig. At last, the light at the end of the tunnel, so to speak, has grown bright, and Boston is now rediscovering itself—and entering a new chapter in its history. *May 2003*

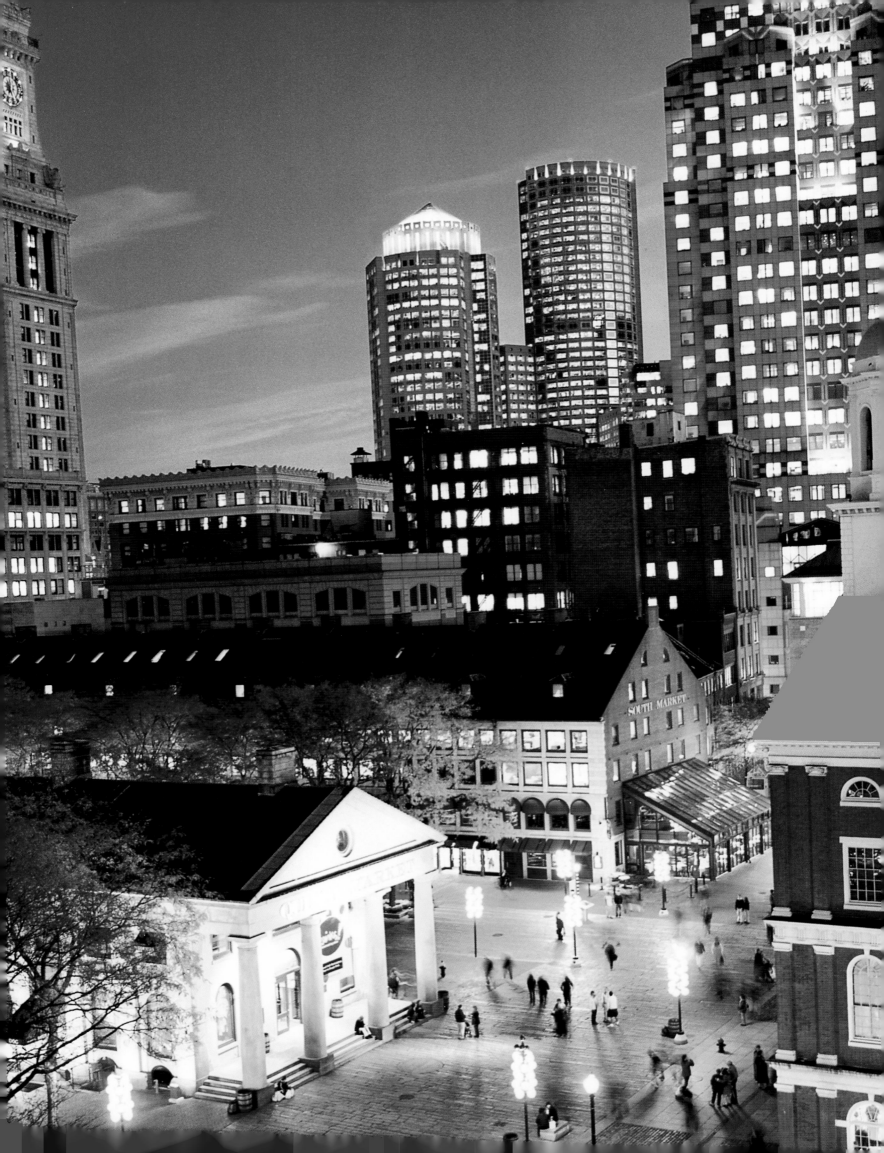

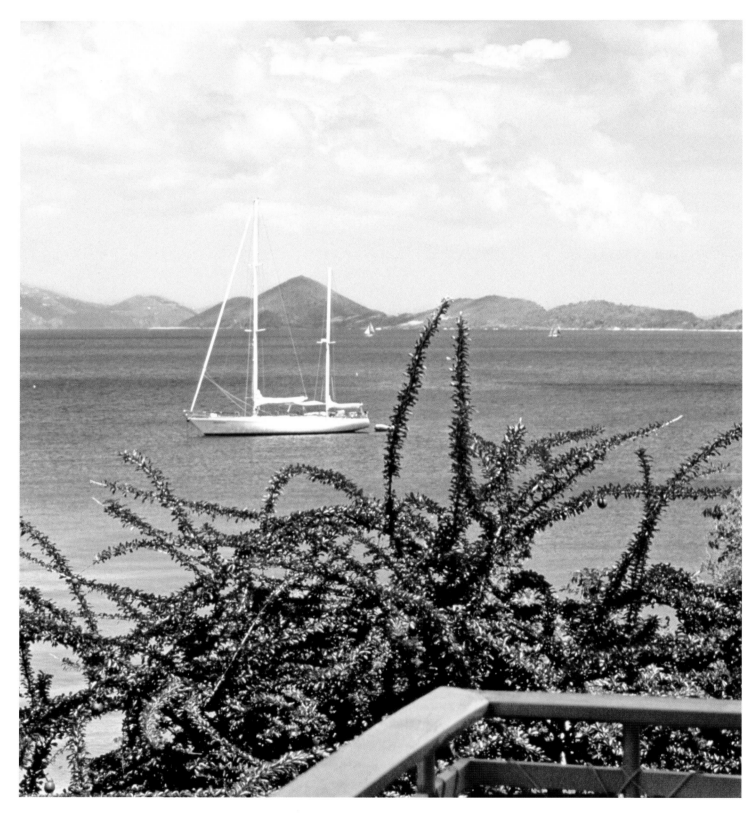

ST. JOHN, U.S. VIRGIN ISLANDS

Caneel Bay, Room 7D

Ask a Rockefeller to come up with urban—and urbane—perfection, and you will be rewarded with Rockefeller Center. Travel nearly two thousand miles due south and ask the same family to design an Edenic island in the sun, and the result will be the legendary Caneel Bay. When it comes to location, both enterprises win hands down. The nature of Caneel's particular version of heaven lies with—nature. Here you have a lush 170-acre private peninsula, which just happens to be fringed with seven exquisite beaches. The rest of the island, happily, is dominated by the U.S. Virgin Islands National Park. Cottage 7 was built for the Rockefeller family, but they have been kind enough to allow Richard Nixon and the Aga Khan, among others, to use it from time to time. If you request Room 7D, their kindness will almost certainly be extended to you, too. *January 1992*

RATTANAKOSIN ISLAND, BANGKOK, THAILAND

Arun Residence, The Arun Suite

Remarkably, this inspired vantage point wasn't always so coveted. The 80-year-old building on Rattanakosin Island that now houses your suite stood abandoned at the end of a shrine-dotted alley until 2005, when it was reinvented as a five-room inn. The island was a lot more popular back in 1782, when King Rama I decamped here to establish Siam's new capital, and even more so when construction of the temple before you commenced in 1809. The soaring central spire of Wat Arun (Temple of the Dawn), which tops out at 259 feet, symbolizes Mount Meru, the spiritual center of Buddhist cosmology. Its four satellite prangs pay homage to the wind god Phra Phai and are covered in seashells and porcelain from the ballast of Chinese boats. Steep, narrow steps lead pilgrims to Arun's pinnacle, or you can forgo the strenuous hike and contemplate the temple's majesty from your own palatial digs. *October 2008*

Oberoi Amarvilas, Kohinoor Suite

It is the ultimate shrine to passion. Mourning the loss of his beloved wife Mumtaz Mahal, the fifth Mogul emperor, Shah Jahan, spent 22 years of his reign building her final resting place, the Taj Mahal. Nearly four centuries later, this legacy of Persian architecture is still an astonishing sight—so much so that it was deemed one of the New Seven Wonders of the World in an international poll. Finally, Agra has a suitably grand perspective on the mausoleum: the terrace of the 3,000-square-foot Kohinoor Suite, atop the Oberoi Amarvilas, where the marble and gilding mimic the Taj's opulent aesthetic. For a closer look at the icon, take the hotel's five-minute buggy ride. Either up close or far away, you'll want to experience the Taj with someone who believes that love—its pleasure and its pain—is everlasting. *June 2008*

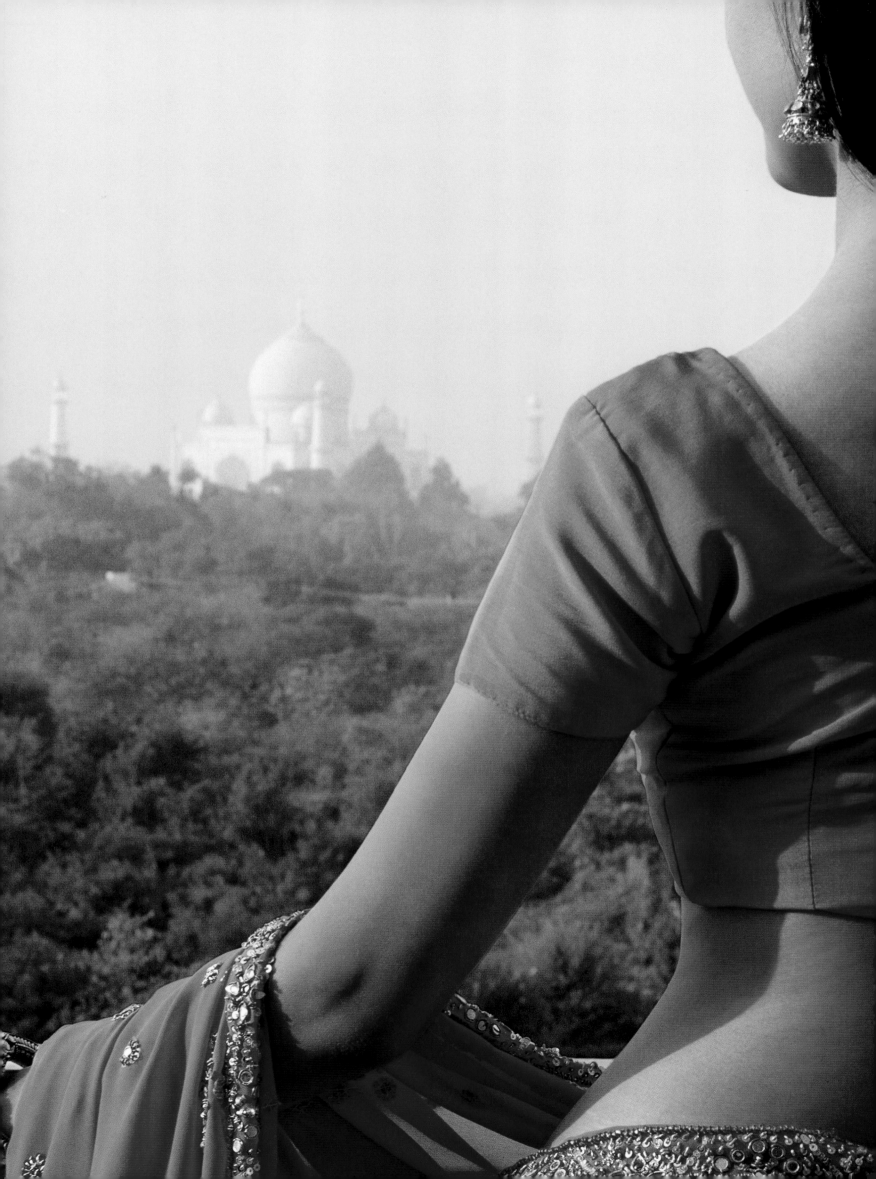

Mirror Lake Inn, The Adirondack Suite

Trout fishermen have the jump on you down at the Ausable River, but what's the rush? Dawn is the time to rise for this view of Mirror Lake. Besides, it's June and the days here are 15 hours long. By noon, your swimsuit will be drying on the railing and you'll be famished, no matter how many homemade pancakes you've had for breakfast. Clear Adirondack air has that effect on a body. No wonder Olympians train year-round just a quarter-mile away. Long winters are kept artificially long on porcelain ski slopes, wheeled bobsleds, and indoor ice rinks, where athletes of every rank turn passion into perfection. Lazier natures hike or golf or bird-watch—or tote cameras or easels, as many an artist has done before. The source of the Hudson River is just south, and the source of inspiration is all around. *June 1997*

SCHWANGAU-HORN, GERMANY

Hotel Rübezahl, Room 28

The cows can eat the grass. You sit on your balcony and drink beer like a good Bavarian. The hotel has a certain fairy-tale feel—hand-painted furnishings, white curtains, red geraniums budding, blooming, and fading on the windowsill. Austria is ten minutes away by car, just behind those deep brown Alps, but you're in Schwangau, with the tormented ghosts of Bavaria's two king Ludwigs. The first abdicated after a scandalous affair with dancer Lola Montez. The second, notoriously mad, waged a senseless war against Prussia and in 1886 met with a mysterious death by drowning—but not before building the massively gilded, famous castle of Neuschwanstein, the architectural inspiration for Disney's Magic Kingdom. In Schwangau's nearby and no less magical realm, skiing gives way in spring to hiking and bathing. And Room 9, the hotel's rustic, mosquito-netted honeymoon suite, will spark yet another much-loved sport. *March 1997*

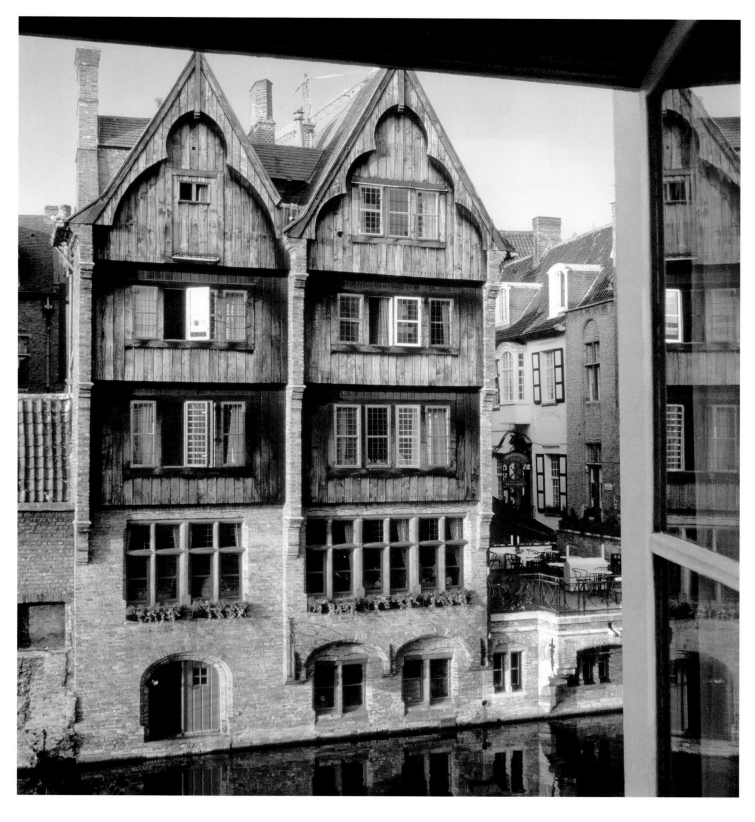

BRUGES, BELGIUM

Duc de Bourgogne, Room 4

Your view is of a world financial center: the Wall Street of six hundred years ago. Europe's first bourse was set up in the open air here sometime during the fourteenth century, and Bruges quickly developed into the commercial capital of the Old World. There was no Dow Jones, but there was plenty of heavy trading and enough Flemish corporate raiders and "Jan" Boeskys to keep everyone on their toes. The Duc de Bourgogne was built in 1648 as an inn that also functioned as the office for the tannery guild. It is, appropriately enough, located on Tannery Square and sports a forlorn-looking cow over the front door. Across the canal from Room 4 are the twin towers of the Bourgoensche Cruyce. The best view of the town is from the canals—mere tourists can hop on a boat in the summer, but Masters of the Universe wait for winter and take to their skates. *November 1990*

Park Hyatt Toronto, Room 403

"Ugly as sin, poorly clad, and oppressively suspended," was one *Toronto Star* reporter's take on the Michael Lee-Chin Crystal—architect Daniel Libeskind's spiky extension to the Royal Ontario Museum—when it opened two years ago. The arresting sequence of brushed-aluminum and glass prisms is certainly an anomaly in Yorkville, a neighborhood saturated with Victorian and Edwardian facades. And yet, despite the dissent, the addition has its share of admirers. Your room, decorated in soft beige and white, cultivates tranquillity as artfully as the Crystal (which it overlooks) stirs passion. The ten-year-old Park Hyatt, housed in a 1933 building, is a relative veteran among the condo, hotel, and office towers of Toronto's rapidly expanding skyline. For a better look at the shifting cityscape, head up to the hotel's Roof Lounge, which offers panoramic views. Here, one thing is clear: Whether you protest or applaud the Crystal, its impact is undeniable. *August 2009*

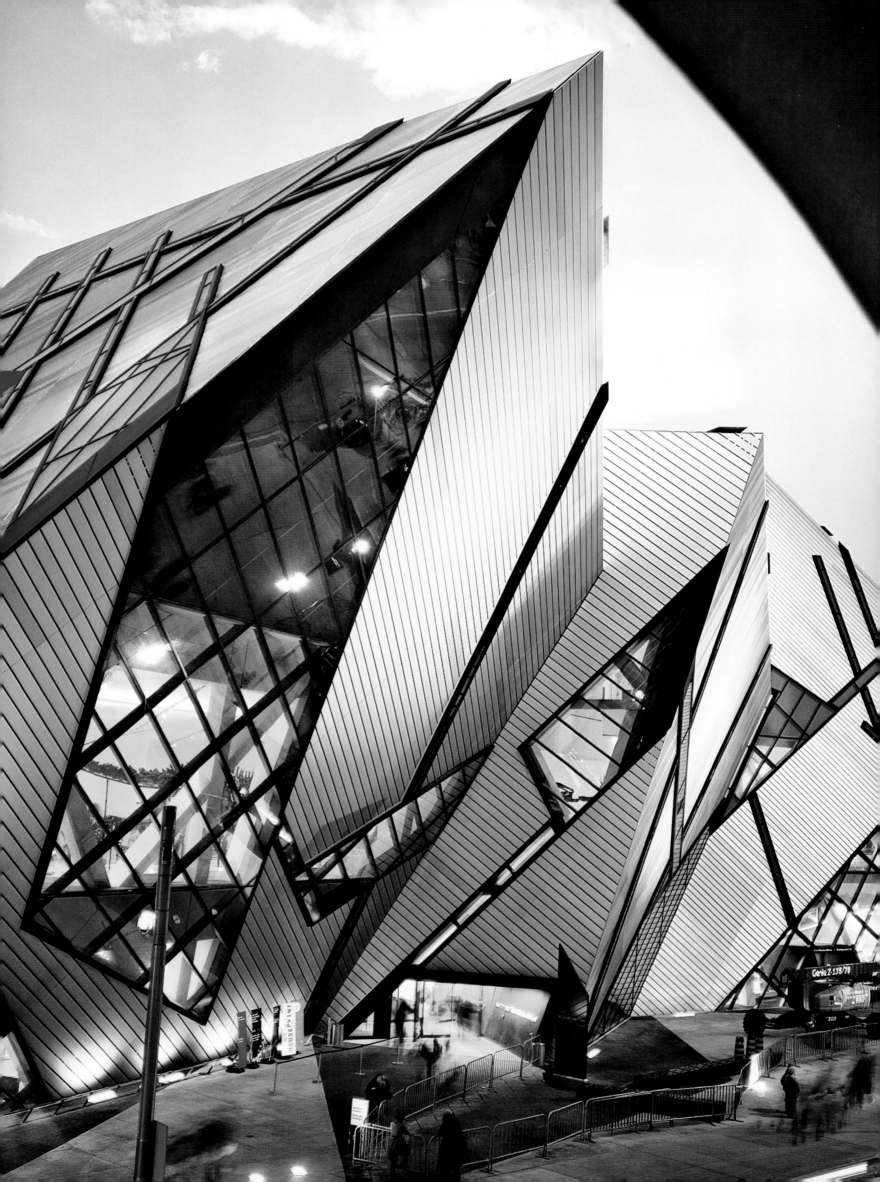

Spring Creek Ranch, Cabin 3114

Vast, gorgeous, and empty, right? Wrong. Like any wilderness, this valley has its denizens, and not just skiers and dudes. In fact, the newest settlers came because this is a prey-rich environment. For the first time in 50 years, Jackson Hole is home to wolves. The Teton Pack—a male, female, and as many as five pups—won't be loping across your view, having reportedly denned some miles to the east, near the National Elk Refuge, not in the Tetons with the black bear, pronghorn, moose, and rabbits and rodents. The beasts you're most likely to encounter are horses (if you ride), cutthroat trout (if you fish), and salmon (if you eat). But guests at Spring Creek may identify most with the wolves—roamers with a home base, viewed by locals as glamorized interlopers. Welcome to the still-wild West. *October 1999*

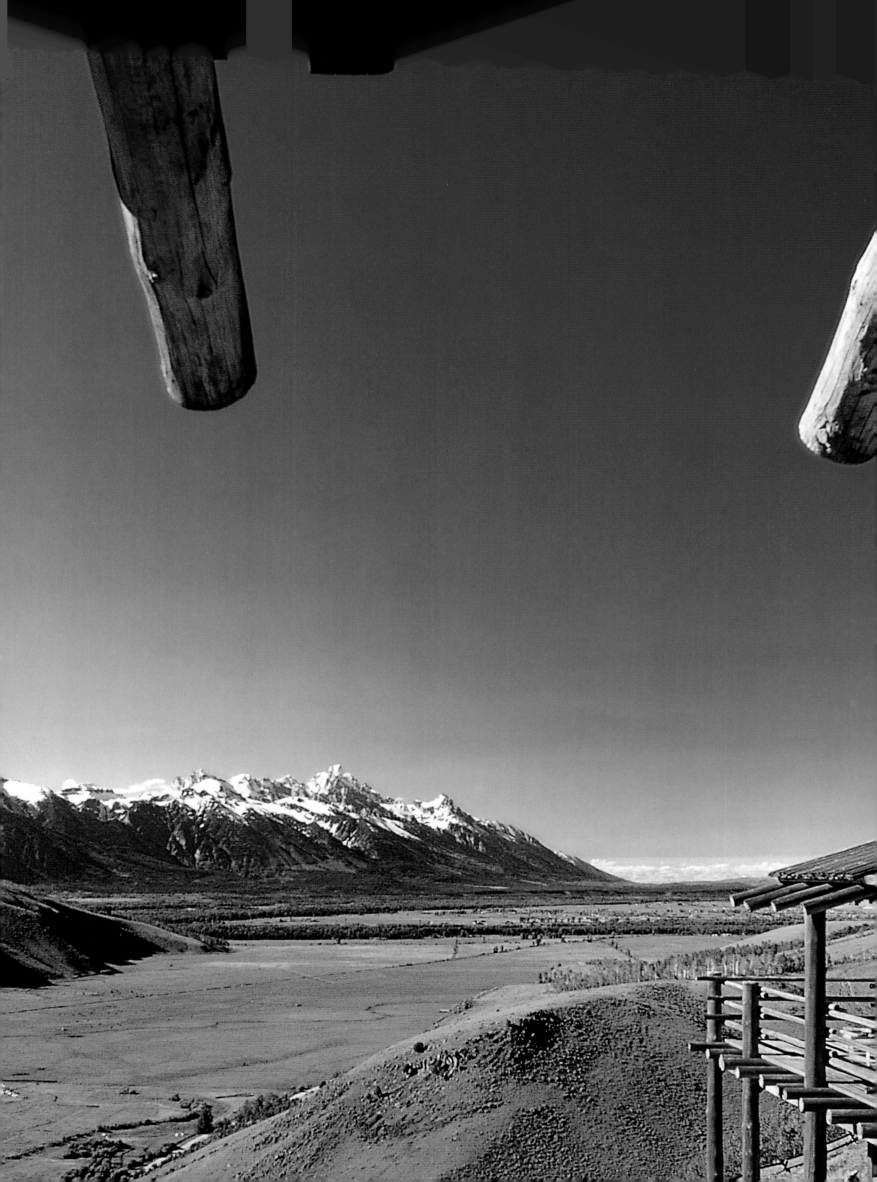

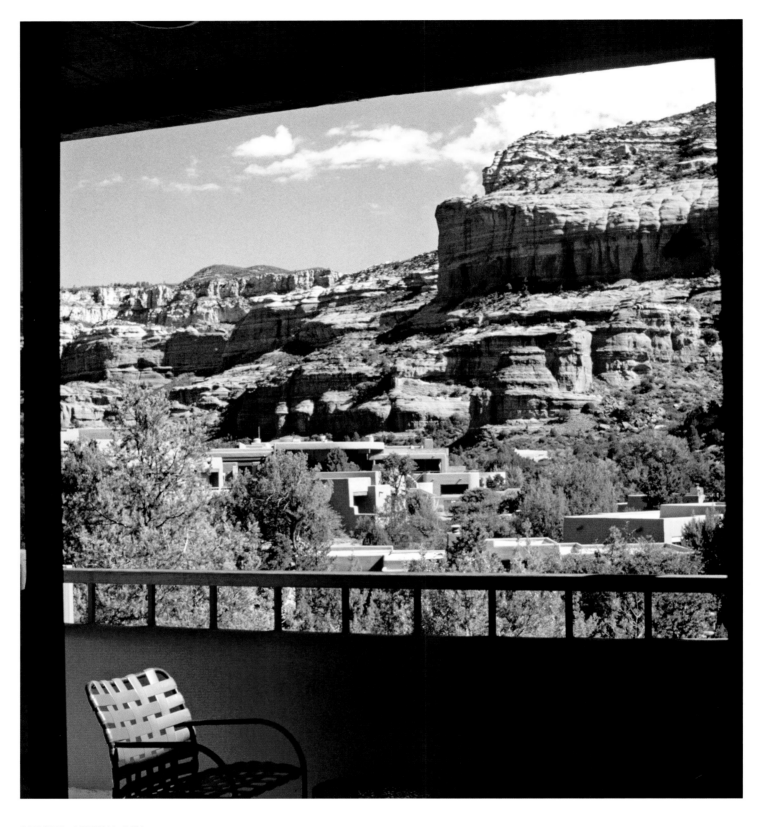

SEDONA, ARIZONA, USA

Enchantment Resort, Room 311

Fall for a night or two of Enchantment and you'll find yourself gazing out at the red rocks on Boynton Canyon. Not a national park, it is less well known than its flashier rival to the north, but here you are free to wander, hike, or jeep, with not a concession stand in sight. These crazily formed rocks are baked from the same geologic layer cake as the Grand Canyon, except that they came out of the oven in such strange shapes that they've been called names like the Coffee Pot or Lizard Head ever since. It's as if God had taken canyon-building lessons from Antoni Gaudí. If any of these formations look familiar, it's probably because you've seen them as background in old westerns on late-night TV. Check into Room 311 and you get not only a front-row view of the canyon but some welcome man-made things as well, such as swimming pools, tennis courts, and room service. *December 1990*

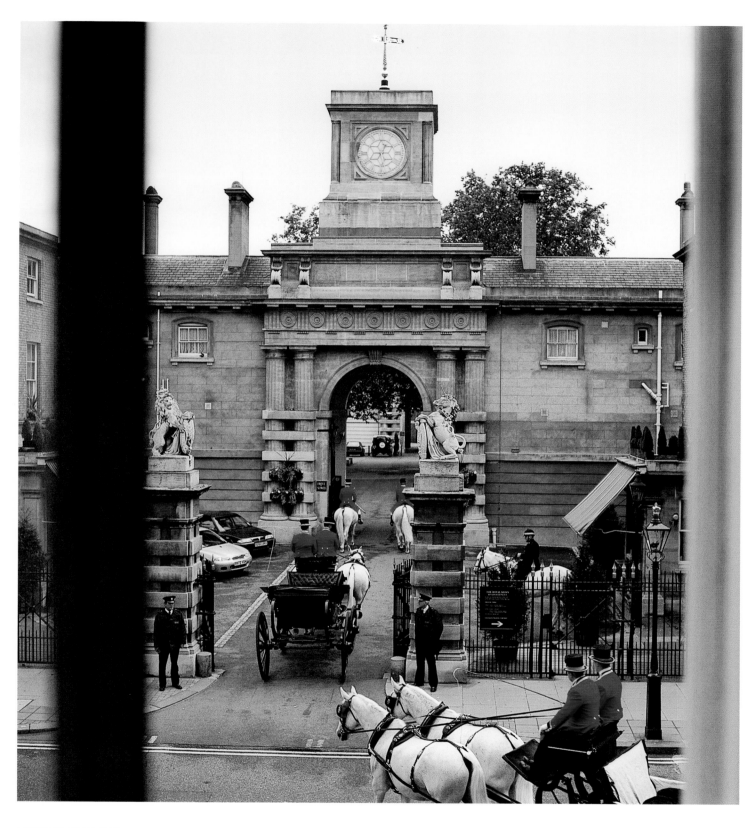

LONDON, ENGLAND

The Rubens at the Palace, Room 115

You are behind Buckingham Palace, watching a centuries-old event. The Royal Mews before you is the start and finish of processions that happen only a few times a year, one of them in the fall. Royal regalia will trot out and color the streets this November when two coaches collect the crown (the first coach) and the queen (the second) for the short trip to the Palace of Westminster, where H.R.M. officiates at the opening of Parliament. A grander procession, called Trooping the Colour, occurs in June and has historically been the public celebration of the monarch's birthday (never mind that Elizabeth II was born April 21, this is tradition). And at the Rubens, as at its sister properties, the Chesterfield in Mayfair and the Montague in Bloomsbury, tradition and history are on daily parade. *October 1998*

Tanga Ssugo Settlement

You'll sleep under the stars, literally, in Tiébéle Village, a tribal settlement in the West African nation of Burkina Faso. Your unconventional lodging for the night is a rooftop terrace like this one, and chances are you'll retire here after an evening spent seated around a crackling fire, listening to a village elder recount fables. What tiny Tiébéle lacks in stature (only 450 Gurunsi tribespeople live here), it more than makes up for in spectacle: Its striking adobe huts, waterproofed with zebu dung, are decorated in bold geometric frescoes that are said to have inspired Le Corbusier (the patterns are echoed in his High Court Building in Chandigarh, India). The capital, Ouagadougou, hosts Africa's largest film festival, but tourists to this former French colony are rare. Few outsiders see firsthand the primeval beauty and elemental style of these traditional homes. *March 2006*

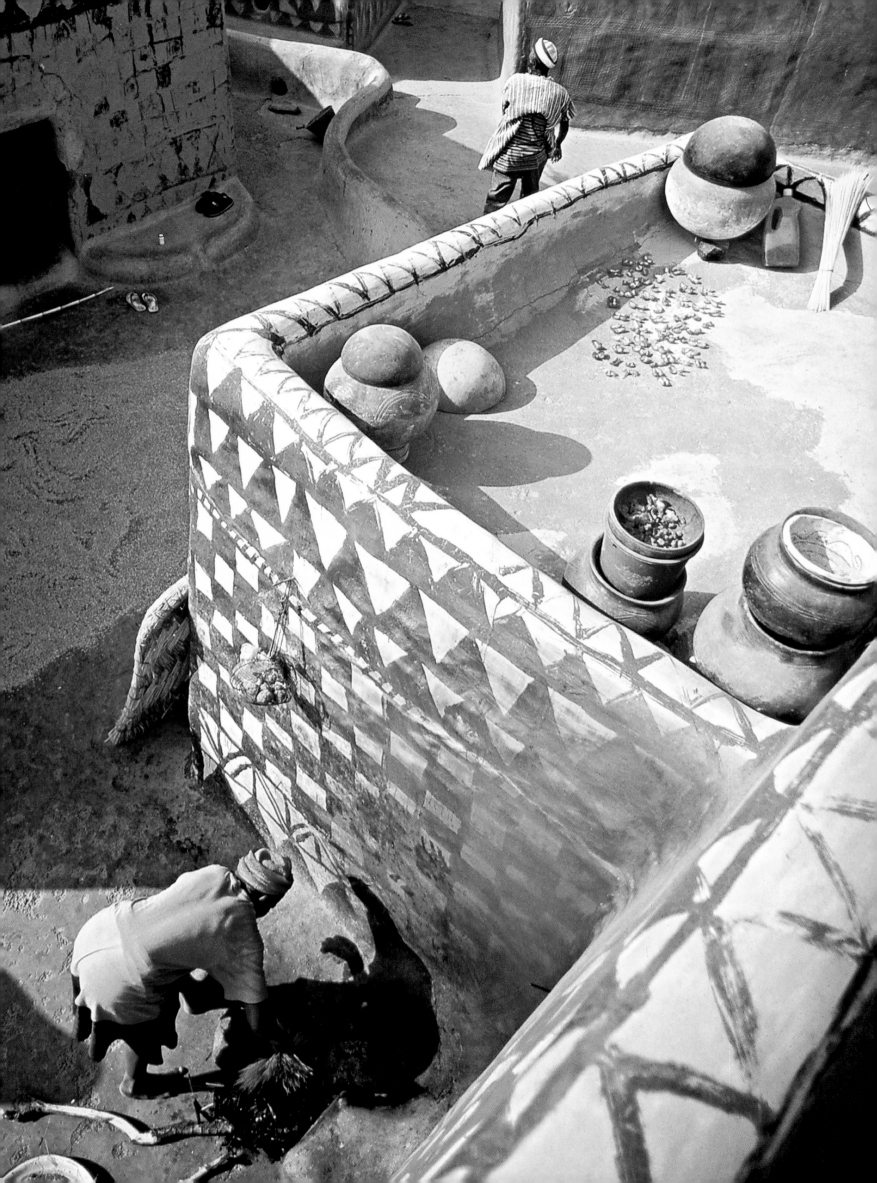

Hole Hytteutleige, Bungalow 16

For stunning scenery, there's little that can top the magnificent fjords of southwestern Norway. Geirangerfjord, the shiniest jewel in the crown, is often billed as the most picturesque in all of Scandinavia—a claim that's tough to dispute, judging from your view. The ten-mile waterway, enclosed by mountains that rise more than 5,000 feet, winds through an area dotted with lodges and small farms, a pristine and popular summer playground that lures hikers, kayakers, and anglers. Cruise ships, which began sailing this fjord in 1869, also arrive come summer, among them the world's largest pleasure vessel, the *Queen Mary 2*. For the land-based, the mossy-roofed *hyttes* ("cabins") at Hole Hytteutleige offer rustic communion with the surroundings—complete with outdoor barbecues perfect for grilling fresh-caught fish from the waters below as the sun goes down. *June 2005*

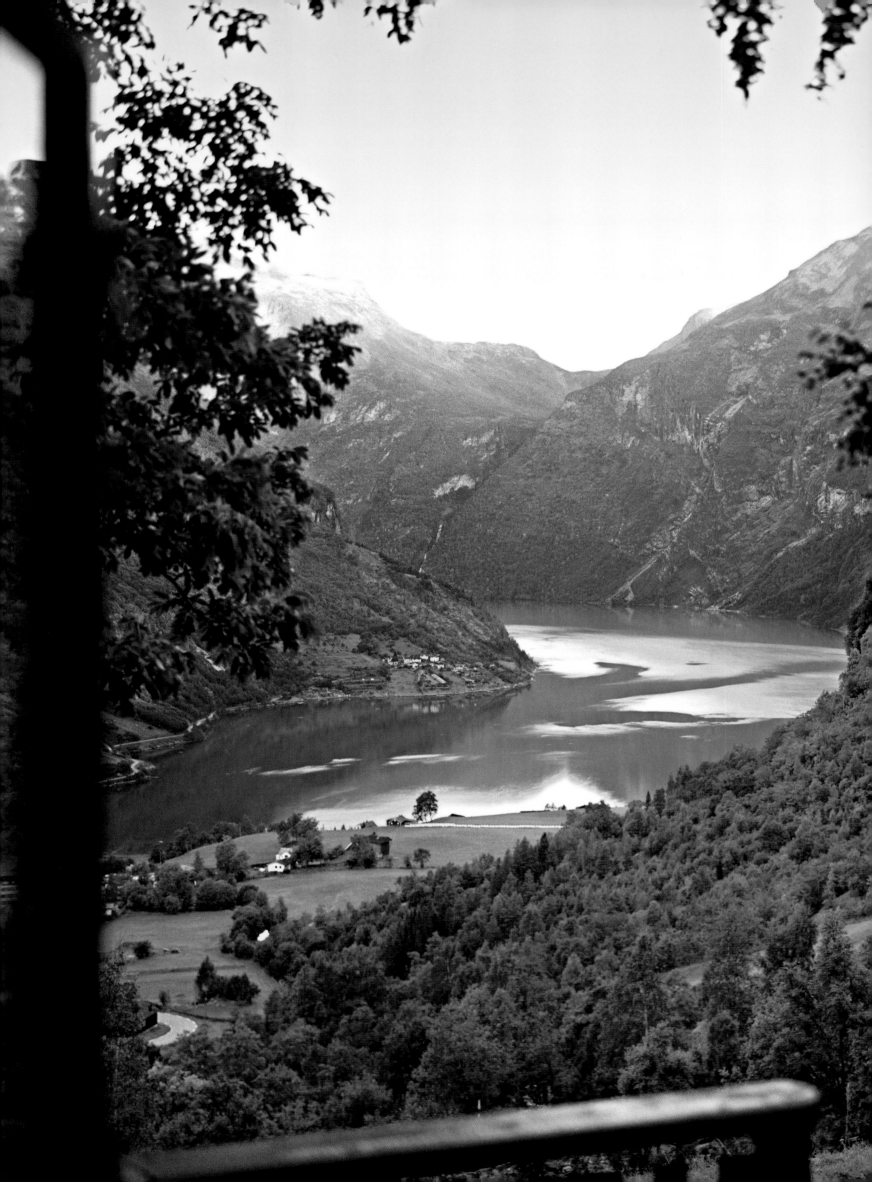

MOSCOW, RUSSIA

Ritz-Carlton, Ritz-Carlton Suite

Question: Whom do you picture sitting in these Russian Empire-style chairs (besides yourself)? Perhaps Nicholas and Alexandra? Mikhail and Raisa Gorbachev? Stalin whispering to Beria? Or even Putin to Medvedev? With the Kremlin in the background, the grandest new hotel in Moscow could serve as a stage for centuries of Russia's incarnations. In fact, the Ritz-Carlton itself is a phoenix built on the site of the Intourist Hotel, the world-renowned Soviet dump demolished in 2002. Tverskaya Street has been reborn, too, emerging as one of the splashiest shopping districts in the world—and, assuming you have any funds left after shelling out for this suite, there's plenty of room in its 2,550 square feet for that new silver samovar or a colossal jug of beluga caviar. Answer: Whoever gets to sit in those chairs will find himself in the heart of Russia, and in the midst of its latest rebirth. *May 2008*

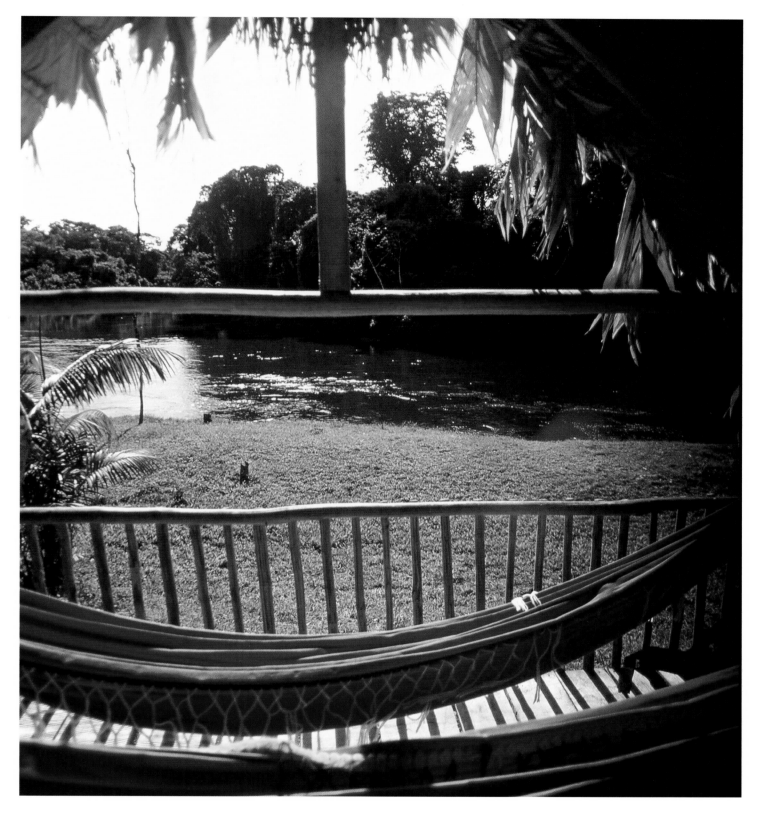

AWARRADAM, SURINAME

METS Awarradam Resort

The only passage through this jungly edge of the Amazon is by dugout canoe. Your hut faces the Gran Rio, part of an extensive river system that remains the sole means of navigation through Suriname's dense rain forest—an interior wilderness that accounts for more than 90 percent of this equatorial country. Many regions feel as much like Africa as they do like South America, and not only in terms of vegetation and climate. Maroons, descendants of escaped slaves from the plantation era, make this their home and have retained their traditional West African ways, from tribal rule to religion. Suriname, formerly the Netherlands-controlled colony of Guiana, was given up by the British in a 1667 swap with the Dutch for a more northerly territory. That other New World colony? Its name was subsequently changed to New York. *November 1998*

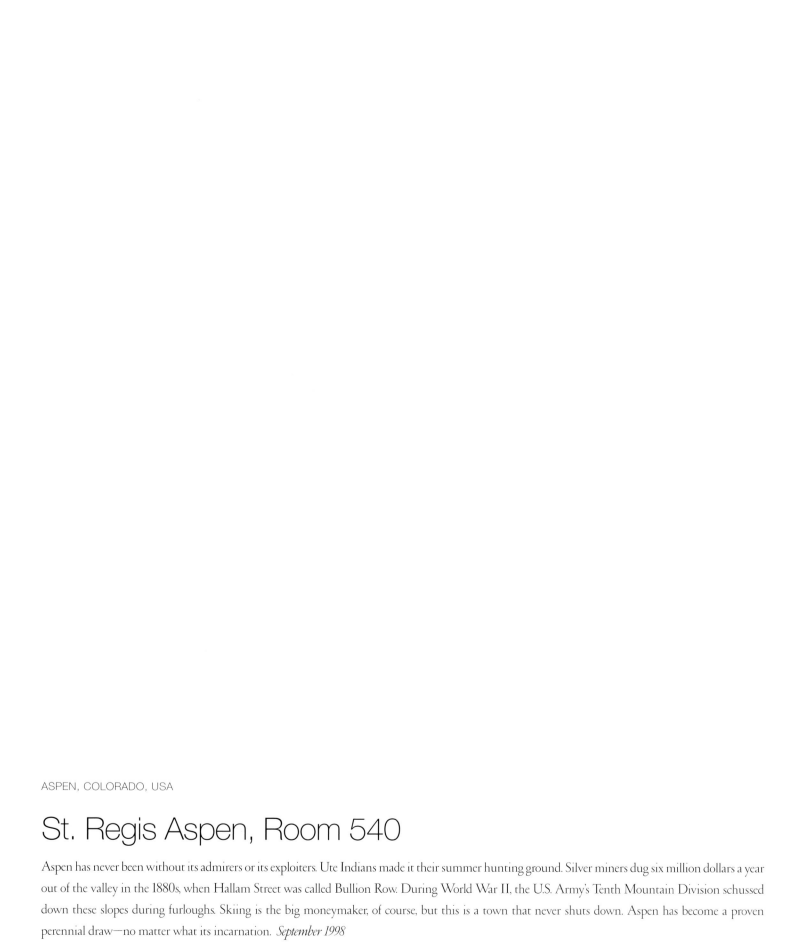

St. Regis Aspen, Room 540

Aspen has never been without its admirers or its exploiters. Ute Indians made it their summer hunting ground. Silver miners dug six million dollars a year out of the valley in the 1880s, when Hallam Street was called Bullion Row. During World War II, the U.S. Army's Tenth Mountain Division schussed down these slopes during furloughs. Skiing is the big moneymaker, of course, but this is a town that never shuts down. Aspen has become a proven perennial draw—no matter what its incarnation. *September 1998*

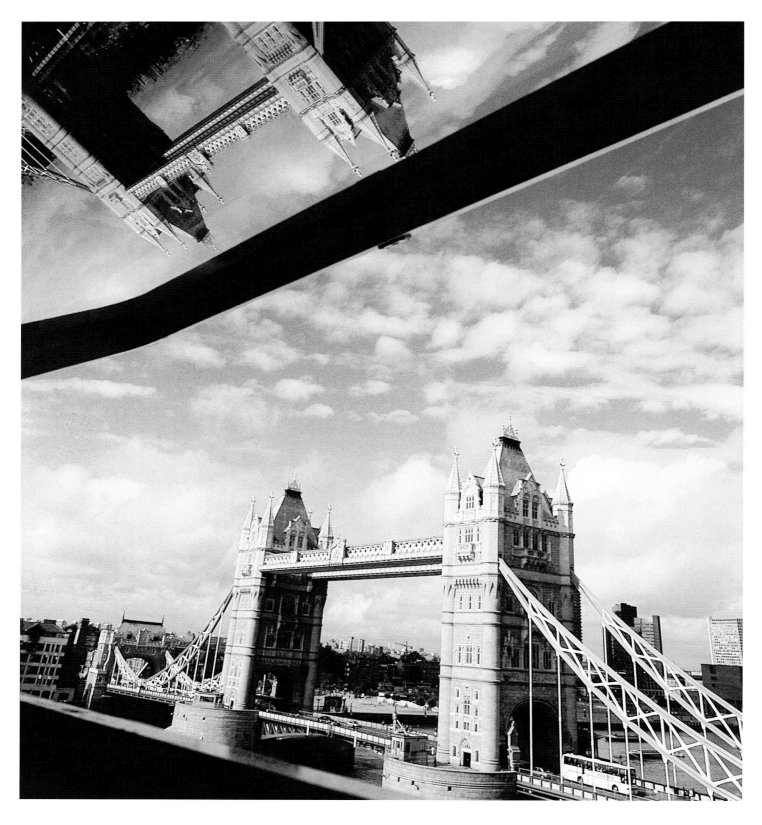

LONDON, ENGLAND

The Tower, Room 644

State-of-the-art engineering from 1894 looks twice as antique reflected in one of London's modern temples of commerce. But Tower Bridge still bustles. Although her drawbridge has been used only a few times a week since the wharves upriver closed in 1970, she still raises her roadbed for any ship that calls for passage. Electric motors have replaced the original hydraulics—purposely covered by these grand neo-Gothic towers and now proudly on display in the old powerhouse-cum-Bridge Museum. Elevators lift pedestrians to the walkway 145 feet above the river—glassed in since 1982, after having been closed for more than seven decades following a spate of nosedive suicides. From this vantage point, London's history-spanning skyline spreads out all around, and nowhere is that span more dramatically exposed than at the foot of the bridge itself, where the 900-year-old Tower of London stands adjacent to this named-in-homage hotel. *January 1997*

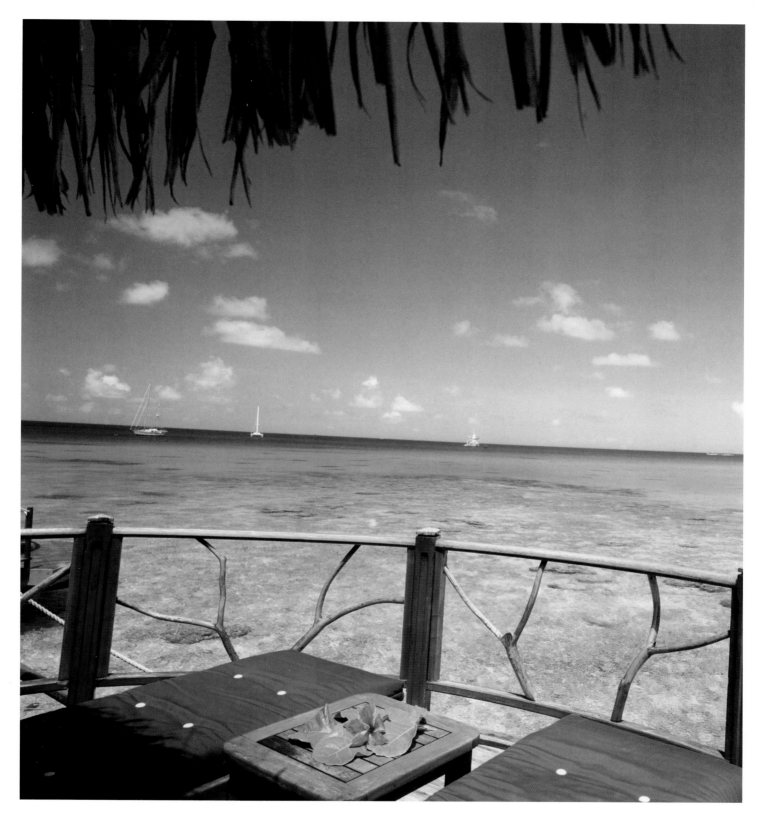

RANGIROA, TUAMOTU ARCHIPELAGO, FRENCH POLYNESIA

Hotel Kia Ora, Bungalow 5

You're in the middle of the South Pacific, but even though the water stretches to the horizon, that's not the ocean: It's one of the world's biggest lagoons, on Rangiroa, an atoll large enough to contain Greater London. Welcome to the middle of nowhere. Three-thousand-plus miles from Sydney or Los Angeles, the silence is profound. The 2,400 resident Rangiroans are vastly outnumbered by sharks, dolphins, manta and eagle rays, barracuda, turtles, and, quietest of all, coral, The only sounds are of wind, lapping water, and an occasional bird flitting by. This is the Pacific at its most pacific. *July 2008*

Hotel Portillo, Room 628

This month, it's possible to drink in a jaw-dropping wintry view—albeit at the southern end of the globe. The 800-acre Portillo Ski Resort, high in the Andes, about a two-hour drive northwest of Santiago, sits above the tree line—the surrounding mountains reach altitudes of 19,000 feet—offering stark vistas of the craggy snow-covered peaks reflected in the Lake of the Incas, seen outside your window. There is little flora (or fauna, for that matter) to soften the edges, although the range's impressive oversized condors occasionally swoop down in a display not seen at ski resorts in the Alps and the Rockies. Even if there are no appearances by the mountains' flying residents, over the course of the day guests at the historic Hotel Portillo can watch the peaks change from a soft pink at dawn to burnt orange at dusk, with a full day on the powdery slopes separating the two spectacles. *August 2005*

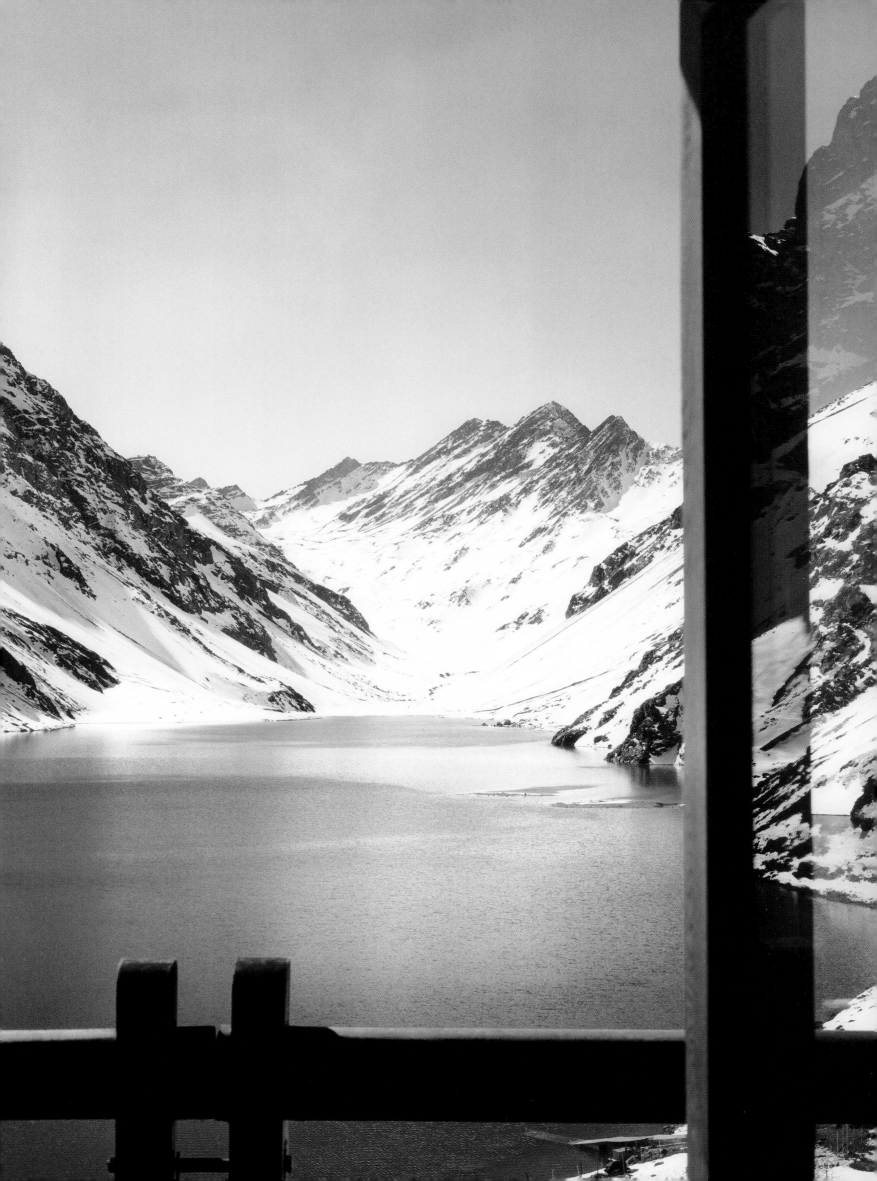

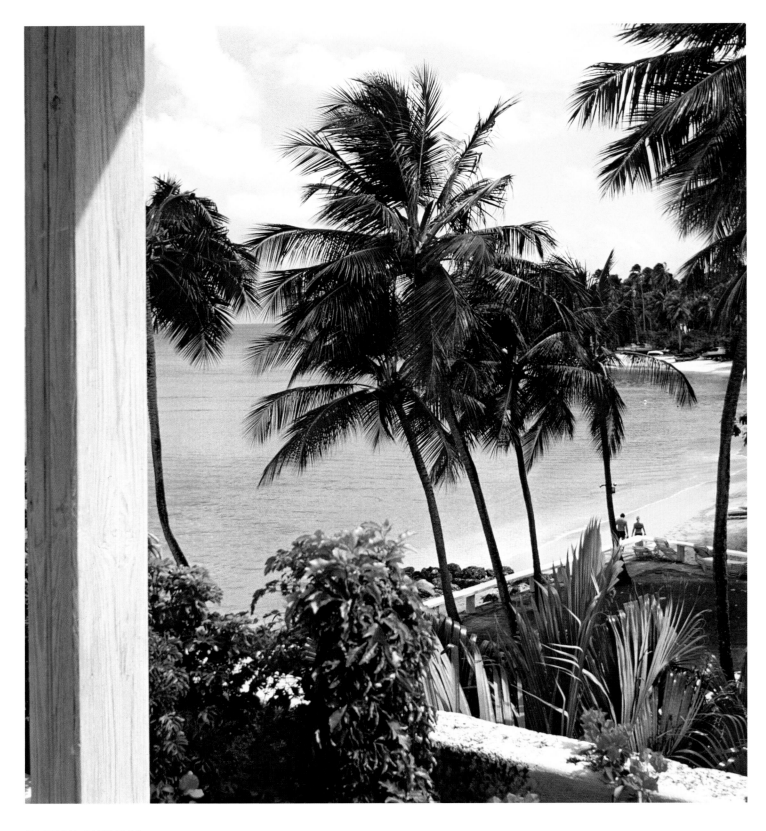

ST. PETER, BARBADOS

Cobblers Cove, The Camelot Suite

From a rooftop terrace with its own secluded pool you can look down on a white beach. The beach is shared with a house owned by Claudette Colbert. Cobblers Cove is a luxurious enclave within one of those little pieces of England afloat in the Caribbean: Barbados. The vegetation—palm, frangipani, Poinciana trees—may not be English. But there are other deeply planted roots that are: for example, the third-oldest parliament in the Western Hemisphere, the House of Assembly, founded in 1639. Another tradition is the elegantly arcane game of cricket. You could not suspect, in the privacy of Cobblers Cove, that Barbados, only twenty-one miles long and fourteen miles wide, has a population of 250,000, making it one of the world's most densely populated places. The hotel's Camelot Suite has a king-size four-poster bed. The rates include water sports and day and night tennis. Which adds to the sense of being blissfully self-sufficient. *May 1990*

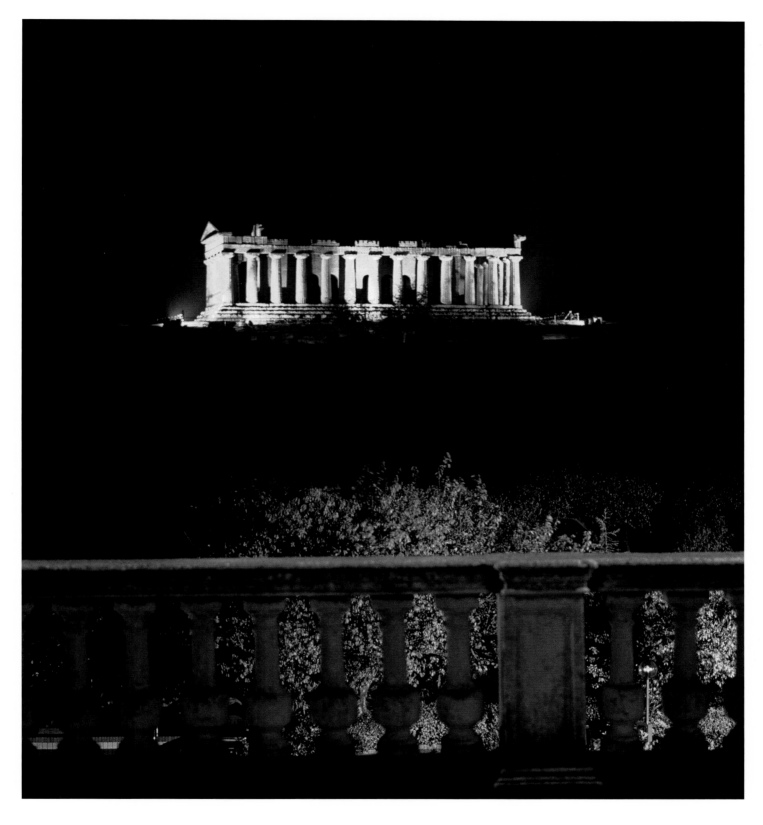

AGRIGENTO, ITALY

Hotel Villa Athena, Room 205

No, you're not in Athens, gazing at the Parthenon through the moonlight—and a miasma of urban smog. This is Agrigento, on the southwestern coast of Sicily, which was settled by Greek colonists around 581 B.C. and where you can see some of the best-preserved Greek ruins in the world. We're looking at the most spectacular, the Temple of Concord (fifth century B.C.), from Room 205 of the nearby Hotel Villa Athena. Somewhat ironically for a temple dedicated to the ancient Hellenic gods, it owes its surprisingly unscathed appearance (only the roof is missing) to the Christians who converted it into a church in A.D. 597. Agrigento's most famous hometown boy was the philosopher and statesman Empedocles. Legend has it that he threw himself into Mount Etna's volcanic crater in a dramatic bid to prove his own deity. The jury is still out on whether he succeeded. *August 1990*

St. Martins Lane, Room 605

Perched high atop the column to your right in Trafalgar Square, Nelson has lorded it over the skyline since 1843. Now it's your turn. You're in Covent Garden, facing the London Coliseum Theatre, which houses the English National Opera. Beyond the curtains of your floor-to-ceiling windows, the lights of the West End sparkle. When your eyes tire of the view, turn your attention to your room, where a lighting system, controlled via a dial next to the headboard, lets you adjust the light color to match your mood—are you fiery red or green with envy? Should you lose your battle with jet lag, rest easy. Lord Nelson will watch over the city while you sleep. *August 2007*

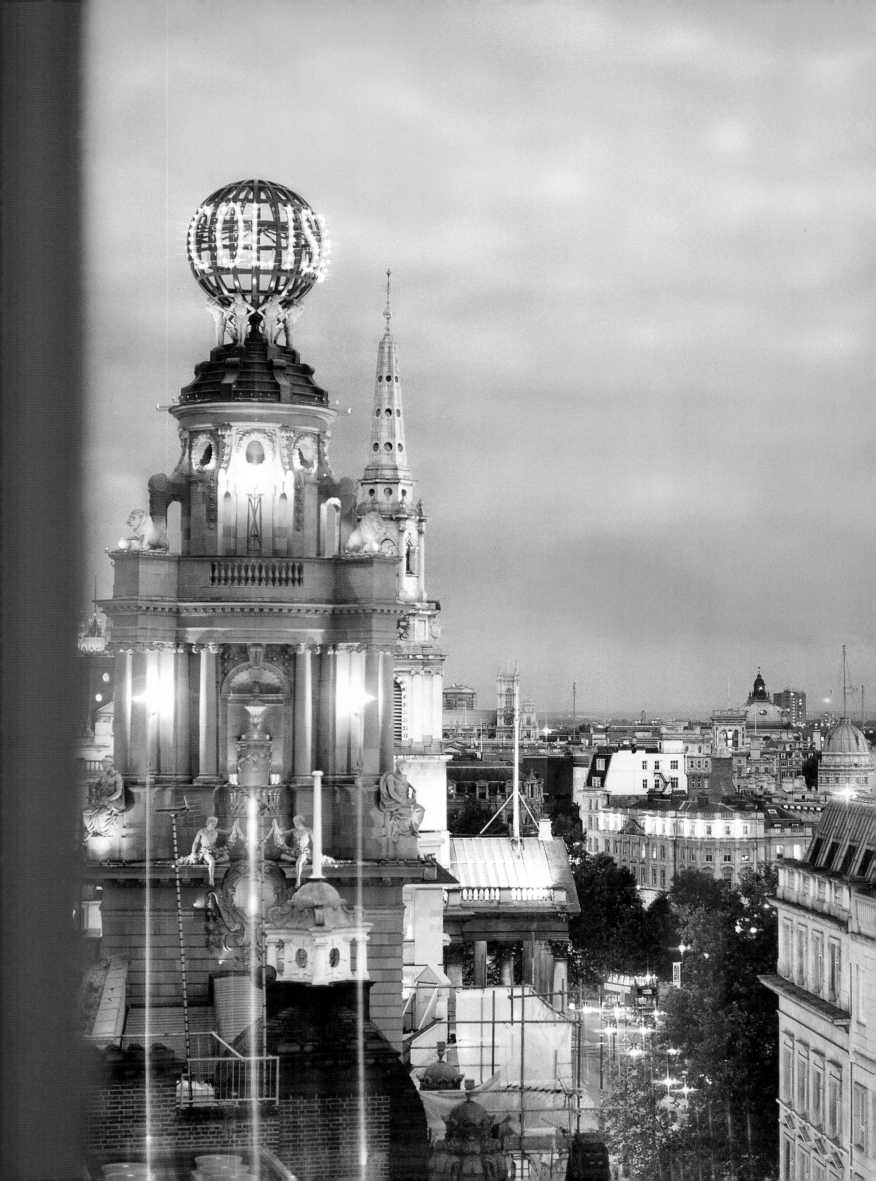

Four Seasons Hotel, Room 5102

From way up here, as the song says, Manhattan is an "isle of joy." And for a cool 2.5 grand, you too could be on top of this (helluva) town, with cocktails—some say the city's best—for two. The 180-degree view form the terrace on the penultimate floor of the Four Seasons Hotel, New York's tallest, makes your Manhattan—or all downtown at least. The lines and details of I.M. Pei's impeccably elegant 52-story hostelry pay homage to its 1930s neighbors-in-the-sky, including the aerodynamically ebullient Chrysler Building and the still-grand Empire State. The illuminated pyramid just ahead tops the Park Avenue Tower. Four miles due south is the financial district, and, tucked in on the horizon, the Statue of Liberty. *July 1994*

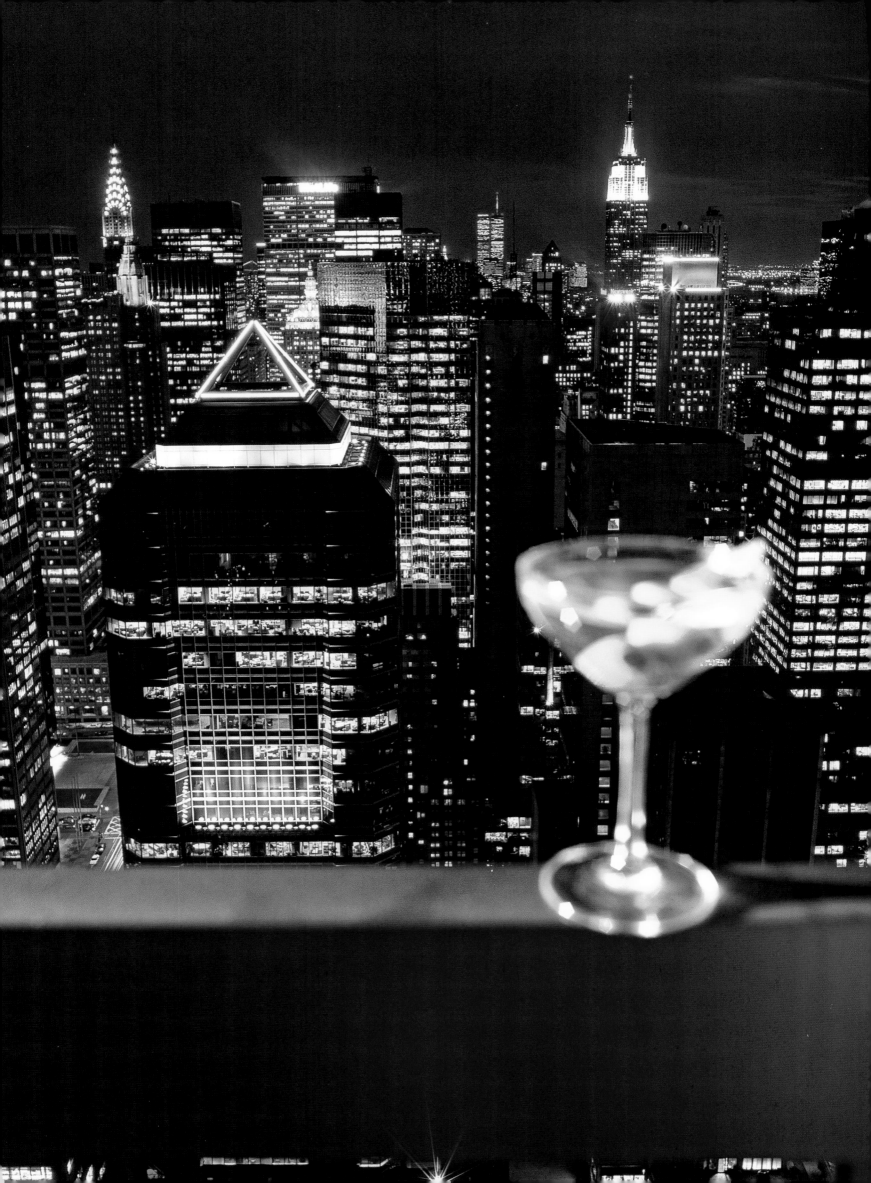

KOH SAMUI, THAILAND

Four Seasons Resort Koh Samui, Deluxe Villa 905

The healthy glow that distinguishes a departing guest from an arriving one at this villa reflects more than sunshine. Over the past 20 years, Koh Samui has established itself as Thailand's self-improvement mecca, specializing in Ashtanga, naturopathic flower remedies, and Indian Ayurveda, among other treatments for body and soul. But less ascetic health seekers lacked a sinfully accommodating retreat from the purges and fasts—until the Four Seasons scattered 60 seaside villas on the island's northern shore. The resort's purification programs, based around raw juice and coconut oil cleanses, combine with yoga and massage for a serious detox regimen. Good thing a personal coordinator is on call to nudge pampered campers off their plush daybeds. *September 2008*

Typique Maison Turque, Upstairs Room

Gazing at the broad, ocher-toned landscape outside your window, you may think of a Brueghel the Elder canvas come to life. While careful brushstrokes created the Flemish painter's sixteenth-century masterpieces, Cappadocia, this fantastical region in central Turkey, came into being as the result of capricious forces ten million years ago: the eruption of three surrounding volcanoes in the Uchisar area. The lava produced layers of soft rock called tufa, which, shaped over time by wind and rain, formed a dreamscape of conical structures. These "fairy chimneys," in the local parlance, have traditionally been used as houses, as the name of your accommodation plainly suggests. The hotel's owners, brothers who left their family's dwellings in 1981 when the government declared the valley a cultural reserve, were granted permission to reoccupy their former home. Their tufa compound now has guest rooms and a museum. *October 2003*

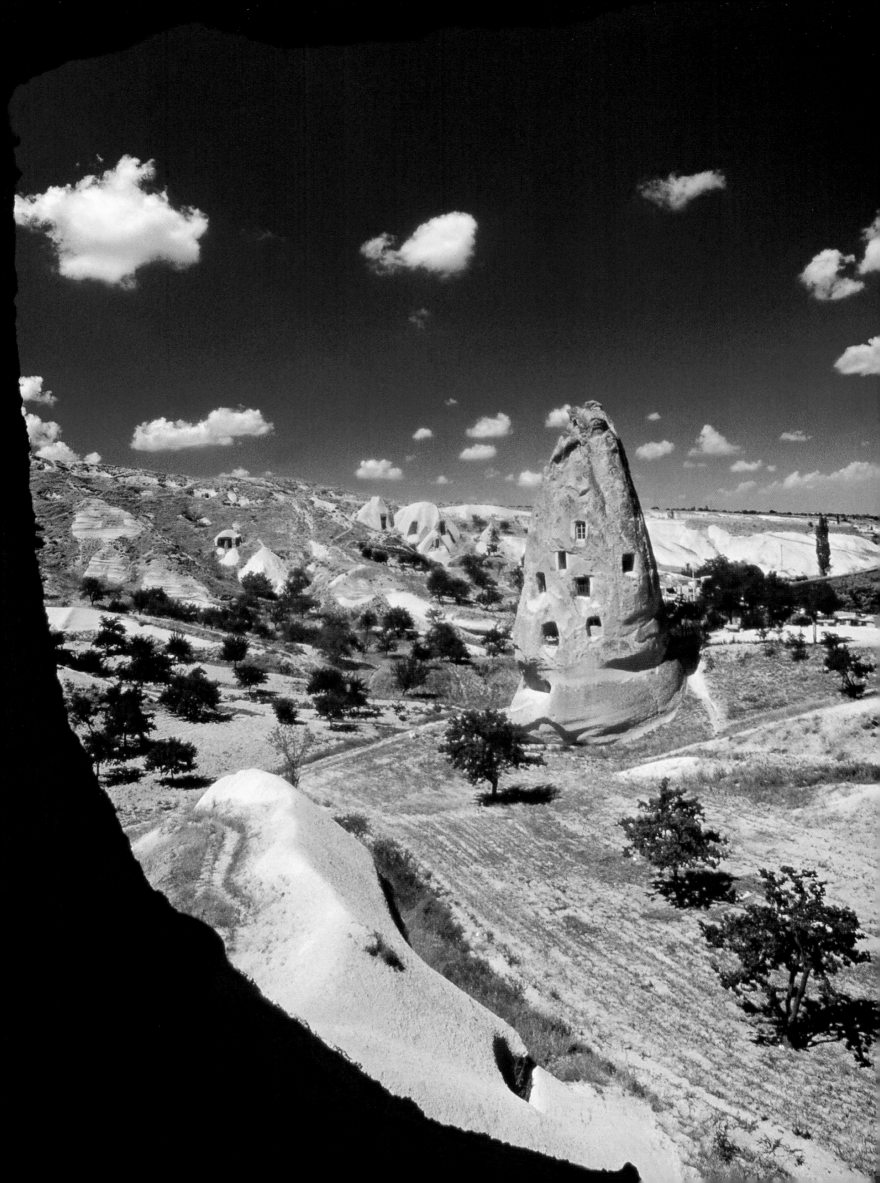

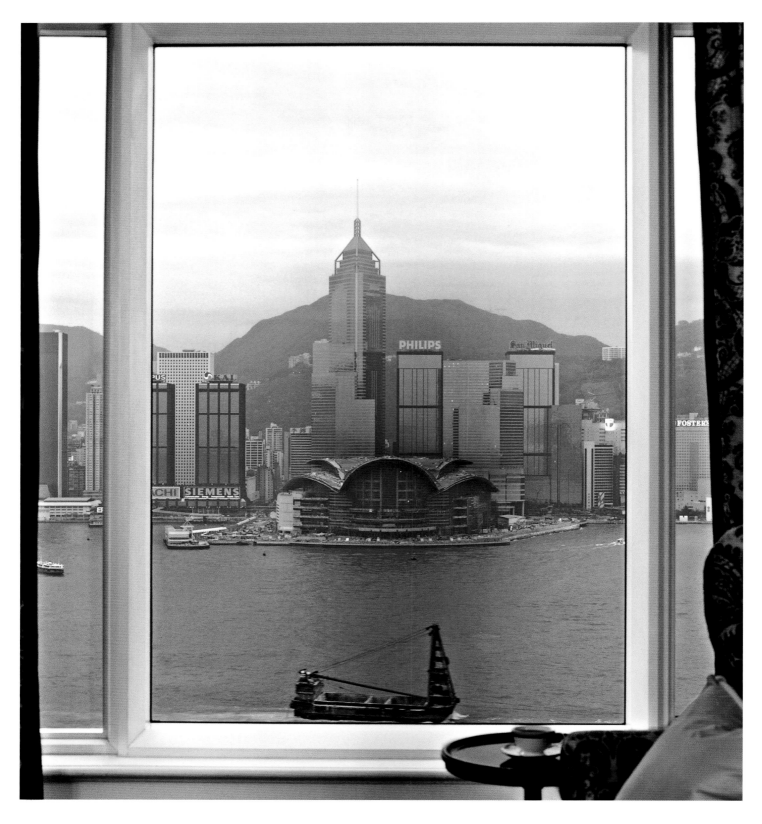

HONG KONG, CHINA

Peninsula Hong Kong, Room 2007

Within the blink of a midnight eye—a flick of the cesium clock that separates 23:59:59 from 00:00:01—you will be gazing down no longer at the colony of Hong Kong but, at long last, at China proper. Of course, this land has always been China's, really. The barbarians held it for 156 colonial years, a mere hiccup in Chinese time; and its return has a poetic justice to it. The squatting-crab Convention Centre is the place for the handshakes and the tears, and for the changing of flags at the very instant Monday, June 30, becomes Tuesday, July 1. The towering real estate behind will be the colonials' most enduring legacy. Other memories—such as the Victorian ban on Chinese living on the hill beyond—will slowly fade, and before long it will be as though the barbarians had never been here at all. That is China down there, they will say. Always has been. *July 1997*

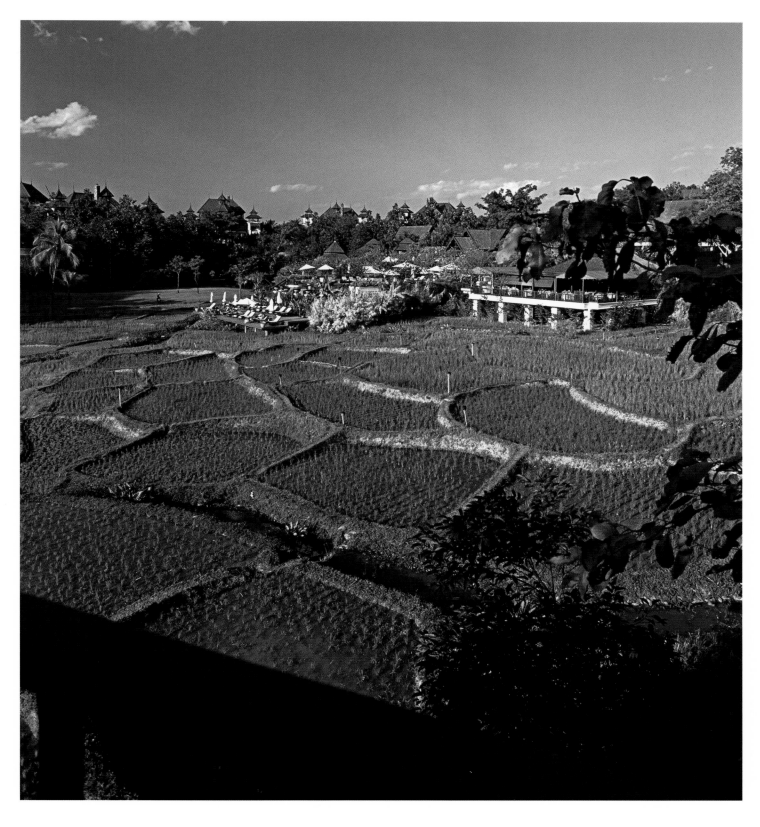

CHIANG MAI, THAILAND

Four Seasons Resort Chiang Mai, Pavilion 1501

A more apropos vista here in the foothills of northern Thailand you'd be hard-pressed to find. These rice paddies were once rolling hills within the former kingdom of Lan Na—literally, "land of a million rice fields"—which encompassed parts of modern-day Laos, Burma, and Thailand. Its monarch, King Mengrai, seized control of the area in 1296 and built Chiang Mai, or New City, which later became the kingdom's capital. Thailand's second-largest city, Chiang Mai is prized for its abundance of *wats* (more than 300) and as a temperate base for trekking in the surrounding mountains, where hill tribes still dwell. The Four Seasons, ensconced in a valley ten miles north of the city, is designed as a quintessential northern Thai village, with a working rice farm as its centerpiece. The paddies, meticulously sculpted between your raised pavilion and the resort's pool, are harvested nine times a year, and the crops donated to local villagers. *August 2001*

Just Inn, Tuscany Suite

Whether or not you're serious about wine, this view is an inspiring one with which to start the day. The tidy rows of cabernet sauvignon vines that extend to the oak trees and barley fields in the distance are a prized part of the 165-acre Justin Winery, one of five dozen notable growers in California's upstart Paso Robles area, halfway between San Francisco and Los Angeles. Since its first crush in 1987, the small winery has, thanks in part to its flagship Isosceles blend, helped this region linger in oenophiles' minds and on their palates. The grapes outside your suite will ripen in October—cabernet is the last crop of the season. To enjoy the fruit of earlier harvests, sit down in the dining room for a multicourse meal and a sampling of the house wine: There are nine types to choose from, including syrah, chardonnay, and sauvignon blanc. *August 2004*

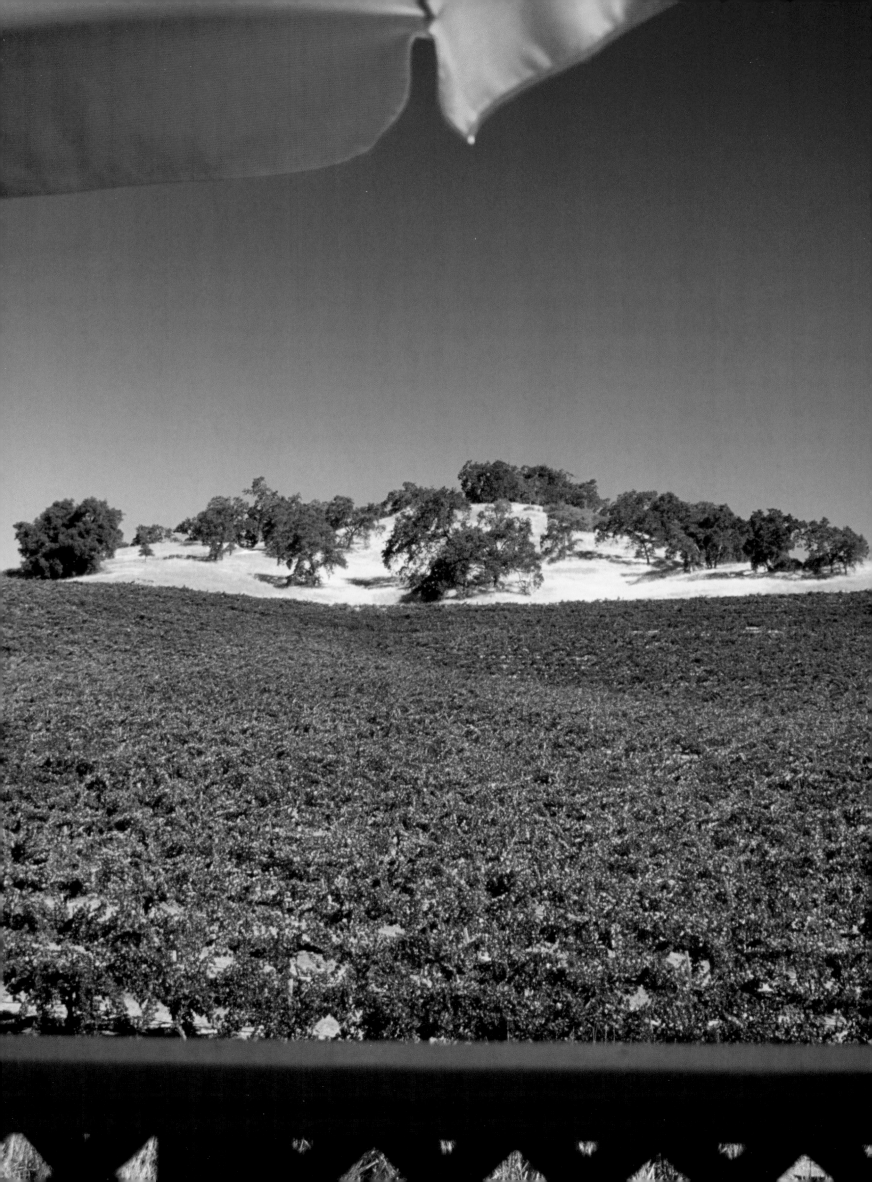

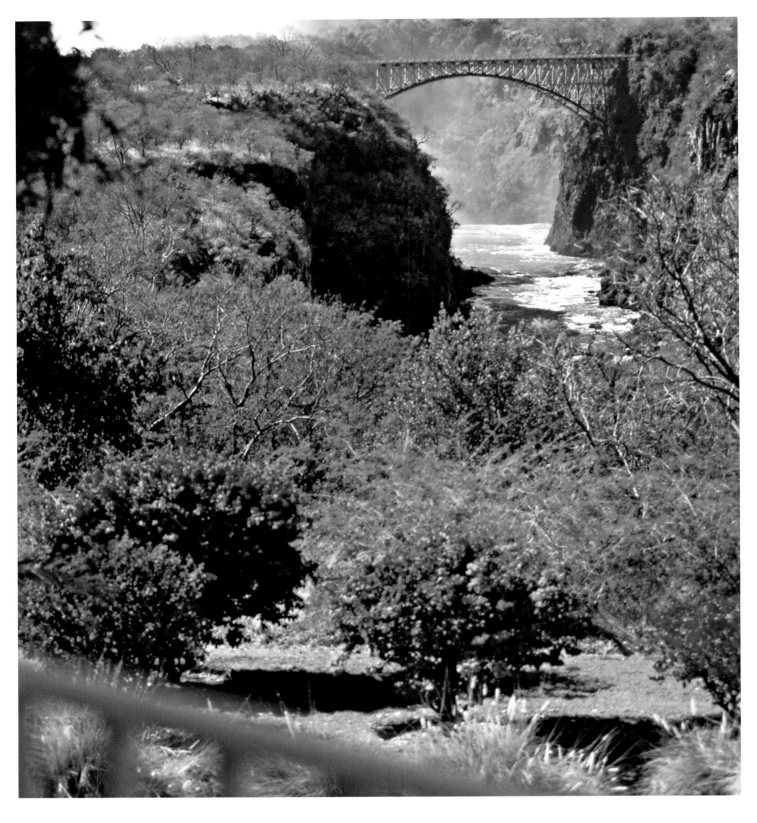

VICTORIA FALLS, ZIMBABWE

Victoria Falls Hotel, Room 56

Pay no attention to the occasional screams you hear. It's just thrill seekers taking the world's longest bungee plunge off that famous turn-of-the-century bridge, 364 feet above the Zambezi River. Listen instead to the steady, ancient sound of *mosi-oa-tunya*, or "smoke that thunders," known as Victoria Falls since David Livingstone renamed it in 1855, opting for patriotism over poetry. In March and April it is a deafening avalanche of water, the mist alone enough to sustain the surrounding riverine forest over which your balcony hovers. Travelers have been soaking up this view since 1905, when rooms cost a guinea and a rickshaw took them to the bridge—and that was thrill enough. *June 1998*

LAIKIPIA, KENYA

Ol Malo, Cottage 4

Even those who feel a twinge of vertigo will agree that the panorama of Kenya's Northern Frontier is—altitude aside—breathtaking. Happily, it will remain this way: The hot, arid lowlands over which your thatched cottage is precipitously perched were designated a national reserve a few decades ago. Species rarely seen elsewhere in any numbers, including the reticulated giraffe, Grevy's zebra, and the beisa oryx, all find relief here by the Ewaso Nyiro, or "black river," and in the forest shade alongside the water. A safari lodge set on its own 5,000-acre tract, Ol Malo translates from Samburu as "the place of the greater kudu," in reference to the tall, jowly antelope that roam the terrain. Between picnics in the bush and camel treks—both arranged at Ol Malo—you can meet with local Samburu, close relatives of the Masai tribe. Just be sure to leave ample time to soak in the views on the trip back up. *June 2001*

Playa Mambo, Penthouse Cabana

"The moon was shining magnificently, drawing a long silvery line upon the sea. . . . For a time we felt ourselves exalted above the necessity of sleep," wrote the American explorer John Lloyd Stephens during his 1841 voyage to the Yucatán. No offense to Stephens, but you'll likely disagree. In fact, there's no use fighting sleep as you lounge in these soft sheets with the sounds (and sights) of the azure sea just beyond your terrace. Should you escape the billowing bed-net, a saltwater shower and the catch of the day await. Outside Playa Mambo's unassuming grounds, the nearby ruins reflect the ancients' penchant for all things aquatic: The Temple of the Diving God was built for Tulum's predominant deity. Visit the mural of the moon goddess Ixchel, too—one of the few remaining depictions of her. And when evening sets in, pay homage to the real thing, just like the adventurers who marveled at her handiwork more than a century ago. *December 2009*

Hotel Bella Vista, Room N1

This view of the monolithic Matterhorn so struck fear in the hearts of nineteenth-century alpinists that almost all attempts to summit the 14,692-foot peak began on its southern side, in Italy, where the prospect is less foreboding. But after seven failed attempts, British illustrator turned mountaineer Edward Whymper gazed up at the spire from Zermatt and realized that its precipitous appearance was an illusion—the behemoth could actually be more easily conquered from Switzerland. He was (almost) right: On July 14, 1865, his team reached the summit, but four men plummeted to their deaths during the descent. Your chances are better today thanks to fixed ropes, well-placed mountain huts, and an abundance of guides. The chalet-style Hotel Bella Vista is the ideal spot from which to launch an ascent. But while making your grand plans, keep in mind that looks can be deceiving. *March 2009*

Terre di Nano, The Casetta

Liberate your inner Cellini in Tuscany's Val d'Orcia. "My ancestors," wrote the sculptor, "lived like little lords in retirement." You too can enjoy all the fruits of these hills with none of the heavy lifting. This agriturismo estate near Siena delivers not just olive oil and wines from the groves and vineyards of the surrounding valley but also a harvest of history, beauty, and serenity. The Val d'Orcia has been immortalized by Sienese artists, and among its picturesque villages is Pienza, created by Pope Pius II in 1462 as the "ideal" Renaissance town. In fact, the entire valley (about the size of Corfu) is a UNESCO World Heritage Site. Why? For a truly delightful reason: It has inspired images of "landscapes where people are depicted as living in harmony with nature." Truly, lucky little lords. *February 2009*

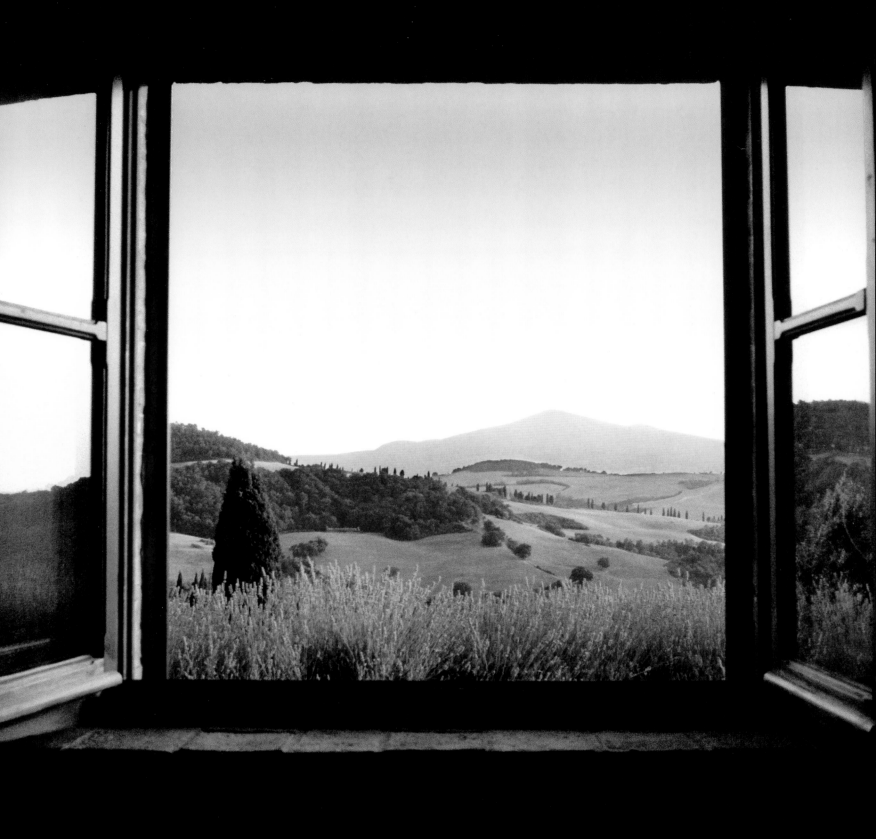

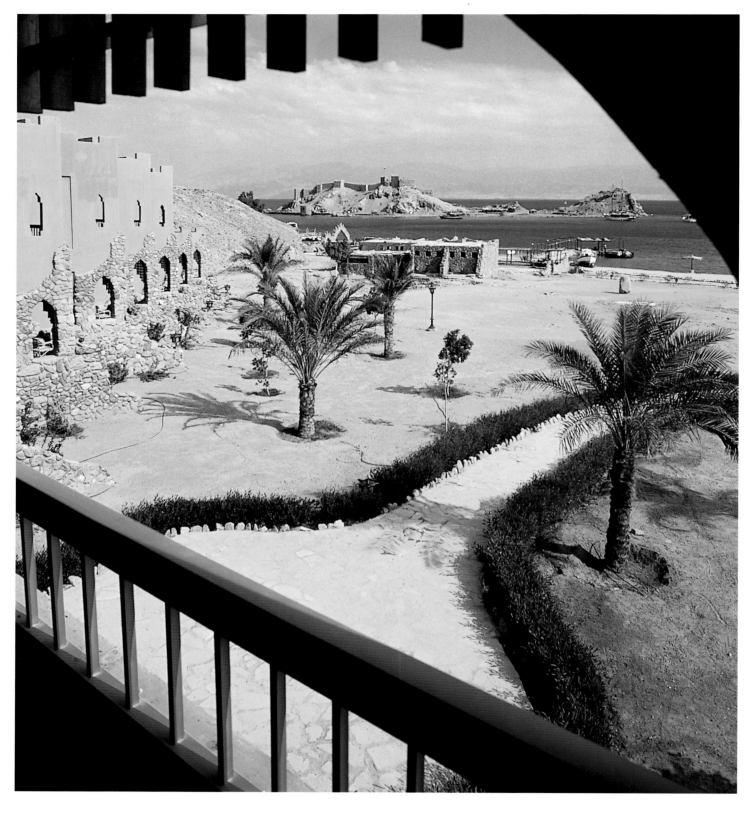

TABA, EGYPT

Salah el-Deen Village, Room 357

Two kinds of current now flow in the turquoise Gulf of Aqaba. Taba made headlines as the site of King Abdullah's first foreign visit as head of Jordan, a historic meeting with Egypt's President Mubarak to mark a new era of Muslim unity, and of shared power. An eight-mile underwater cable now links Africa and the Middle East, connecting electrical grids in a network that will stretch from Morocco to Turkey—excluding Netanyahu's Israel. Power politics aside, Israelis join Europeans at Taba and all the growing Sinai resorts, if not for nature or history, then for slots and cards. It's the newest struggle on very old ground: environmentalists versus developers who want a Vegas in Arab sands. *June 1999*

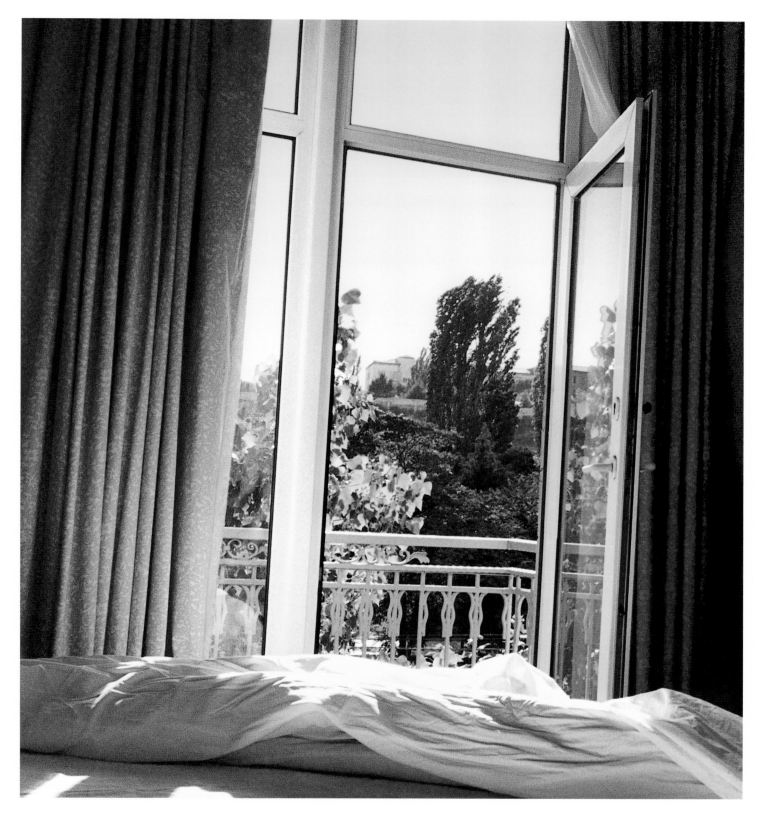

BAKU, AZERBAIJAN

Hyatt Regency Baku, Room 217

Had you awakened to this cypress-filled morning in Tuscany or Provence, life would be easier. But you are in Baku, and it is no sleeping beauty. While far to the west a border war continues with Armenia, big oil deals are being struck here (the Hyatt Regency's pool area is the meeting site of choice), precariously reushering Azerbaijan into the global oil trade—a trade it once dominated. Jutting into the Caspian Sea on a crooked finger of land, Baku endured conquest after conquest—Persians, Mongols, Ottomans, and, finally, Russians. Having shed its Soviet layer in 1991, Azerbaijan is now poised and eager to seal deals for a new dawn. *April 1999*

King Pacific Lodge, Princess Royal Suite

Take a seat. In a short while, the summer sun will lazily complete its arc before dropping out of sight beyond Barnard Harbour. You're just 90 miles south of the Alaskan border, and for this timber-and-stone lodge on Princess Royal Island, accessible only by boat or floatplane, remoteness is its best trait. Aside from guests like yourself, wild creatures are the sole inhabitants. The most famous resident is the rare Kermode bear, also known as the spirit bear because of its unusual white coat. According to the lore of the indigenous Tsimshian people, Raven, the creator, turned one out of every ten bears white to remind man of an era when the earth was covered in ice. Such glacial images are hard to conjure at this time of year, when the temperature rarely dips below 60 and you're propped in an Adirondack chair, watching that setting sun mark the end of another perfect day. *August 2003*

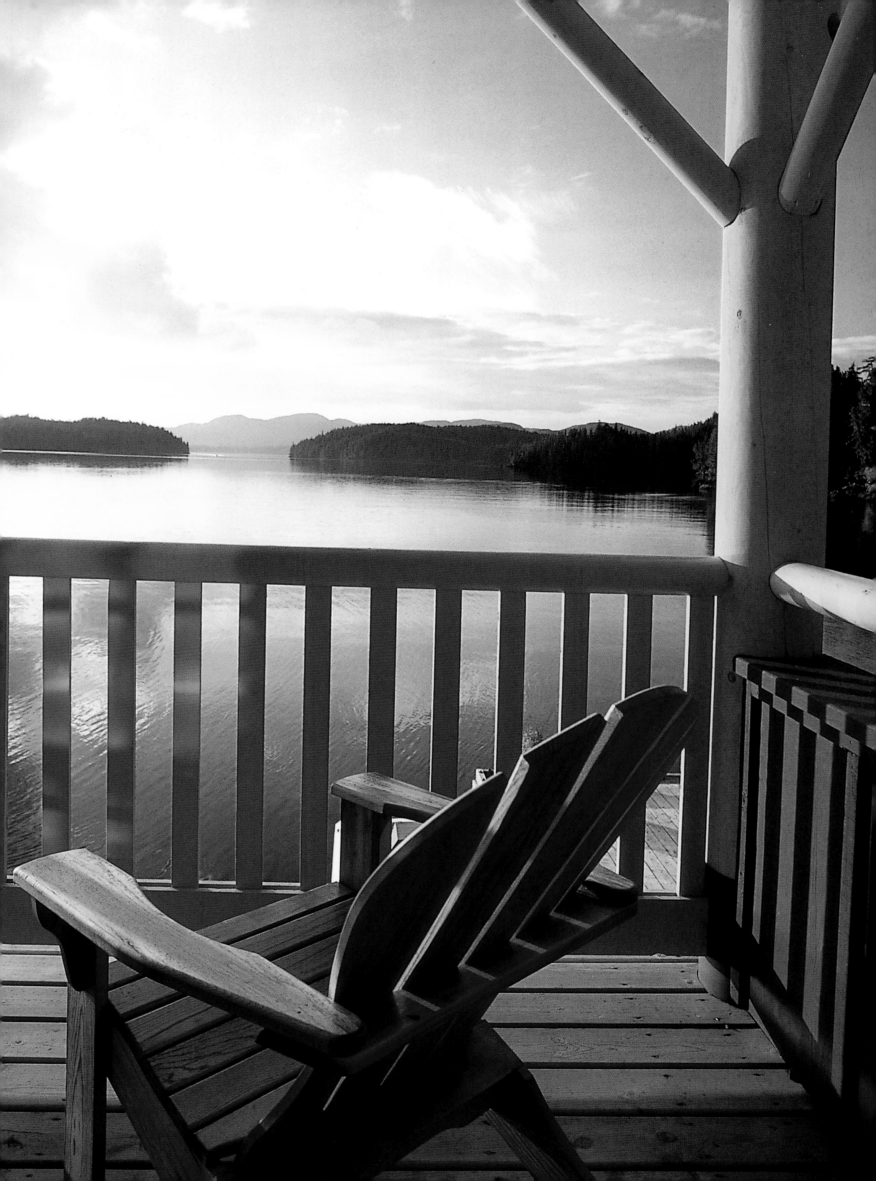

Badrutt's Palace Hotel, Room 609

The majestic, snow-dusted Swiss Alps dominate the floor-to-ceiling view from your balcony at Badrutt's Palace Hotel, the center of the Engadine Valley's glitziest après-ski action. During the last weekend in January, you'll also witness a curious scene on the frozen surface of the Lake of St. Moritz, when some of the best international polo players compete in the Cartier Polo World Cup on Snow. The storied 110-year-old hotel is a front-and-center vantage point for the four-day event, and should you want to test the ice yourself, the staff can have you galloping across the lake on pony-drawn sleds throughout the season. Chances are good that weather conditions will be favorable, since St. Moritz averages 322 days of sunshine a year. *December 2006*

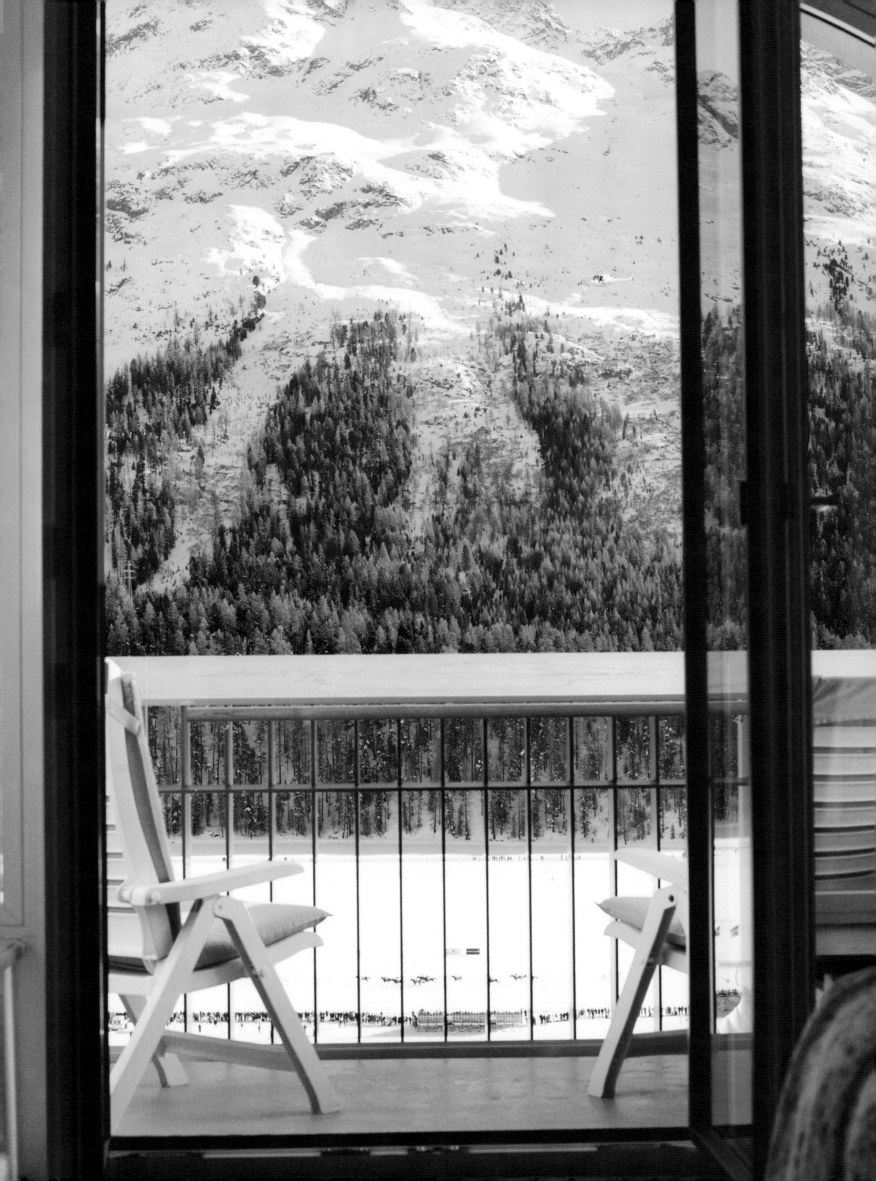

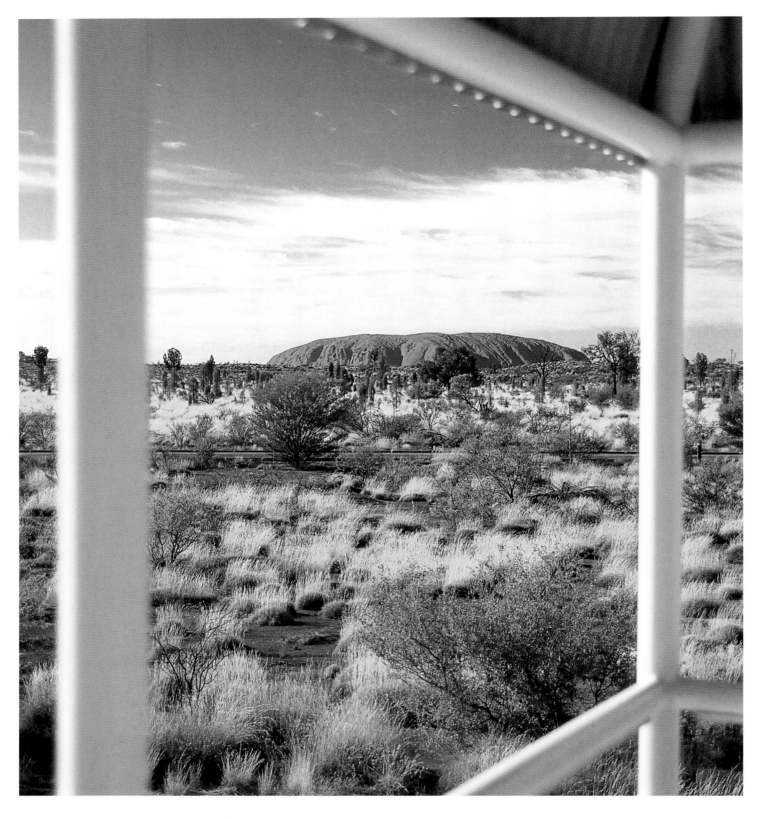

ULURU, AUSTRALIA

Desert Gardens Hotel, Room 319

What Australian monument is more awesome to behold than the hulking monolith yonder? Fittingly, the bulk of Ayers Rock is literally down under, extending four miles beneath the sand. The Anangu, the local aboriginal group, have long considered it sacred, fashioned from mud when, their legends say, giant powers roamed the earth, creating and destroying the landscape. The Desert Gardens Hotel and its surrounding resort complex came into being (less epically) in 1984, one year before ownership of the landmark reverted to the Anangu and Ayers Rock was renamed Uluru. Now, the spiritual and the curious continue to arrive, hoping to capture the rusting, iron-rich tor on film or—despite Anangu pleas—to scale its 1,143-foot flanks. But why climb? You'll have the better vista, and for longer, from your own veranda. *December 2000*

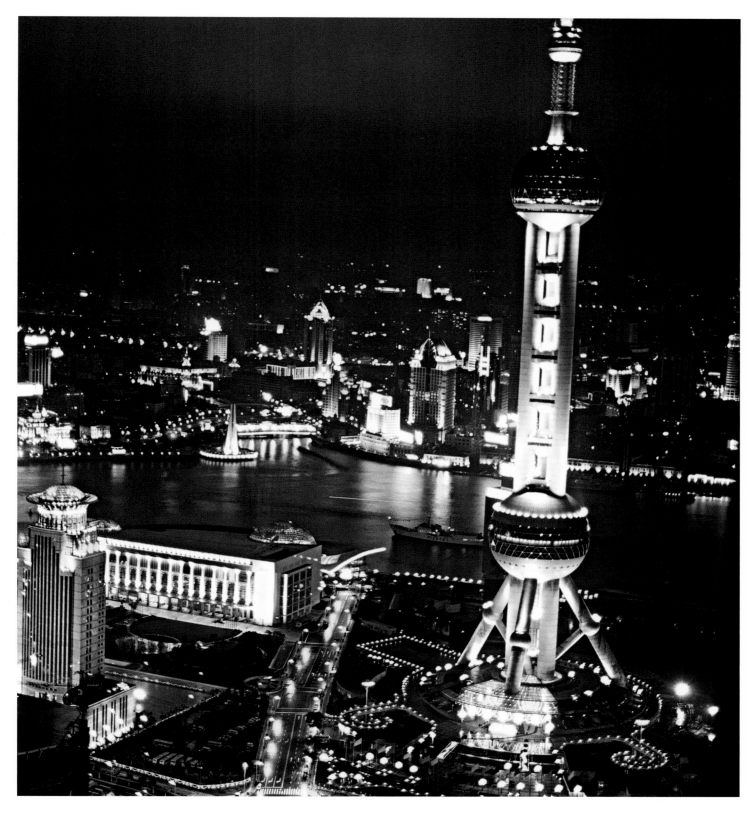

SHANGHAI, CHINA

Grand Hyatt Shanghai, Room 6115

What emerged in the last decade from the marshes and dockyards that once hugged the Huangpu River is Shanghai's gleaming Pudong district. China's new financial and commercial center is also its most unabashed homage to conspicuous construction, having sprouted banks, bridges, and the Oriental Pearl TV Tower, the district's pièce de résistance. Ostentatious as it is, the futuristic mega-antenna was surpassed in 1998 with the completion of China's tallest building, the Jin Mao Tower, from which you're peering out. The Grand Hyatt Shanghai occupies the top 36 floors. The architects of Pudong's great leap upward kept a foot in the past, however, positioning the graceful 88-story Jin Mao at 88 Century Boulevard (the number eight is considered lucky). The cityscape is the backbone of a growing economic power. Beijing may play host to the world in the 2008 Olympics, but who's to say Shanghai isn't faster, higher, and just as strong? *May 2002*

Hotel Vitale, Room 808

From your rooftop terrace, its low-lit walls and potted grasses framing the Bay Bridge and glassy waters below, all is serene. But had this hotel existed just a couple of decades ago, the sound track would have been Embarcadero Freeway traffic several stories below. Since the overpass's demolition after the 1989 earthquake, the mile-long stretch of waterfront that it once dominated has enjoyed a renaissance, of which the Vitale is the latest chapter. To your right, SBC Park has drawn legions of Giants fans since the first pitch was thrown in 2000. To your left, gourmets flock to the Ferry Building, now a high-rent food hall, and to its adjacent three-times-weekly farmers' market. To sample its bounty without whipping up your own in-room repast, head downstairs to the hotel's restaurant, Americano, where chef Paul Arenstam bases his Italian creations on the day's market finds. *December 2005*

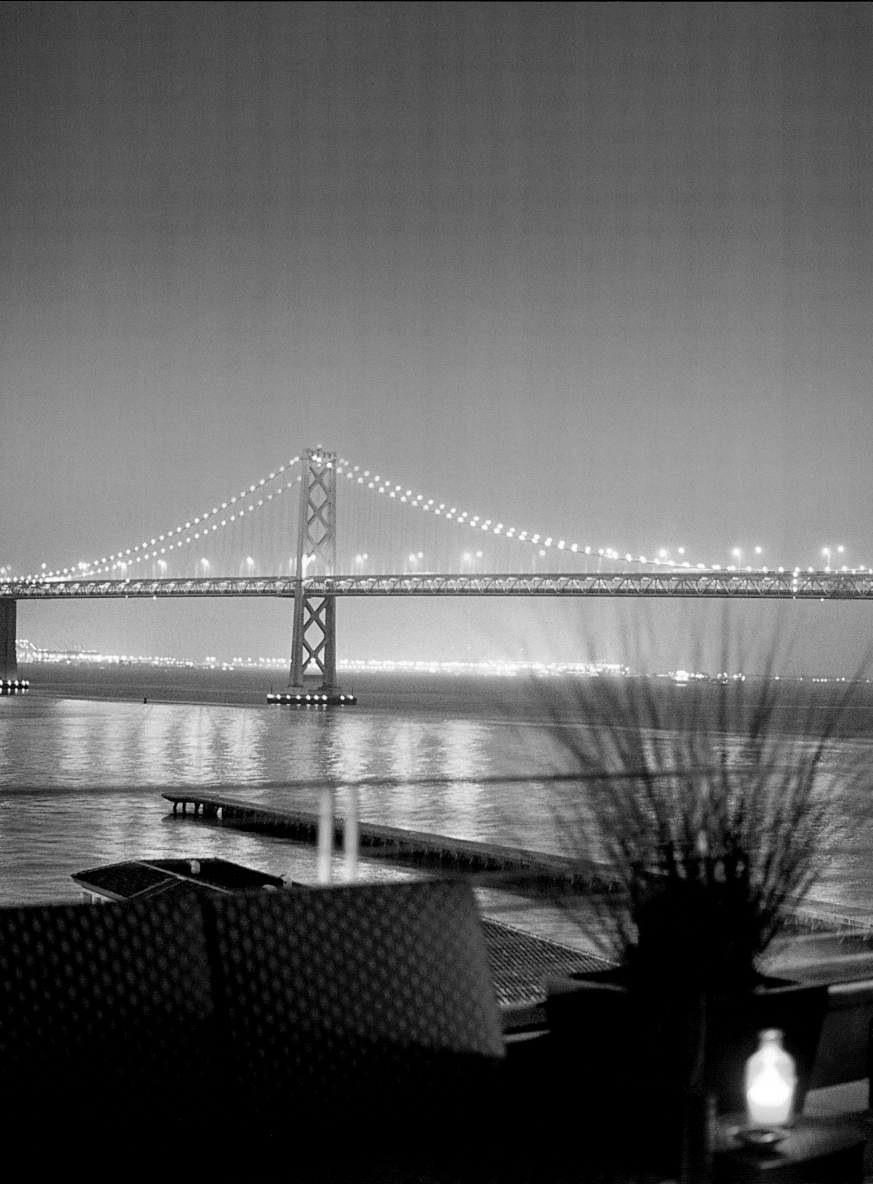

Palazzo Sant'Angelo, Room 214

Set along the widest stretch of the Grand Canal, between the Rialto and Accademia bridges, the stately Palazzo Sant'Angelo, long a private home, reopened its doors as a hotel in 2000. The Palazzo Pisani-Moretta (ca. 1460) seen from your balcony across the waterway, is also a former grand residence; mullioned Gothic windows (the architectural fashion at the time of its construction) help make its pink facade one of the most recognizable along the two-and-a-half-mile Grand Canal. Ironically, the city's most salient feature may yet be its undoing: Venice is sinking slowly into the Adriatic, having dropped some 24 inches over the past 300 years. Plans for the city to erect a multibillion-dollar flood barrier have remained stagnant—unlike the water taxi and gondola traffic outside your window. The hotel's own pier is a handy boarding point for anyone heading to the nearby Piazza San Marco, Palazzo Grassi, or La Fenice. *April 2005*

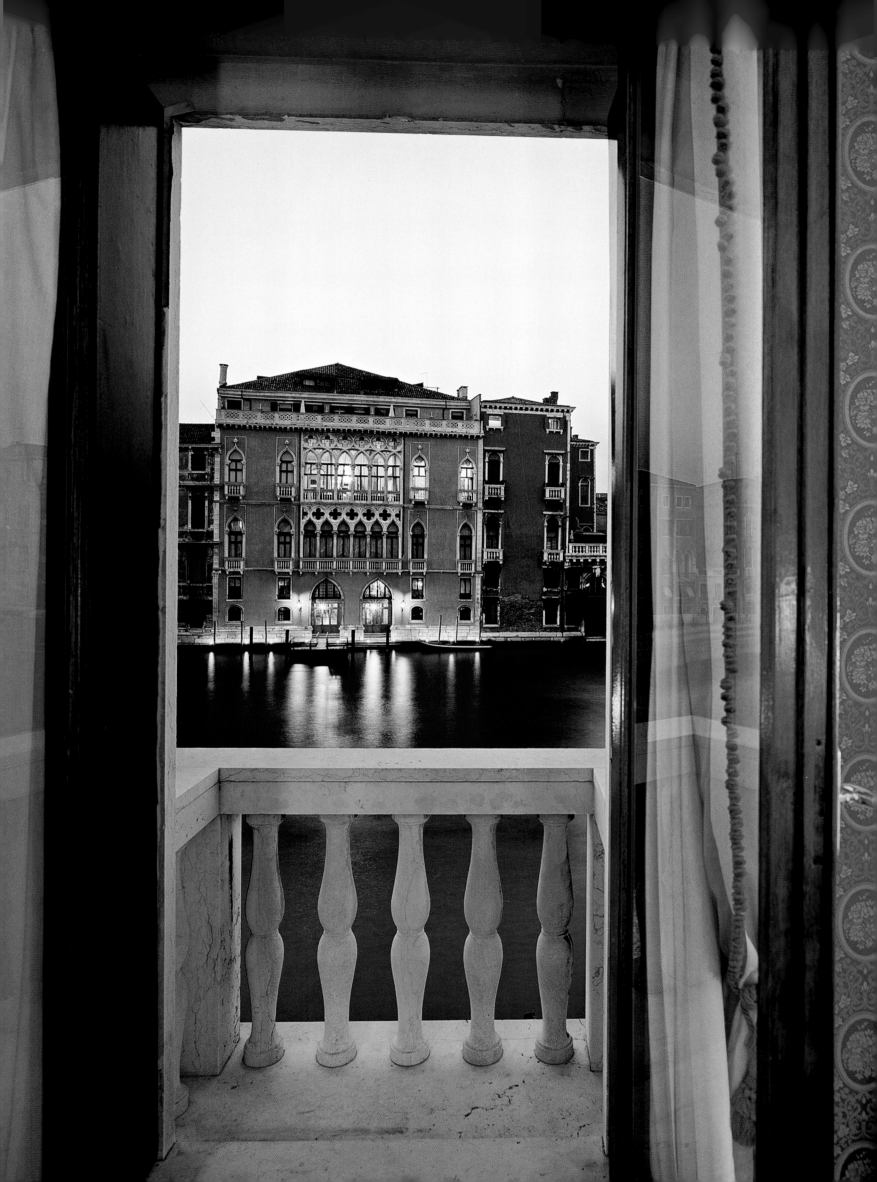

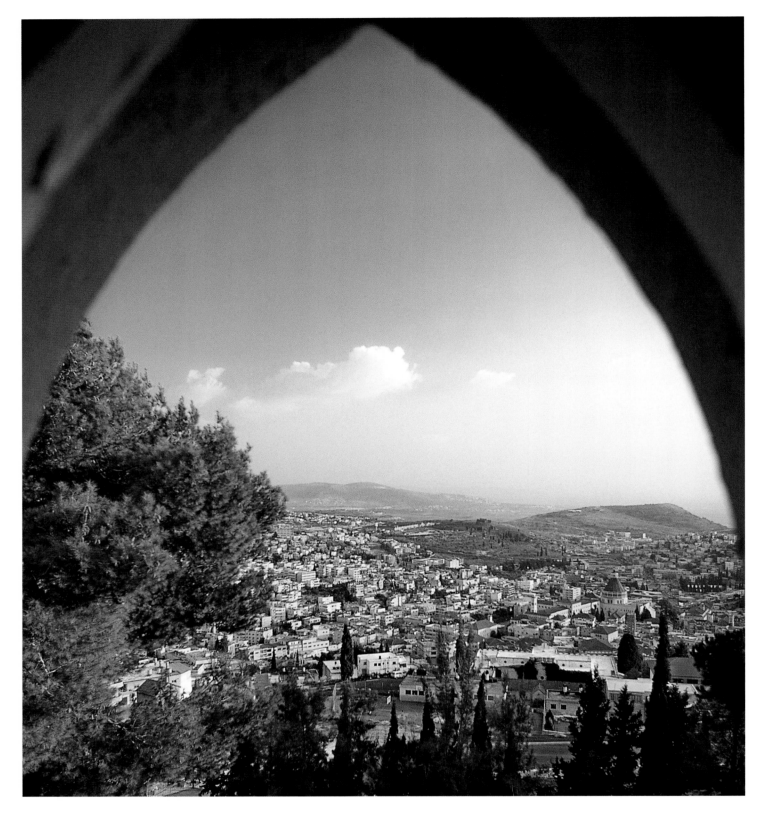

NAZARETH, ISRAEL

St. Gabriel Hotel, Room 405

For the angel's-eye view of modern Nazareth, a slight ascent is required to your room at the St. Gabriel. This former monastery rises up on the Nebi Sa'in ridge over the Old Town, En-Nasra, today the largest Arab city in Israel. The tall church on the right marks the site of the Annunciation, where Mary learned from the archangel Gabriel that she would give birth to a son. The boyhood home of Jesus is well known to more than a billion faithful, although the town's reputation during New Testament times was dubious. The mere mention of it prompted Nathanael of Cana to declare, in John 1:46, "Can anything good come out of Nazareth?" The answer was yes. Two thousand years later, Nazareth is so popular a pilgrimage site that the city has banned traffic from the Old Town and embarked on an ambitious renovation to nearly quadruple hotel space. This time, they want all to find room at the inn. *March 1999*

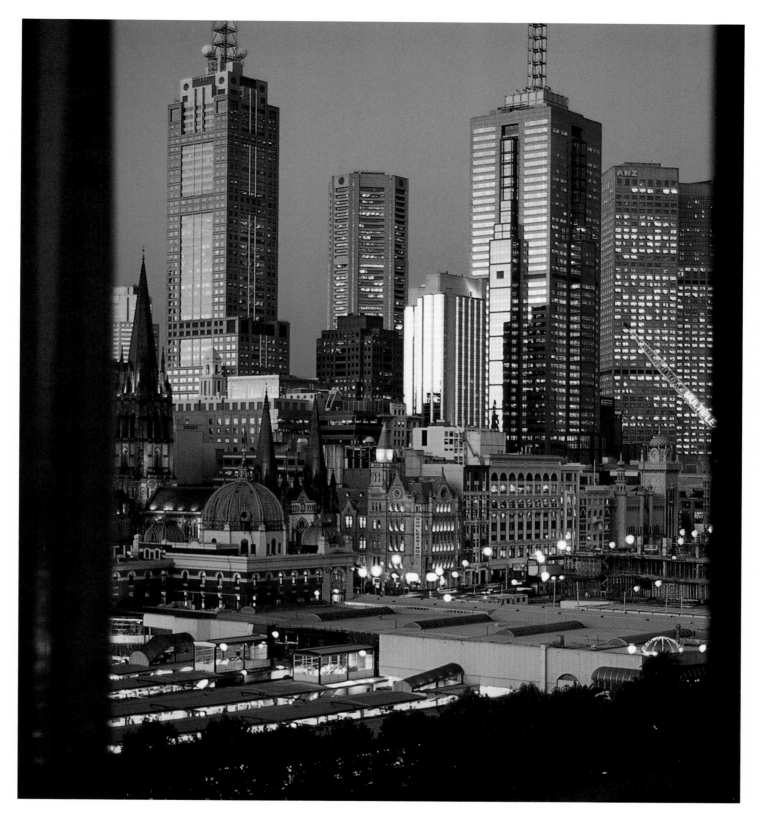

MELBOURNE, AUSTRALIA

Langham Melbourne, Room 1701

It was called "Marvellous Melbourne" after a nineteenth-century gold rush dramatically transformed this once-crude frontier town into the continent's most sophisticated city. Today, its Victorian heyday lives on architecturally, most notably in the dome-roofed Flinders Street Railway Station and the three-spired St. Paul's Cathedral, both in the foreground. More than a century later, Melbourne is again in a state of rapid change, rivaling even its popular neighbor to the northeast. The Langham Melbourne, centrally located in the formerly derelict but currently fashionable riverbank district of Southgate, opened in 1992. The construction crane edging into your view hints at the latest layer presently rising—and a new skyline in the making. *August 2000*

Bellagio, Suite 16-001

"Bright light city gonna set my soul, gonna set my soul on fire." Elvis wasn't kidding. This dry valley town has been setting souls afire since it sprang up in the early 1900s. With its legalized gambling, construction of the Hoover Dam just 34 miles away, and the Union Pacific Railroad, Las Vegas was largely insulated from the economic distress of the Great Depression. Although the current financial maelstrom has hit the city harder, to be fair, its runaway boom meant there was a lot more to hit. But there is an upside: This plush suite on the sixteenth floor of the famed Bellagio can be yours for a fraction of its 2006 cost. And the discount hasn't diminished its quality—after all, the fountains still sing every night, and Lady Luck can shine on any player. As Elvis sang, "All you need's a strong heart and a nerve of steel." *November 2009*

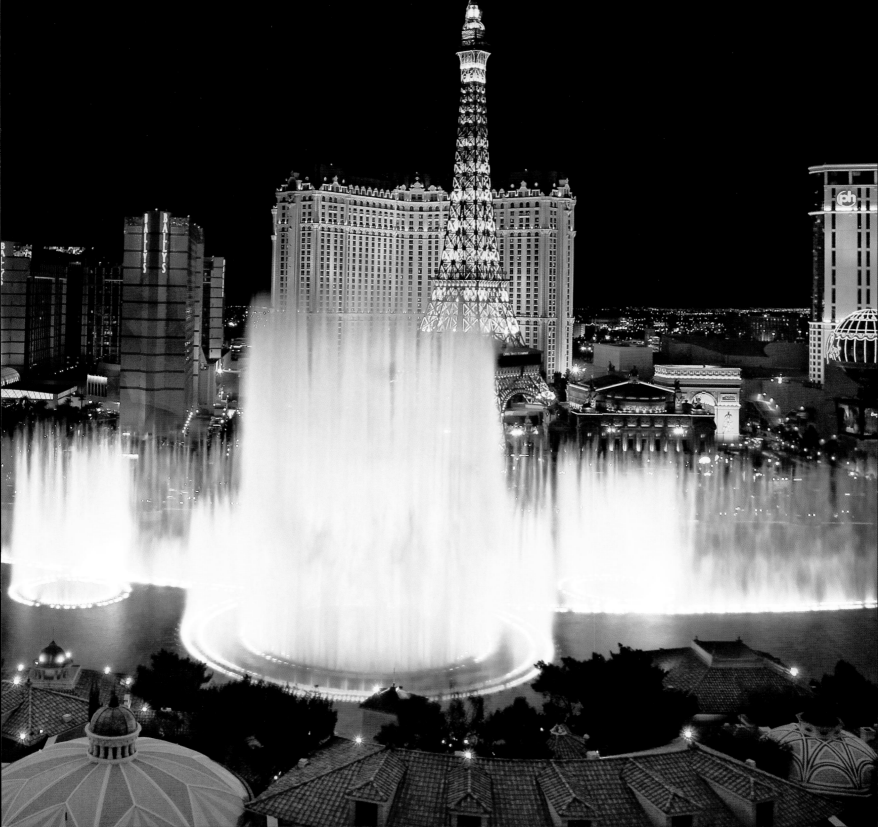

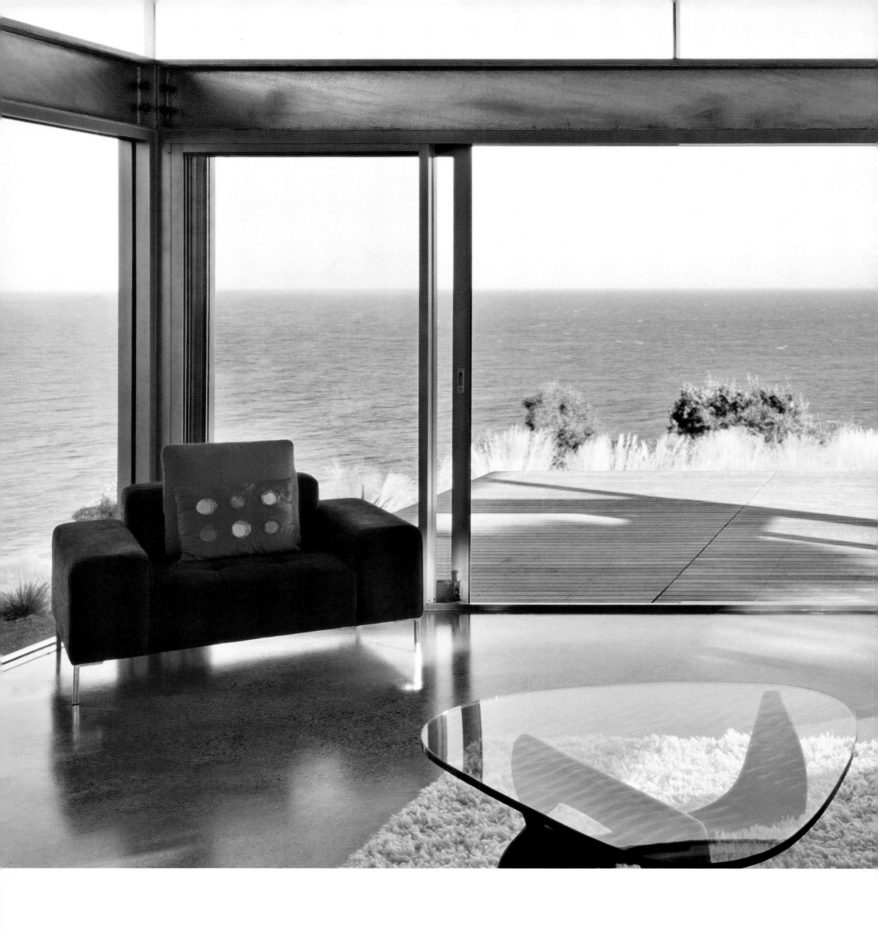

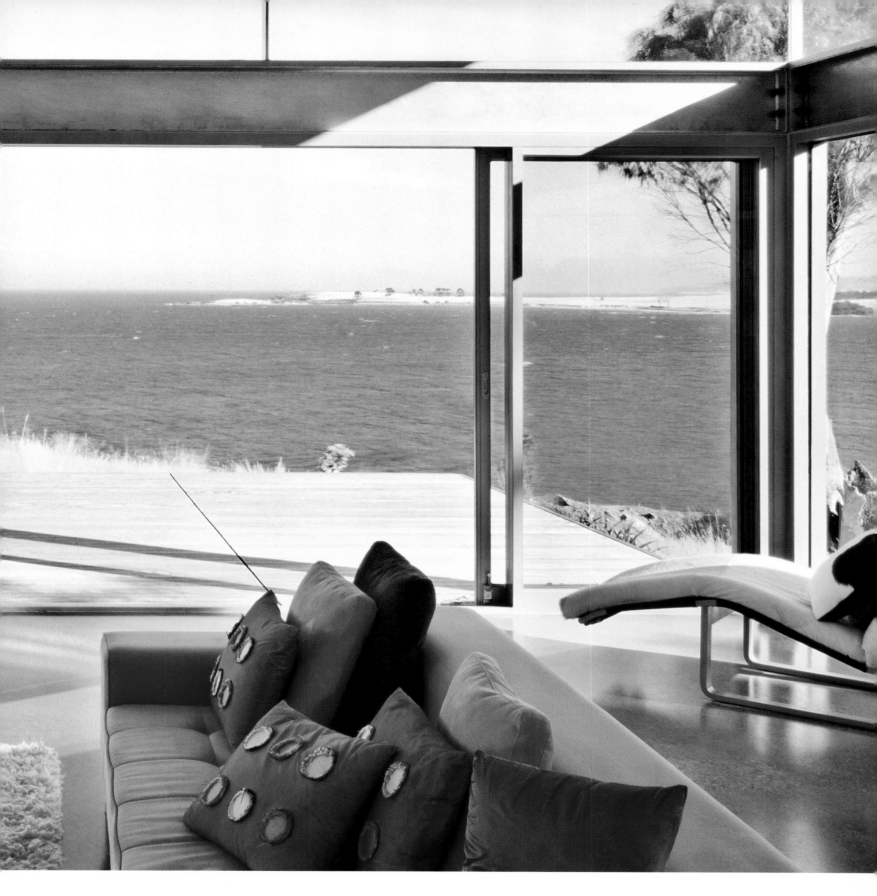

Avalon Coastal Retreat

This stylish aerie is not your grandfather's nature lodge. A studied composition in glass, timber, and steel that sits solo on a promontory on Tasmania's craggy east coast, the three-bedroom Avalon Coastal Retreat exploits its floor-to-ceiling windows, allowing the shifting colors of sky, sea, and shoreline to remain in full view. Here in the uncluttered lounge, the wide panes frame Great Oyster Bay and the sandy coastline of the Freycinet Peninsula (high-powered binoculars are provided). Seemingly incongruous in this raw wilderness—you might even meet a Tasmanian devil on the path to the secluded beach below—the sleek Avalon is more in tune with the environment than its high design might suggest. Like Philip Johnson's Glass House, it expertly plays second fiddle to the surroundings. *May 2006*

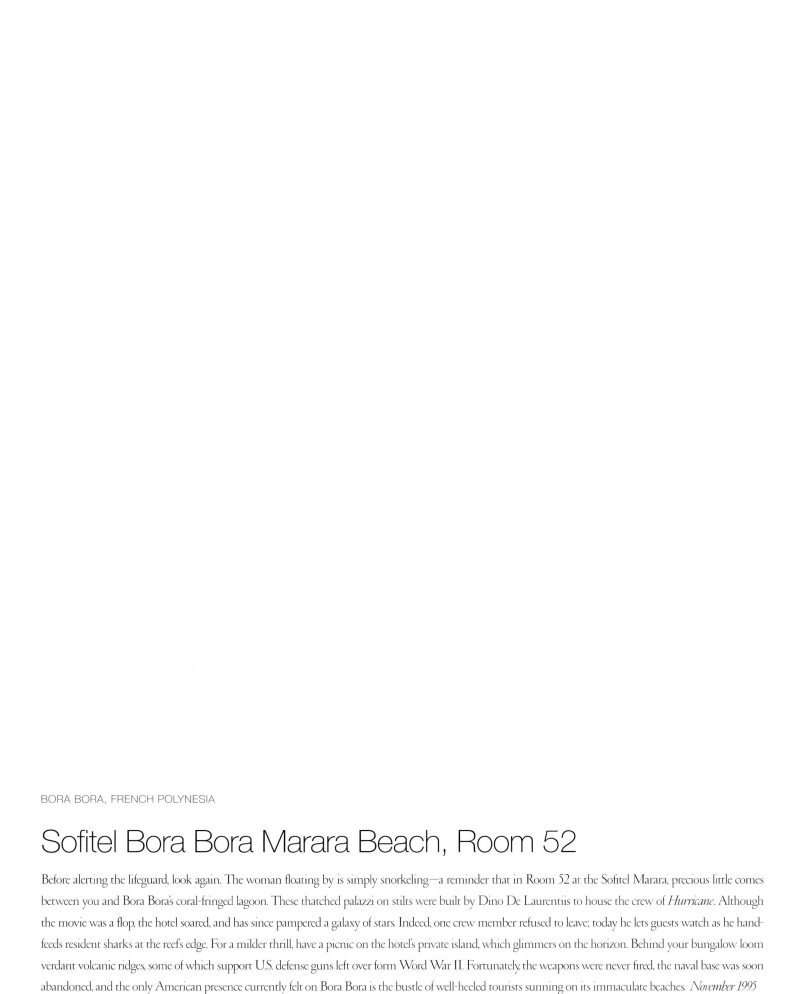

BORA BORA, FRENCH POLYNESIA

Sofitel Bora Bora Marara Beach, Room 52

Before alerting the lifeguard, look again. The woman floating by is simply snorkeling—a reminder that in Room 52 at the Sofitel Marara, precious little comes between you and Bora Bora's coral-fringed lagoon. These thatched palazzi on stilts were built by Dino De Laurentiis to house the crew of *Hurricane*. Although the movie was a flop, the hotel soared, and has since pampered a galaxy of stars. Indeed, one crew member refused to leave; today he lets guests watch as he hand-feeds resident sharks at the reef's edge. For a milder thrill, have a picnic on the hotel's private island, which glimmers on the horizon. Behind your bungalow loom verdant volcanic ridges, some of which support U.S. defense guns left over form Word War II. Fortunately, the weapons were never fired, the naval base was soon abandoned, and the only American presence currently felt on Bora Bora is the bustle of well-heeled tourists sunning on its immaculate beaches. *November 1995*

Hotel Los Juaninos, Room 216

As you stand at the window in Room 216 of Morelia's Hotel Los Juaninos, the first word that comes to mind might well be *divine*. In front of you are the decorative dual bell towers of the glorious cathedral (one of the country's most exquisite) that graces this colonial city midway between Mexico City and Guadalajara. The hotel itself, also an architectural gem, was built in the late seventeenth century as the home for the city's reigning bishop, but his residence there was short-lived: The faithful objected to having their offerings spent on the construction of an extravagant clerical home, and Church leaders, taking a page from the book of St. Francis of Assisi, finally succeeded in assuaging their congregation by turning the palace into a hospital in 1700. At the end of the nineteenth century, the building underwent another "conversion"—into a hotel. In this, its present incarnation, guests can experience services of a higher order. *February 2006*

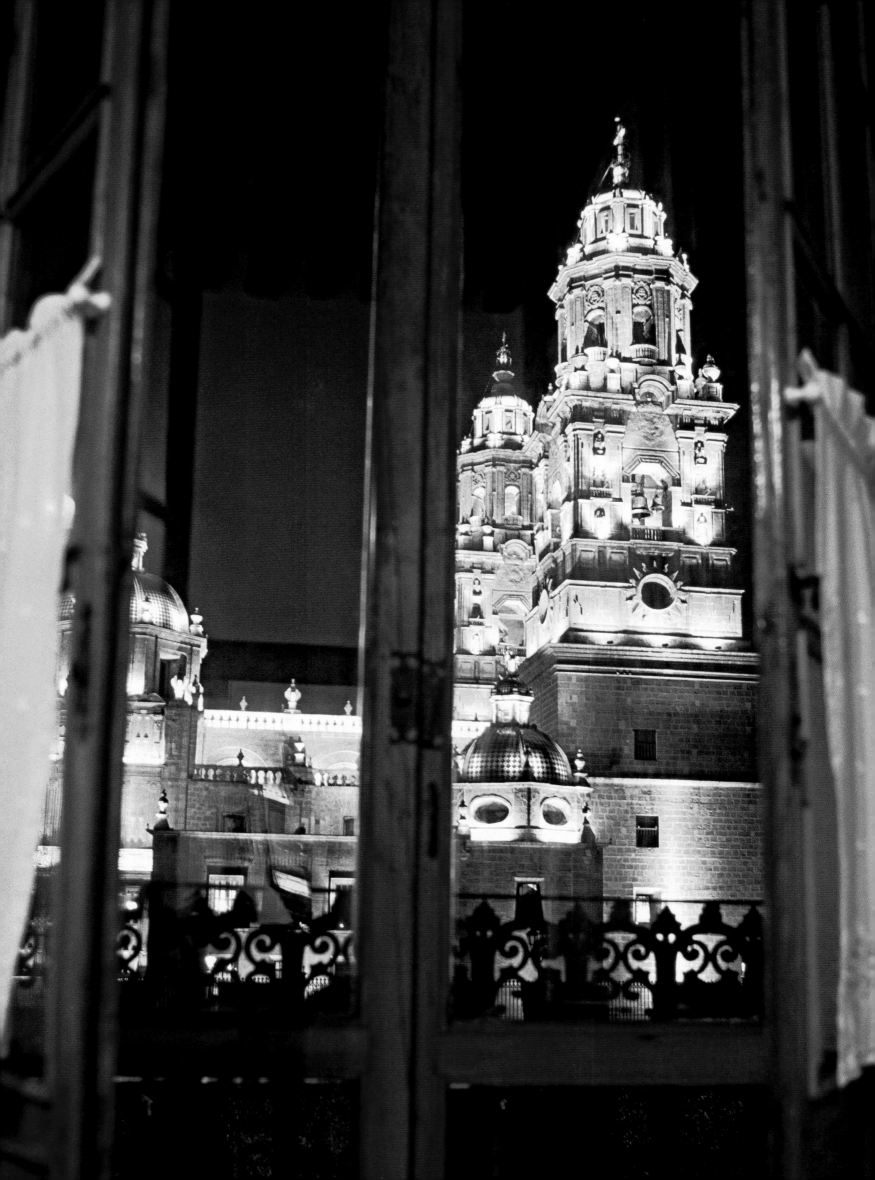

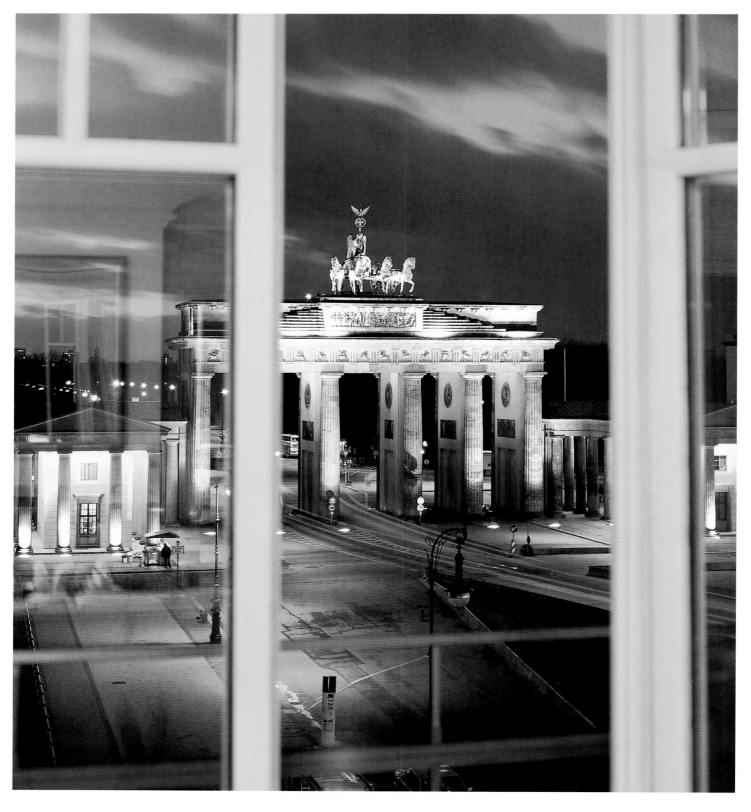

BERLIN, GERMANY

Hotel Adlon Kempinski, Room 312

You are in the restored capital of Germany, looking at a monument that has been a mirror of Berlin's history. The Brandenburg Gate, called the Gate of Peace when it was finished in 1791, was modeled after the Propylaea on the Acropolis—a nod to Athenian democracy—but was soon vandalized by Napoleon, who made off with its copper quadriga in 1806. Restored eight years later, it became the symbol of Prussia's victory. During the Cold War the gate sat in no-man's-land, walled off from the West in a divided city. Today, the gate represents a nation reunited, a heritage reclaimed—as does the Adlon, a turn-of-the-century classic that was demolished by the Soviets and rebuilt in 1997. *May 1999*

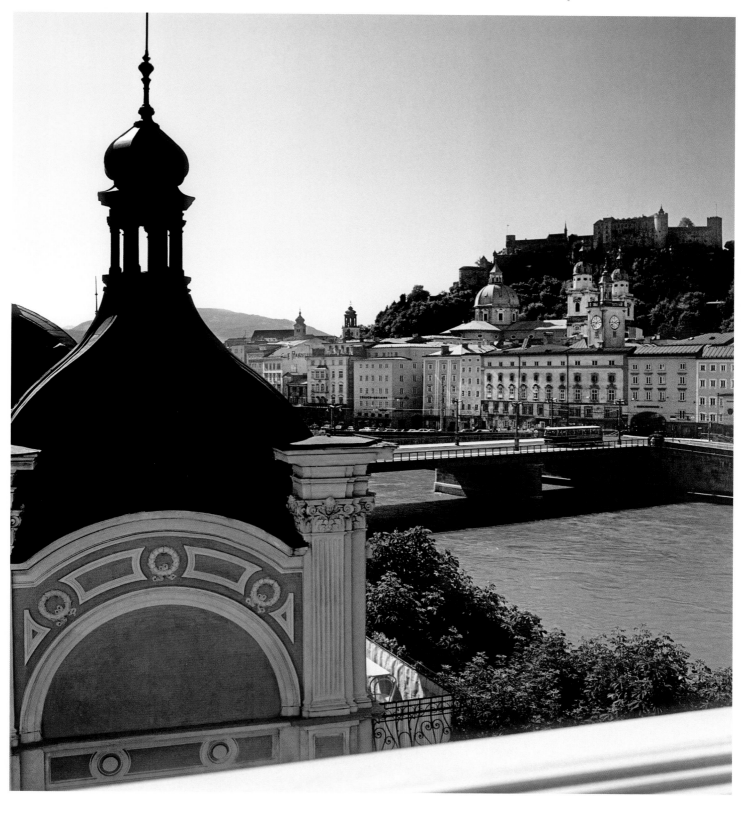

SALZBURG, AUSTRIA

Hotel Sacher Salzburg, Room 328

If Mozart came back to the future and woke up in Room 328 of the Sacher Salzburg, the view of his hometown would be pretty familiar. On the far side of the river Salzach, he'd recognize, on the top of the hill, the Hohensalzburg fortress, which was completed in the 1680s, as well as the Residenz, to its left, which dates from 1120. The small onion dome crowns the Nonnberg Convent, whose first abbess, Erentrudis, was installed in 700. It has grown a bit in the 1,300 years since then and is now home to 38 nuns. The Hotel Sacher Salzburg, built at the start of the Austro-Hungarian Empire, presides regally over the west bank of the river. During the last war she was hostess to the German Foreign Office and then, after 1945, to the U.S. occupying forces. Buffalo Bill and Lauren Bacall—discerning travelers both—have stopped by, as did Adolf Hitler, en route to Berchtesgaden. *October 1989*

Mandarin Oriental Kuala Lumpur, Room 3019

With such giant next-door neighbors as these, you can't help but feel knee-high, even from the top of the cushy, 30-story Mandarin Oriental Kuala Lumpur. The iconic Petronas Towers, at a dizzying 1,483 feet, stood as the tallest buildings in the world when they were completed in 1998—their reign ended in October 2003 when Taiwan's new Taipei 101 officially topped out at 1,667 feet. Kuala Lumpur's famous double spires mimic the minarets found throughout this bustling metropolis of nearly two million, a fusion of Malays, Chinese, Indians, and Europeans. That's quite a shift for a city that a century and a half ago was a fledgling mining community, situated at the confluence of the Klang and Gombak rivers (Kuala Lumpur, in the Malay language, means "Muddy Rivermouth"). Though their vertical majesty has been relegated to second place, the graceful twin skyscrapers still measure up as a sight to behold. *April 2004*

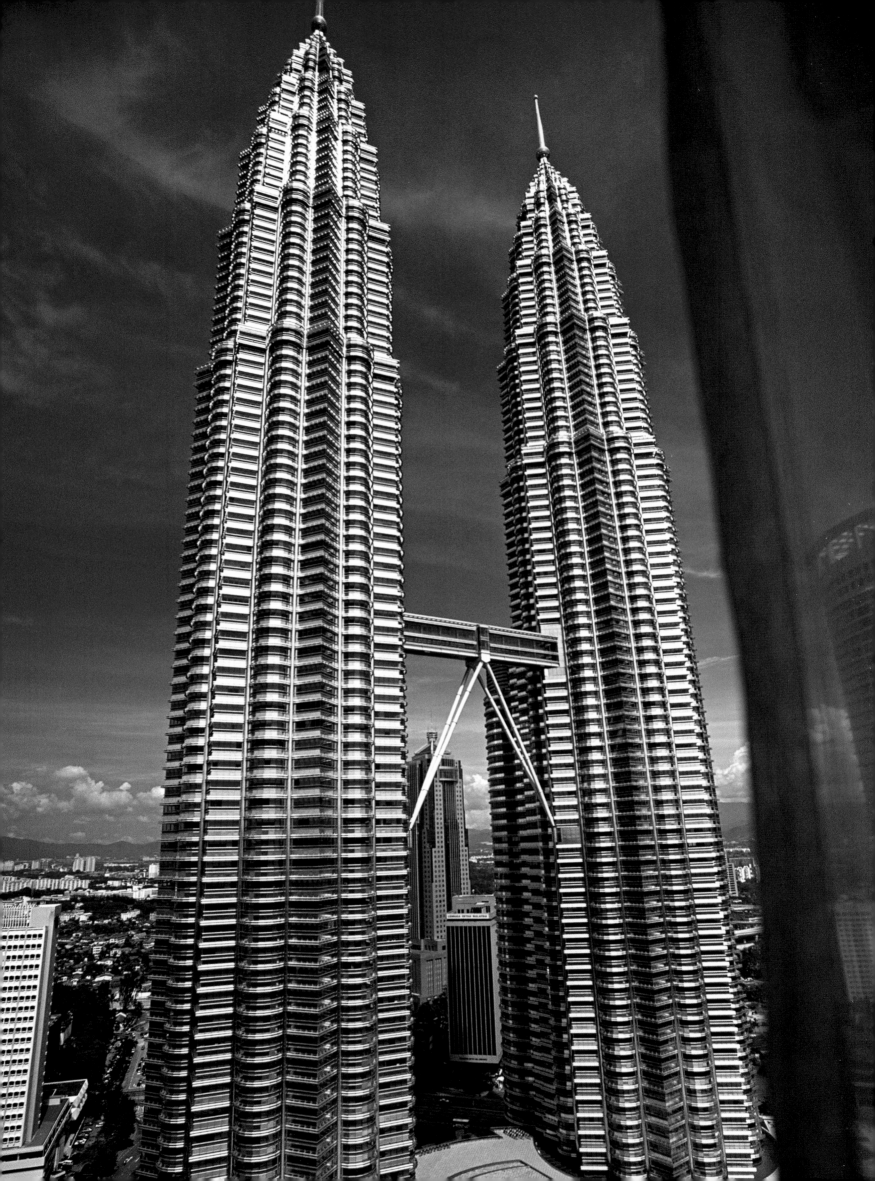

Simpson's Num-Ti-Jah Lodge, Room 24

Movie buffs might think they were in one of those Nelson Eddy backdrops from a forties Rocky Mountain romance. They are. Num-Ti-Jah Lodge was built, virtually by hand, in 1939 on the site of an old pioneer campground at mile 22 on the Icefields Parkway, which runs from Lake Louise to Jasper in the Canadian Rockies. It's so definitive of the log cabin genre that Hollywood couldn't improve on it. The lounge has chairs and tables fashioned from deer antlers and couches covered with bearskins. In addition to Eddy, Alan Ladd and Burl Ives slept here while making movies. Room 24 looks over Bow Lake, and above the timberline is Crowfoot Glacier and the Waputik Icefields, which straddle the Great Divide. Num-Ti-Jah is Stoney Indian for "pine marten," one of the abundant species of wildlife around the lodge. *January 1990*

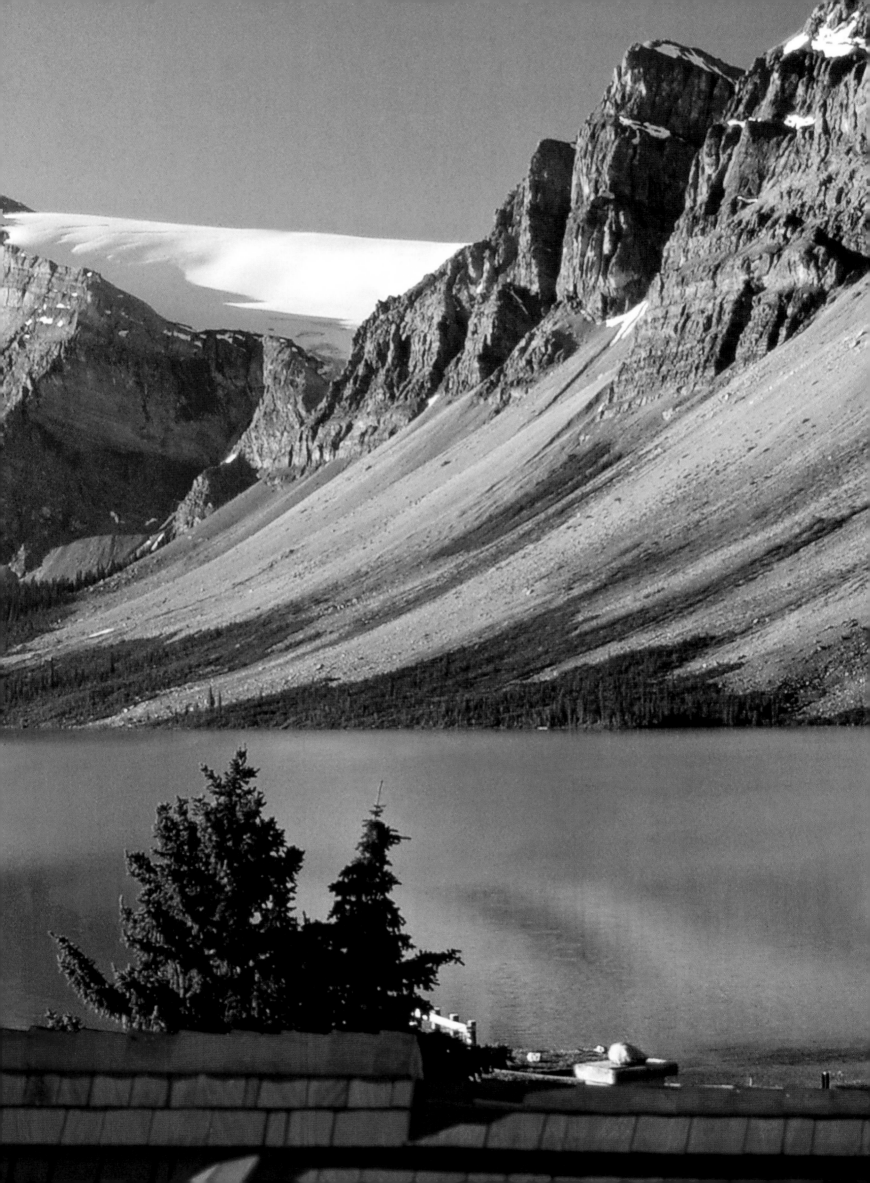

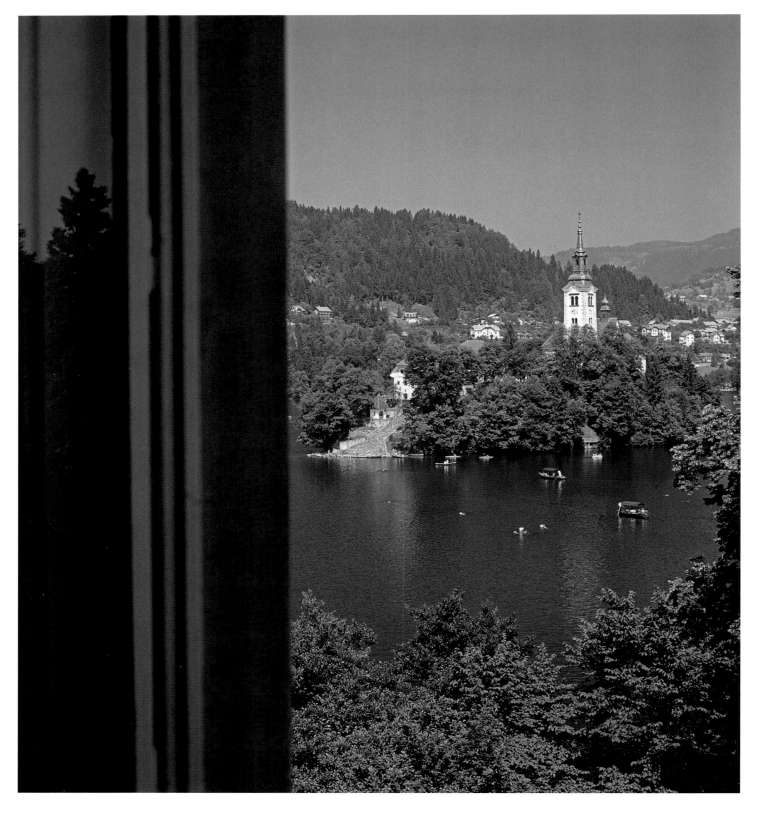

Vila Bled Hotel, Room 315

This is a royal or a revolutionary view, according to your mood: Tito, Nasser, Sukarno, and Nkrumah, as well as Hussein and Haile Selassie, have all stayed here and gazed at the Church of Santa Maria on the island in Lake Bled. Perhaps they made a wish when the church bells rang, since the legend is that these wishes come true. If it's inconvenient to wait for the bells, you can take a gondola across and ring them yourself. Bled is a spa town in the northwestern corner of Slovenia, and the hotel was once the summer palace of a Yugoslav royal dynasty. It has 31 rooms and suites, a private beach and boathouse, and it is near the fortified Castle of Bled, which also has great views from its high cliff perch. *May 1989*

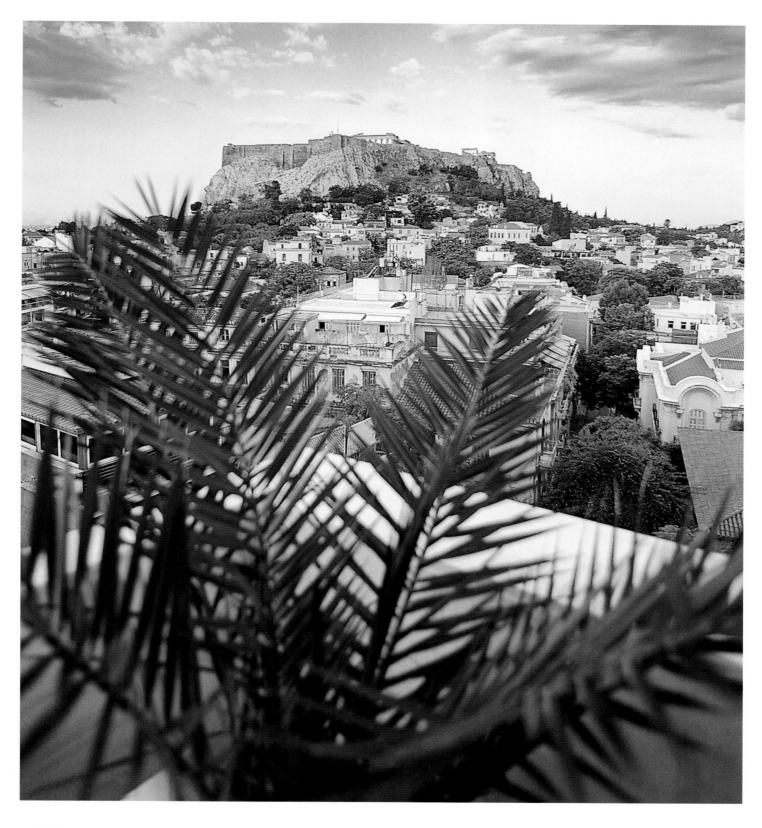

ATHENS, GREECE

Electra Palace Hotel, Room 709

Morning becomes the Electra Palace Hotel. The *nefos*, that noxious cloud, no longer hangs heavy over Athens, so you gaze clear back to the Big Bang of Western Civilization—the Acropolis. The columns smack in the middle belong to Athena's "virgin apartments," better known as the Parthenon. Its complement, the Erechtheíon, presents six caryatids so majestic that you may not notice they're reproductions. Below the limestone, remnants of past glories are scattered in the newly gentrified Anafiótika. You're staying in another ancient village, Pláka, whose labyrinthine alleys and ornamental facades now house tavernas, nightclubs, and trinket shops—a tourist zone. The source of democracy is not just for its citizens anymore. "All good things flow into the city," said Pericles. Consider it a welcome. *April 1998*

Fairmont Empress Resort Hotel, Room 468

Sex, scandal, and murder by mallet. Before he was done in while dozing under a Dorset sun, British architect Francis Rattenbury had given the city of Victoria its imperial line with the Empress Hotel and the spangled Parliament Buildings that face it. The murderer was the architect's own chauffeur—who also happened to be the lover of his second wife—and the notorious murder trial inspired Terence Rattigan's last play, *Cause Célèbre*. As for poor old Rattenbury, he went back home to England, but only after he'd lived the high life on the Canadian frontier, making a fortune in the Klondike and leaving behind a series of grand buildings around British Columbia—none finer than this regal duo on Victoria Harbour. The peaked and gabled Empress has been a popular figure since her opening in 1908, attended by a steady parade of visitors hoping to take the famous afternoon tea—or a spot of bootleg brandy, as in Churchill's case. *December 1996*

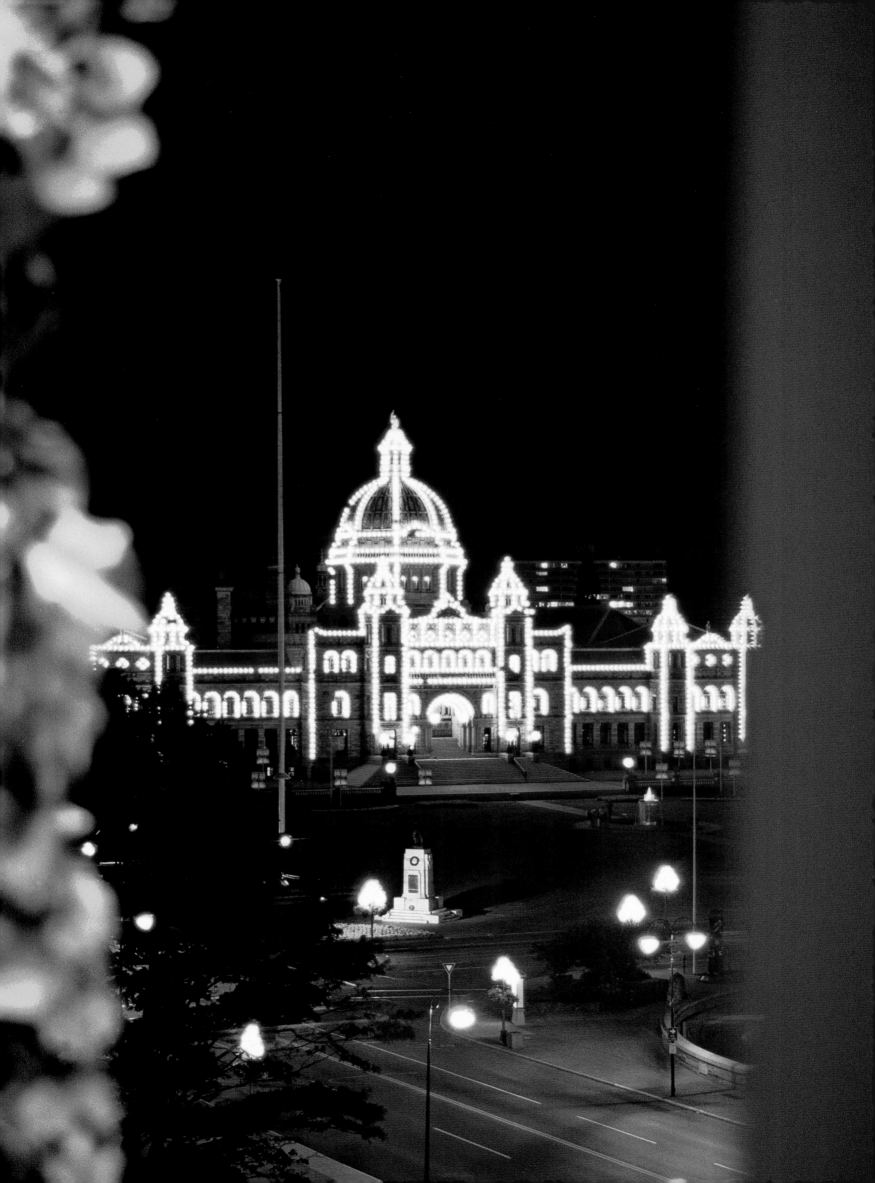

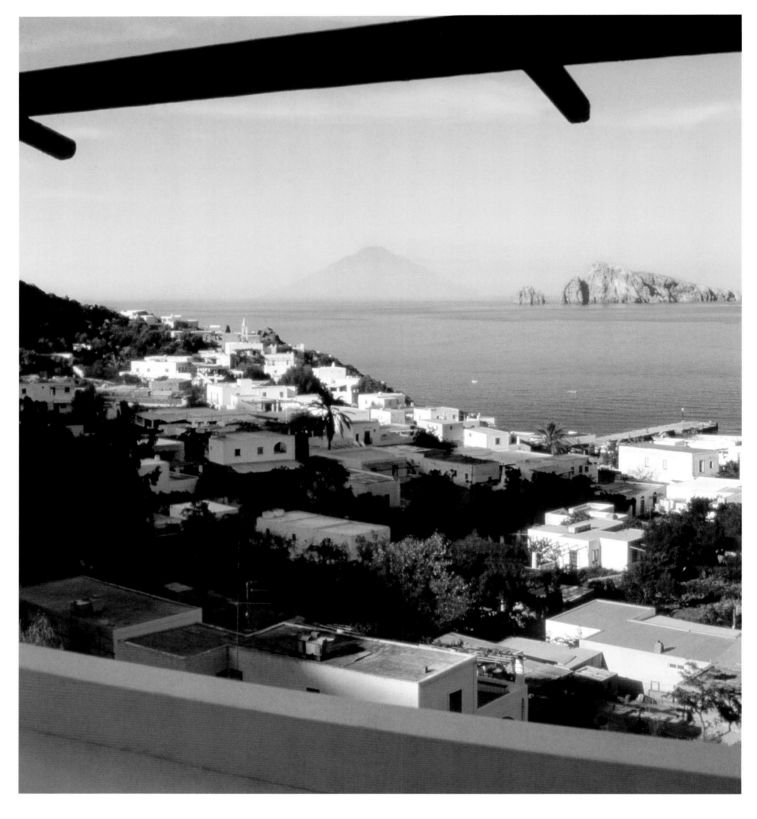

PANAREA, ITALY

Hotel Raya, Room 39

Arrive in Panarea by boat—which also happens to be the only way to get there—and you land within whistling distance of the Hotel Raya's front desk. Let them know ahead of time, and you and your bags will be wafted from the harbor to Room 39, with its view of the still-rumbling volcanic island of Stromboli, before you can say *ciao, bella*. There are only 170 year-round residents on the island, and they have (so far) resisted any temptation to build an airport. Also, they have had the good sense to ban all visitors' cars from their Edenic shores. Travelers who venture here tend toward class, not glitz, and there is a distinct lack of interest in *la bella figura*. Most self-respecting paparazzi have long ago given up on the place—who needs that five-hour hydrofoil trip from Naples?—which, of course, makes Panarea all the more alluring for their erstwhile subjects...and for you too. *July 1991*

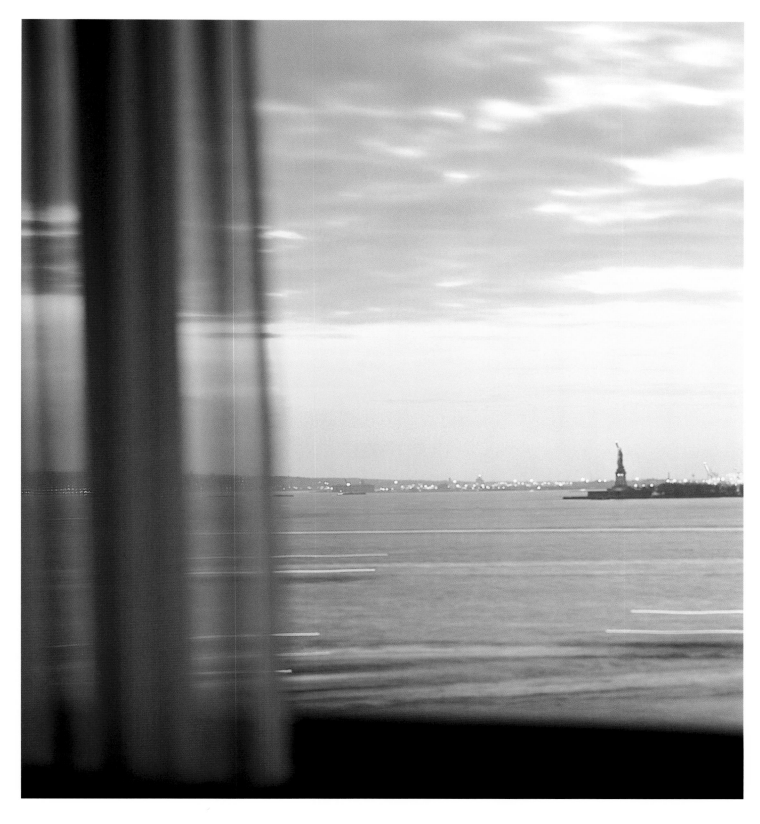

NEW YORK, NEW YORK, USA

Ritz-Carlton New York, Battery Park, Room 817

The Statue of Liberty and her extended torch, the spiritual cynosure of the United States for well over a century, are closer than you think. Greater magnification can be had by looking through the high-powered telescope in your suite or by crossing the Hudson River to Liberty Island by ferry service. In a typical year, four million visitors climb her steely frame, the hardier ones ascending all 354 curving steps to the crown. The southern tip of Manhattan, which has been undergoing a revitalization for the past decade, is starting to pick up where it left off. This Ritz-Carlton, two blocks from Ground Zero, is another sign of renewal in the city—fitting, since Lady Liberty stands for, among other things, the promise of a new life. *March 2002*

Patatran Village, Dahlia Room

"A thousand miles from anywhere," the tourist slogan will tell you, which is why La Digue, a three-mile-long, two-mile-wide speck of an island, is likely to be on the wish list of every paradise-seeker. Edged by dramatic beaches, backed by thick foliage, and ringed by coral-rich waters, it's one of 115 islands in the Indian Ocean that make up the young archipelago nation of Seychelles. Its remote geography, as well as strict development law (no buildings taller than a palm tree), have left the Seychelles' natural beauty blessedly intact. Here on La Digue, oxcarts and bicycles are still the preferred means of transport. Seen from your veranda on its northern tip is one of many powdery white sand beaches punctuated by smooth gray boulders—a combination that makes it perhaps the world's most photographed island. *July 2000*

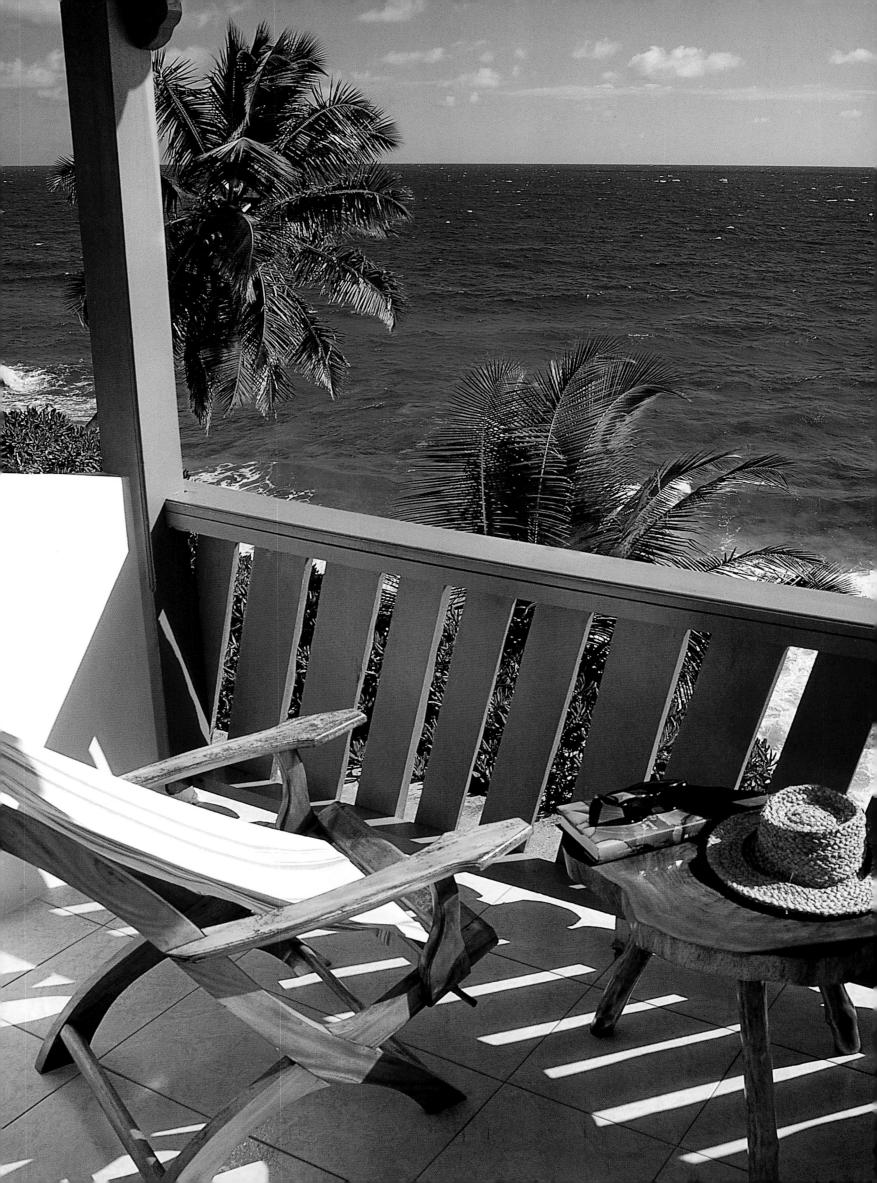

Casa de Sierra Nevada, Room 354

We can't promise the precise shade of the blooming jacaranda tree will remain the same, but the cathedral's pseudo-Gothic facade and tower have been here for nearly a hundred years, designed and built by a self-taught Indian mason who began work in 1880. He is said to have been inspired by postcards of European cathedrals and to have sketched his plans with a stick in the sand. The hotel, built around 1800, has 37 suites in four colonial mansions, surrounded by patios and gardens, with a fireplace in most rooms. It's in the center of a small picturesque town of writers and artists. *March 1989*

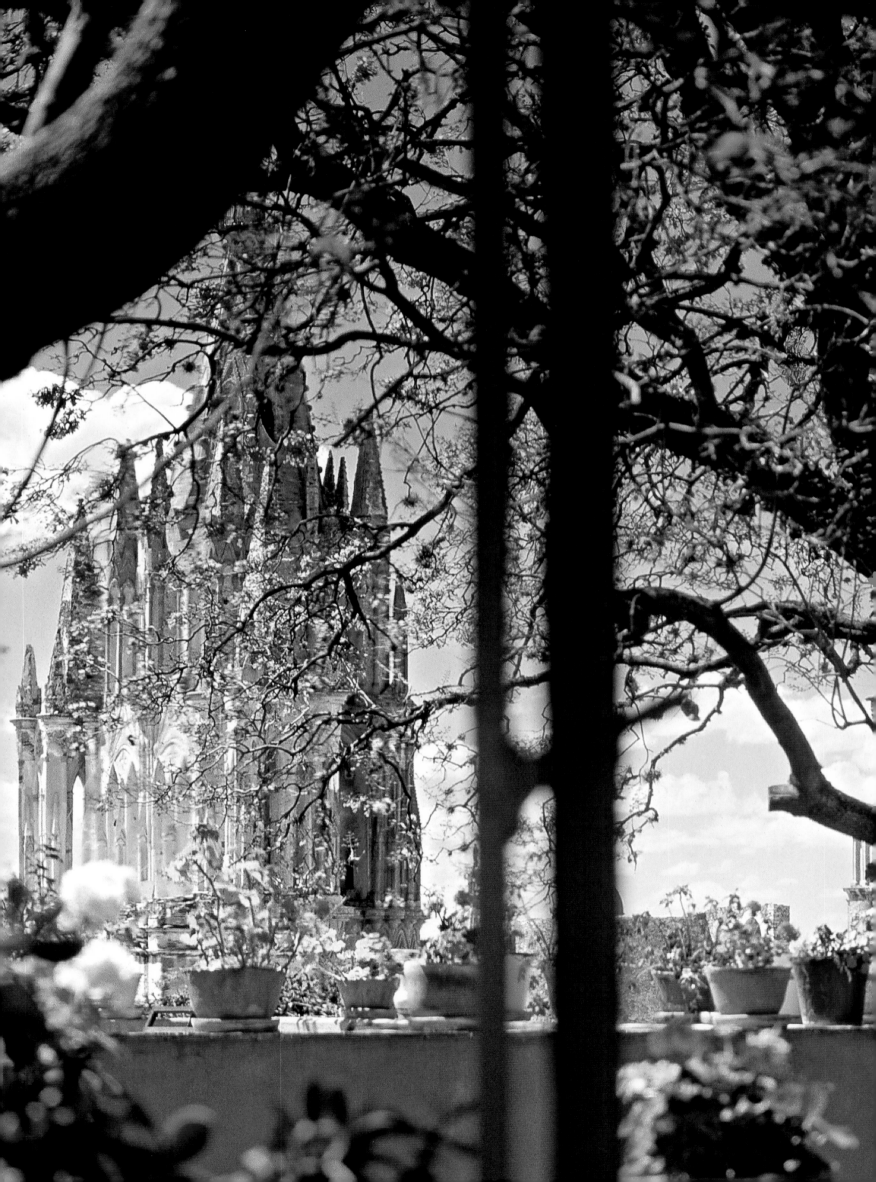

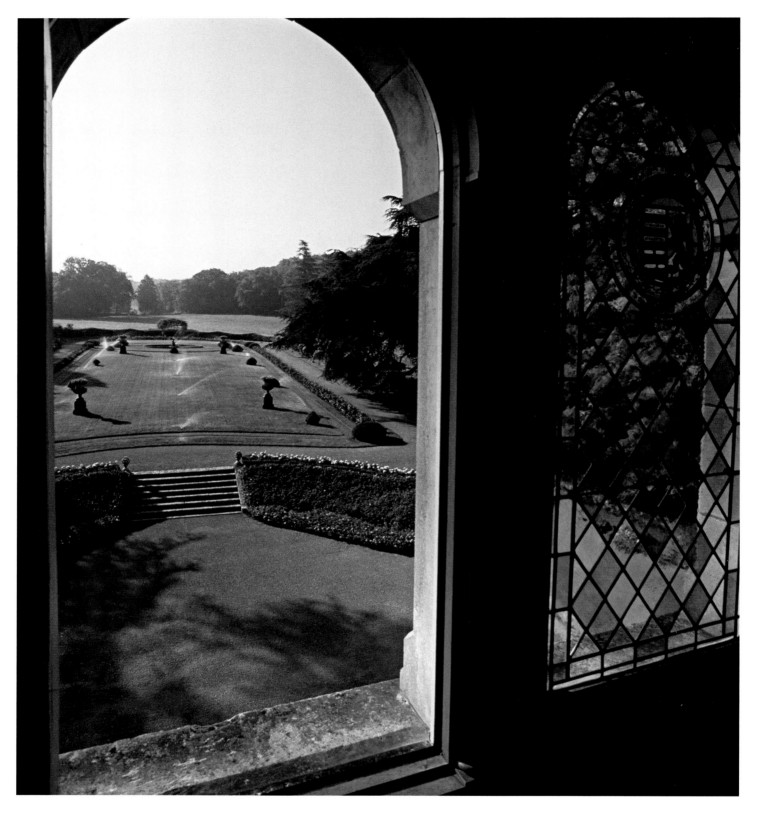

SOUILLAC, FRANCE

Château de la Treyne, Chambre Soleil Levant

All France is on holiday this month, but you've found seclusion. This stately garden belongs to the Château de la Treyne, which has reigned over its craggy limestone cliff above the Dordogne River for 500 years. You are poised above a graceful curve of the river in the Périgord, domain of truffles, fatted geese, and Monbazillac wine; of Euro-yuppies landed in regentrified grandeur; and of armies of visitors day-tripping around the Circuit des Bastides, storming anew the fortified towns erected during the Hundred Years' War. Between sieges, when your spirits and your liver need a break, you can seek peace in your room, the Chambre Soleil Levant, whose name reflects its Sun King decor of golds and yellows, and whose stained-glass windows hint at the private Romanesque chapel it once was. *August 1998*

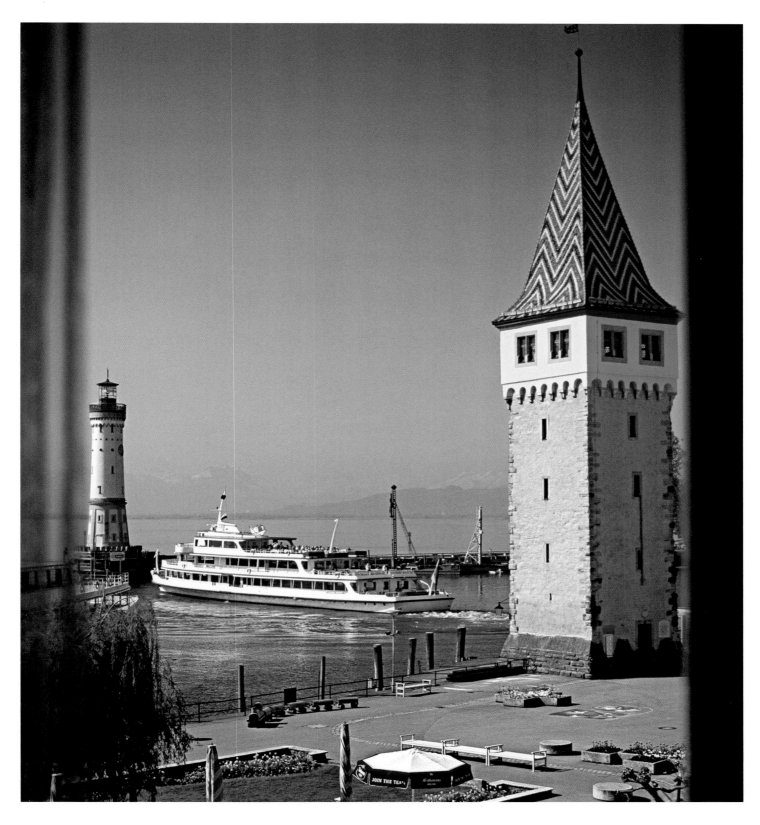

LINDAU IM BODENSEE, GERMANY

Lindauer Hof, Room 208

Jutting into the Bodensee, the small town of Lindau occupies a scenic spot that for centuries has been a beacon to passersby. With the surrounding lake creating a natural buffer, little Lindau first caught the eye of some Benedictine monks seeking sanctum and later of traders seeking profit. The old lighthouse, on the right, was erected in the thirteenth century to safely bring to port ships arriving from Italy. For nearly 200 years, Lindau also served as the terminus of an important courier route to Milan that helped sustain the town's success as a bustling market center. Well traveled by carriages, the route evolved to shuttle not only cargo but passengers, among them Johann Wolfgang von Goethe, returning home from his soon-to-be famous Italian journey. Today, it's holidaymakers who come, arriving by causeway from the Bavarian mainland, and by water, now greeted by the newer lighthouse, on the left. *April 2001*

Zeavola, Suite 51

From your petal-strewn bed, gaze out at the beach and inhale the scent of Zeavola's fragrant scaevolas (*Scaevola taccada*), a flowering shrub that gives this southern Thailand resort its name. The architecture of your expansive teakwood villa was inspired by the dwellings in a rural village, but the allusion, and the illusion, end there: Amenities include hand-painted murals, private gardens, outdoor rain showers, 24-hour room service, and a speedboat to whisk you to this ten-acre resort. Zeavola brings luxe to Koh Phi Phi Don, which had been dominated by backpacker shacks prior to the devastating 2004 tsunami. But the recovery of the island is well under way, as the resort testifies. Come evening, you'll walk a few steps from your villa to a candlelit dinner on Laem Thong Beach, serenaded by the murmur of the Andaman Sea. *July 2006*

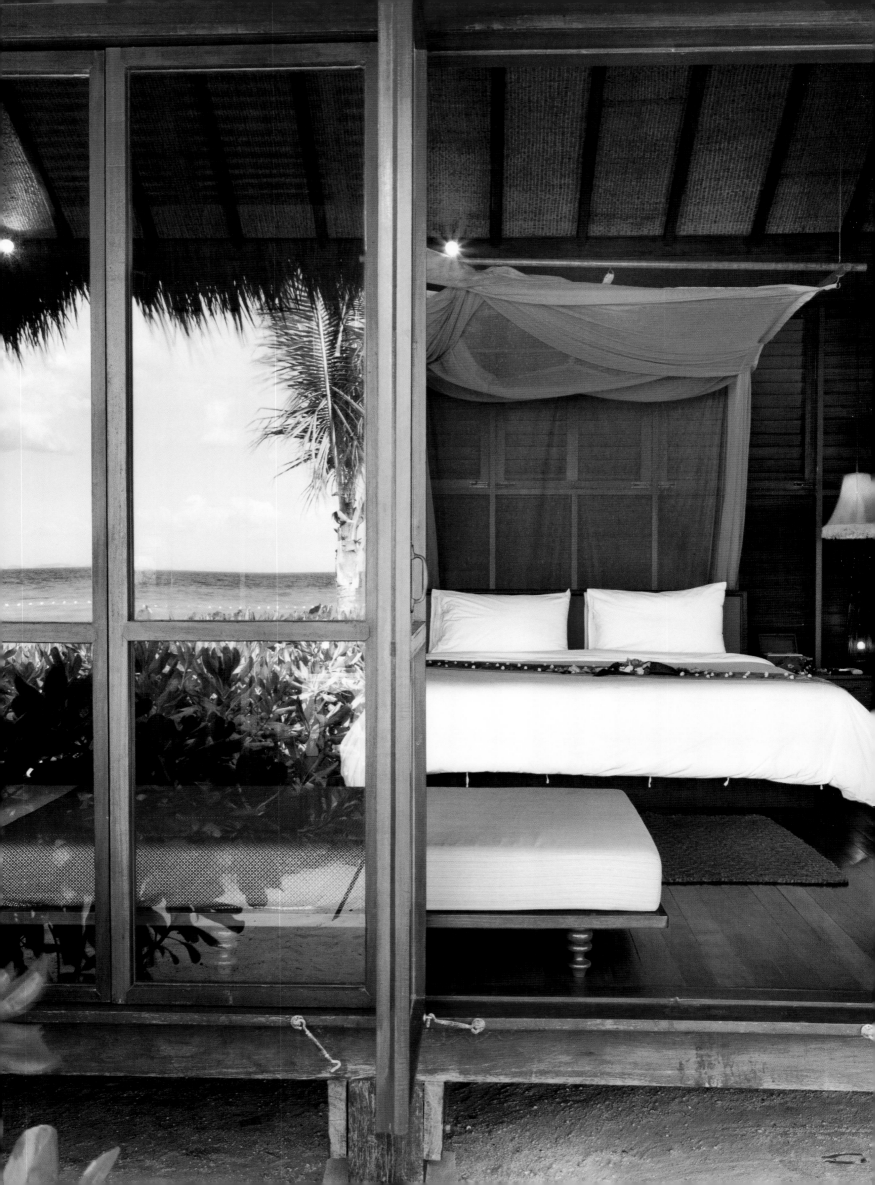

Luna Lodge, Bungalow 1

Early risers will awaken to the symphony of some 400 bird species emanating from the leafy canopy below. Like them, your bungalow has an expansive, bird's-eye view of Corcovado National Park, whose lush rain forest ranks as one of the most biologically diverse places on earth. The park is a protected home to a veritable encyclopedia of flora and fauna, among them 6,000 kinds of insects and one-quarter of all the tree species in Costa Rica—and that's only what has been recorded thus far. After Corcovado was established in 1975, a gold rush resulted in damage to the forest and loss of the wildlife residing in it; ten years later, mining was prohibited. Today, on one of Luna Lodge's guided tours, you can pan for gold in streams along the old trails that cross the peninsula—but the payoff from the trek will more likely be experiential than economic. *January 2001*

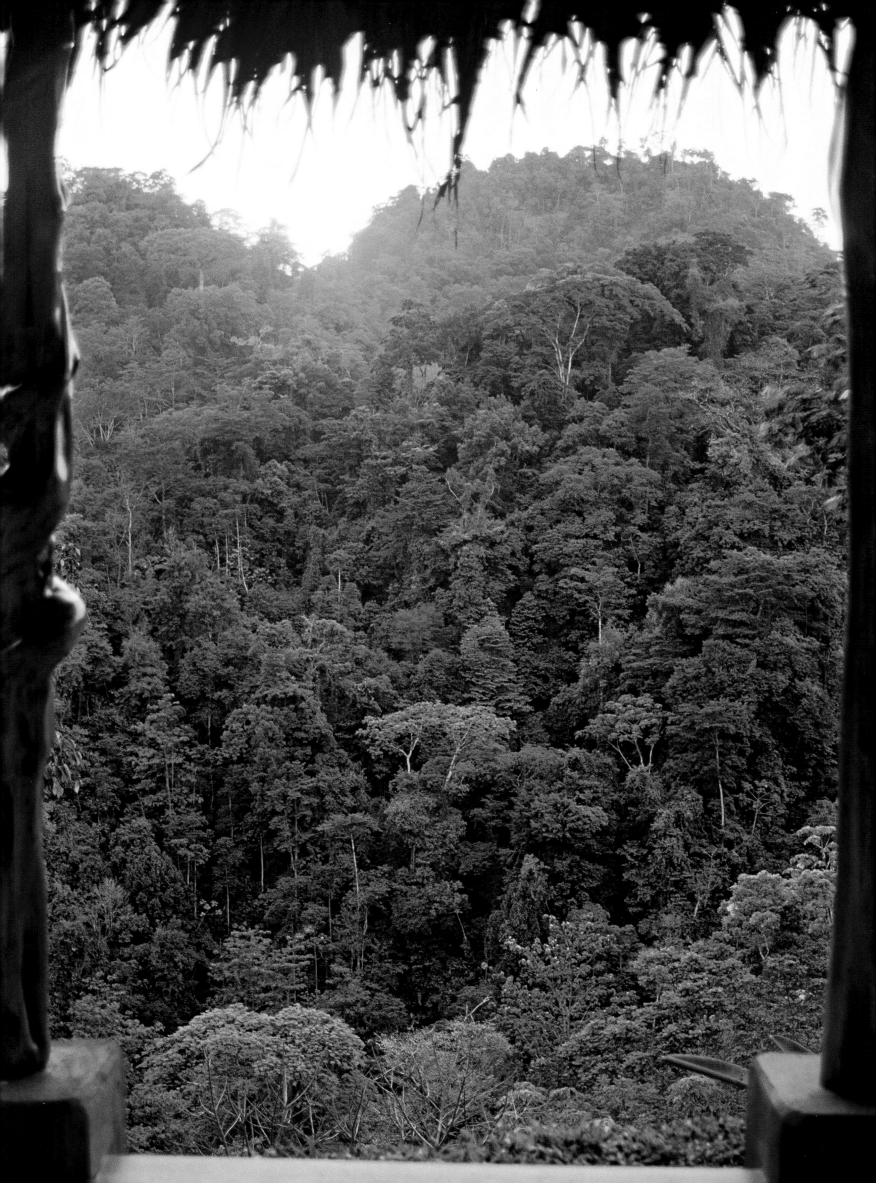

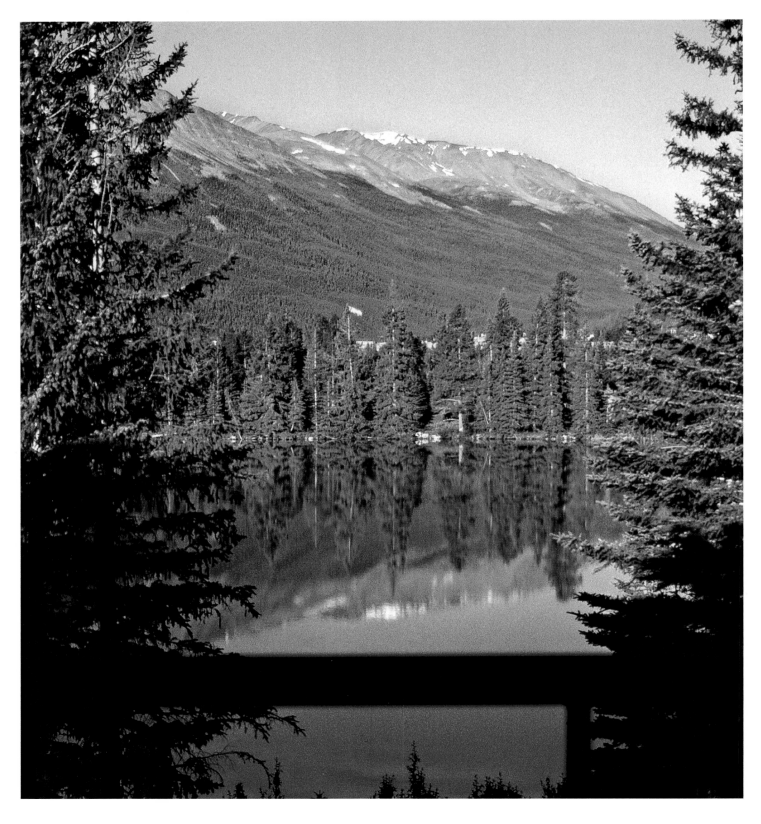

JASPER, ALBERTA, CANADA

Fairmont Jasper Park Lodge, Suite 523

When the Grand Trunk Pacific Railway first started crossing Canada in 1886, some adventurous passengers thought it might be fun to actually get off the train and have a look at all that wilderness up close. And so, about 30 years later, Tent City was built on the banks of Lac Beauvert in Jasper, Alberta: ten tents and a marquee for meals. So popular was this strange new idea of communing with nature that the tents were soon followed by log cabins, and the rest, as they say, is *l'histoire*. The wilderness was kept pristine by the creation of Jasper National Park in 1907, and the lodge was kept booming by a regular influx of movie stars during the forties and fifties. Suite 523 has a private terrace and fireplace and sleeps up to six cozily under goose-down duvets. Just be grateful, as you gaze across this icy mirror, that you were lucky enough to miss out on Tent City. *April 1991*

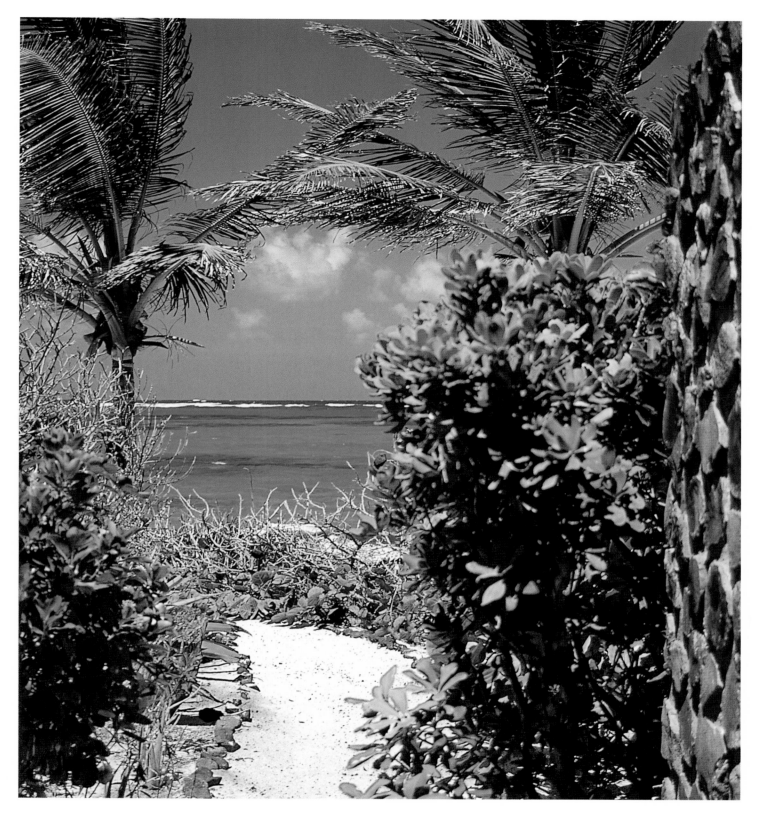

PETIT ST. VINCENT, ST. VINCENT AND THE GRENADINES

Petit St. Vincent Resort, Cottage 12

Even with your door wide open, words like *seclusion* jump to mind on this tiny island resort. You are face-to-face with windward breezes and a coral-filled sea. Only a few dozen guests populate these 113 acres, whose name reveals a further glimpse into the island's history. There is, of course, its relative proximity to the larger island and its namesake, believed by some to have been named by Columbus himself after sighting it on January 22, 1498—St. Vincent's Day. The diminutive *petit* recalls the French influence, still found in the local patois. But you won't have to worry at all about the language—or dialogue, for that matter. Here, on the southern end of the Grenadines, the absence of telephones means an even simpler form of communication: hoisting a yellow flag for service and a red one for privacy. It's the only showing of colors you're likely to engage in. *January 1999*

Rosewood Little Dix Bay, Room 122

Perhaps he'd been at sea too long, but Columbus saw a supine, full-figured female in the undulating hills around this island, an image that inspired the name Virgin Gorda ("fat virgin"). Nearly 500 years later another man of the world, Laurance Rockefeller, was also inspired. He bought 265 acres of the then agricultural island and later donated the land to form Gorda Peak National Park—an early step toward the preservation of this well-visited island. In 1964, Rockefeller also built Little Dix, the island's first resort, around his "wilderness beach." Your terrace overlooks the half-mile crescent and faces the still-voluptuous profile of Columbus's corpulent virgin. *July 1999*

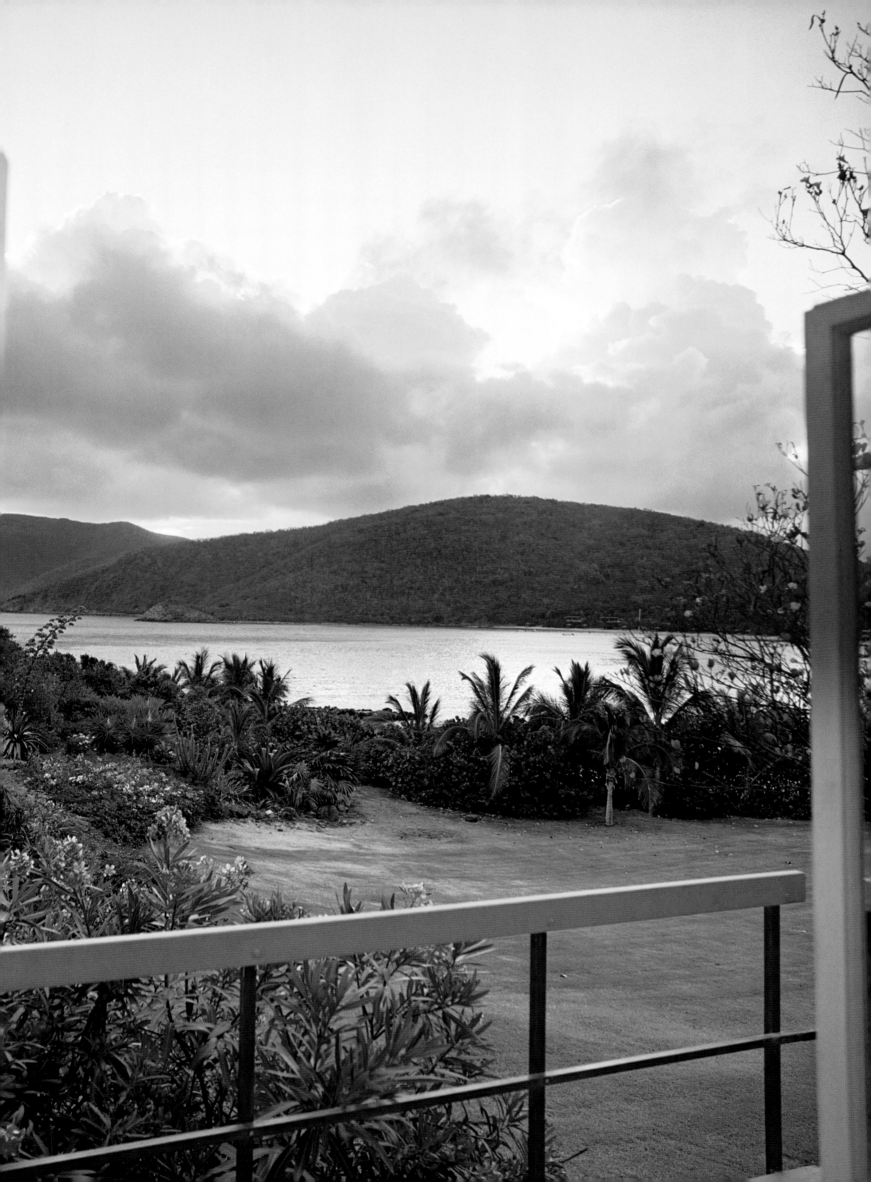

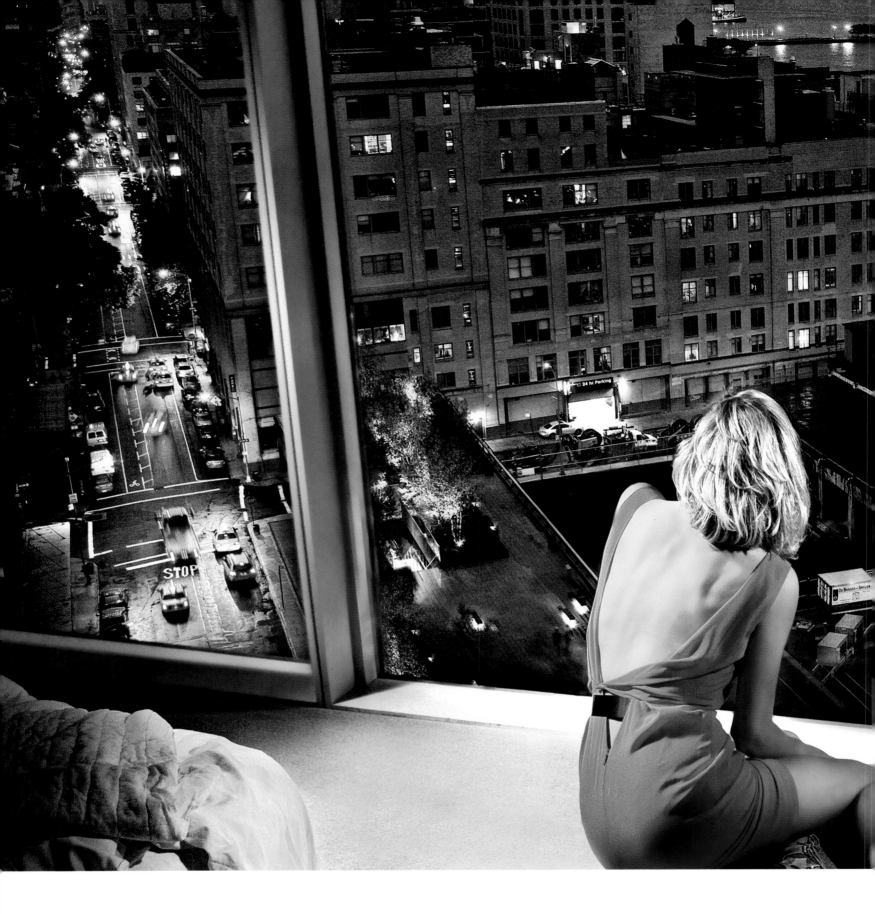

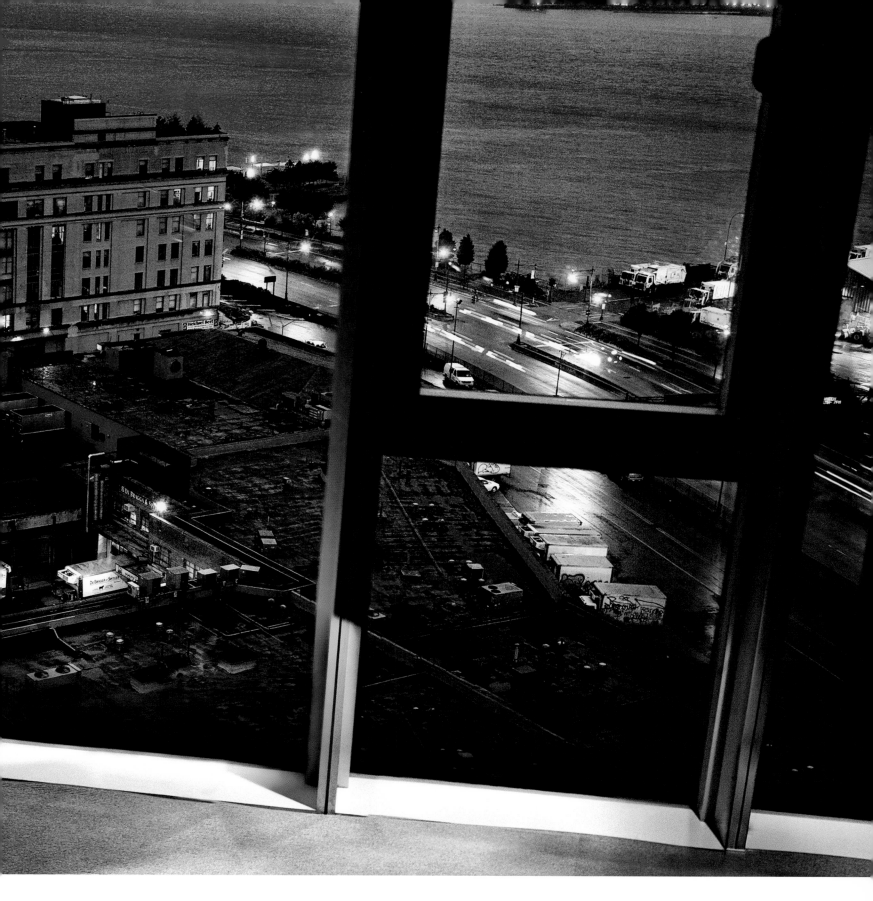

NEW YORK, NEW YORK, USA

The Standard New York, Room 1211

Urban sprawl meets historic preservation—tough to imagine, but the views don't lie. That stretch of green at the left corner of your window is the High Line, a 1.5-mile elevated track built in the 1930s to lift dangerous freight trains off Manhattan's streets. Now a lushly landscaped public park dotted with native plants and LED lighting, it's a paradigm of equilibrium between conservation and design. More than 700 contenders vied for the chance to re-create the structure, but few could have envisioned an 18-story hotel literally straddling the park. Needless to say, your room's mid-century Jetsons-on-a-cruise-ship decor is no accident. Echoing the High Line, the hotel feels like a throwback, a modernized version of a bygone era. Even those non-reflective windows (which have invited more than their fair share of exhibitionism) hark back to a time when the Meatpacking District was less trendy and more seedy. Talk about a fine balance. *September 2009*

Bangaram Island Resort, Room 117-118

Although you'll catch glimpses of snorkelers bobbing in the cyan lagoon outside your bungalow's living room, crowds are never an issue here in the Lakshadweep archipelago, 200 miles off the coast of Kerala and, at a collective 12 square miles, India's smallest union territory. Despite its ambitious name (it means "one hundred thousand islands" in Malayalam, the local language), Lakshadweep comprises 32 coral islands, just three of which allow foreign visitors. Bangaram Island, uninhabited but for the staff of its eponymous resort, sees only about 1,500 visitors annually, thanks to the government's conservation initiative. Among your many rewards for the long journey here—besides the powdery sand at your doorstep—are no TV, no phone, and a chance to indulge in a little divine intervention with a massage at the resort's Ayurvedic wellness center. *January 2007*

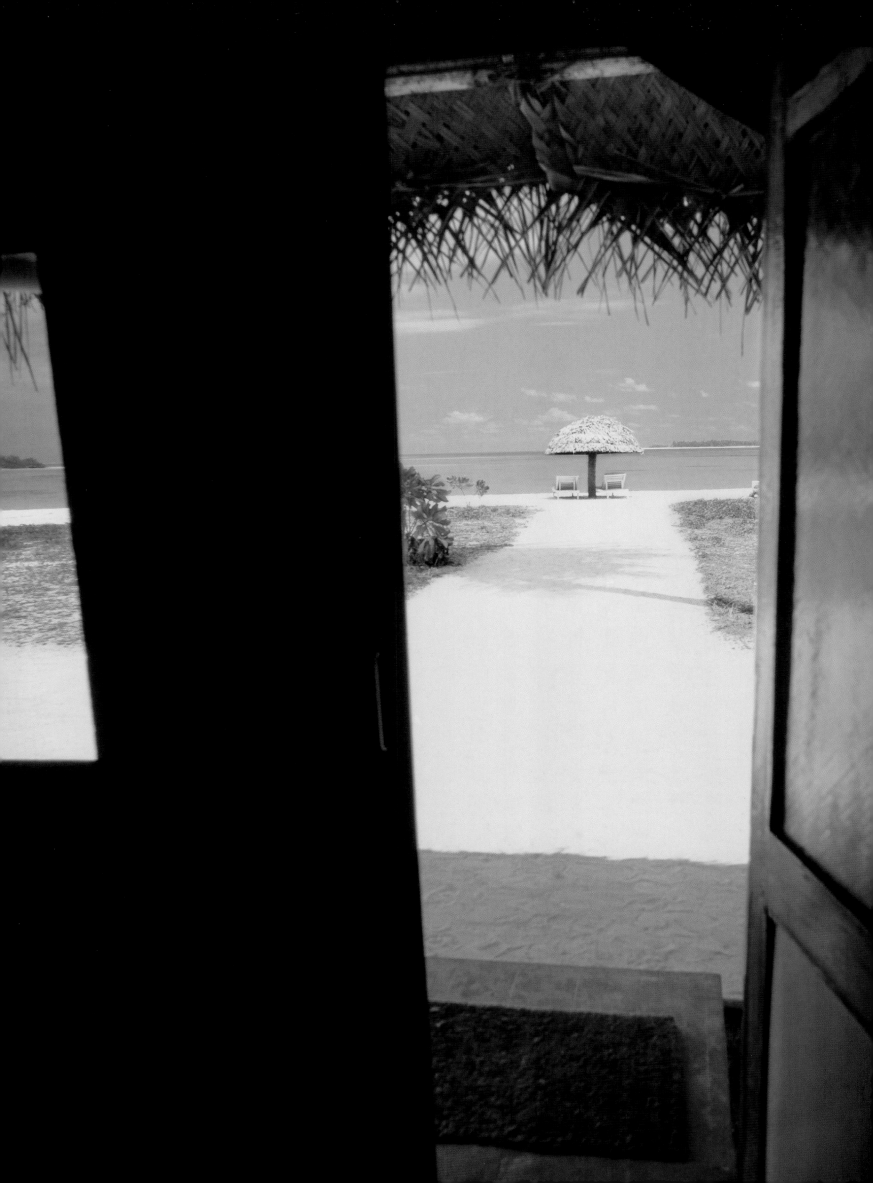

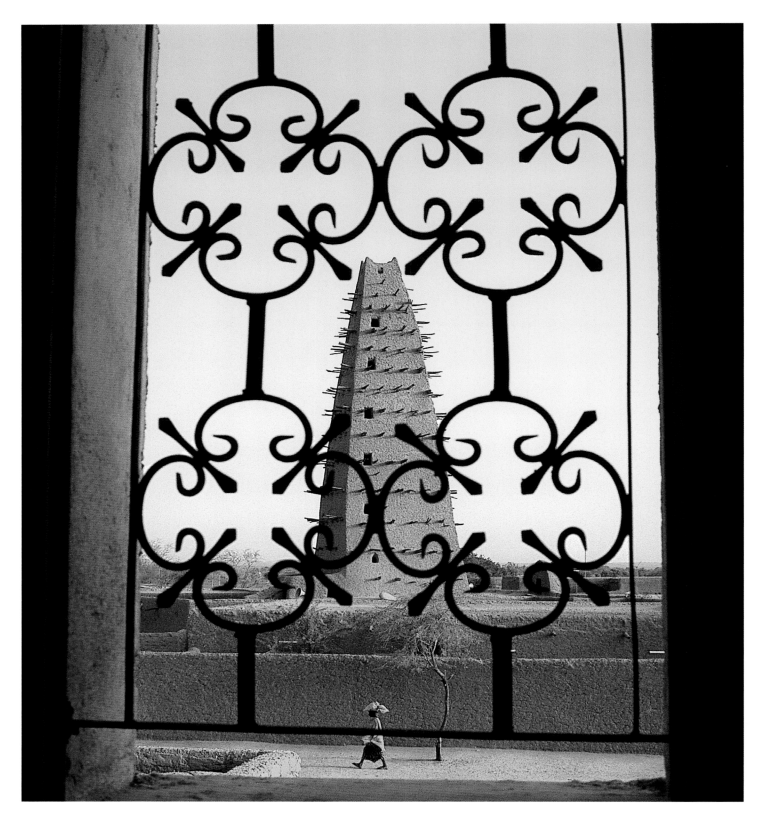

AGADEZ, NIGER

Pension Tellit, Room 4

Despite the prickly appearance of the minaret facing you, the wooden spikes around this 90-foot prayer tower merely function as permanent scaffolding, footholds for local masons who continually repair the clay structure after seasonal rains. Such artful practicality recalls the significance of Agadez as a crossroads on a centuries-old trade route in West Africa. Salt and gold merchants came through this medieval Saharan oasis, along with slave traders and camel caravans. Africans, Arabs, French colonists, and Tuareg herders—all stopped here to rest. The last century added European adventurers who were motoring across the Trans-Saharan. More recently, Italian entrepreneur Vittorio Ginoni opened an ice-cream parlor in Agadez, then this pensione. Directly across from the sixteenth-century Grand Mosque, it preempted the need for wake-up calls: Muezzins use the minaret to beckon the faithful—loudly—to morning prayer at five o'clock. *June 2000*

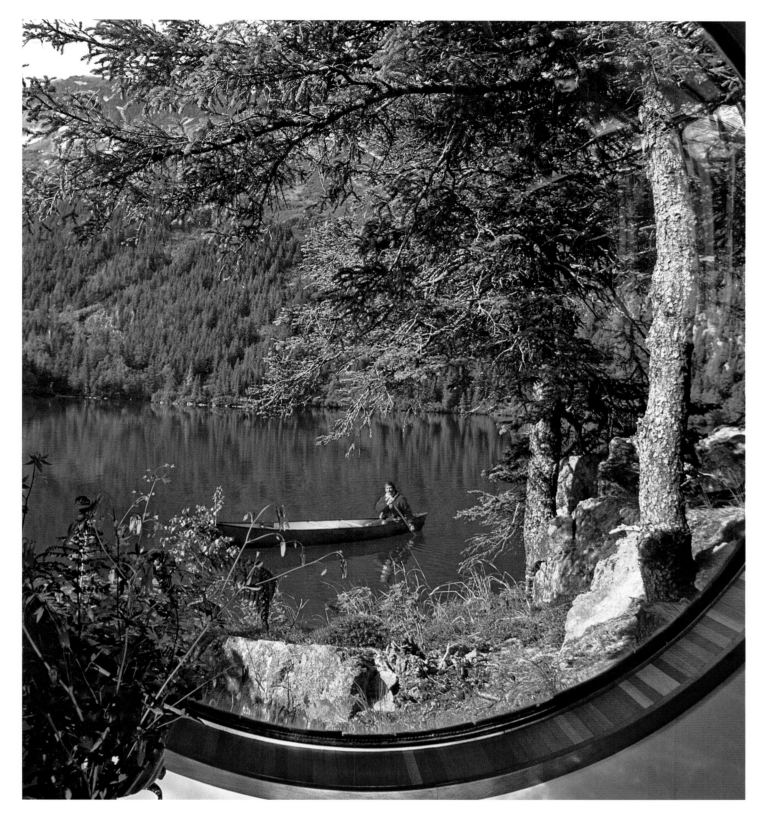

HOMER, ALASKA, USA

Loonsong Mountain Lake Camp

Some travelers go to the ends of the earth to "get away from it all," and some go to Loonsong Mountain Lake Camp and finally understand what that really means. The log cabin, which sleeps six, is on the lake, surrounded by a quarter-million acres of wild land in Kachemak Bay State Park, Alaska's only state wilderness park. The remote valley knows no roads, and your only way in is by floatplane, unless of course you choose to emulate the first Americans and come by foot or canoe. Your neighbors—mountain goats, black bears, wolves, moose, and loons—are shy and will respect your privacy as you respect theirs. Your food—salmon, trout, and local seasonal fruits and vegetables—is gathered from the "backyard" and prepared by the chefs, who live in a cabin across the lake. As you sit down to dinner by kerosene lamp (there's no electricity) reflect, for just a moment, on the meaning of "progress." *June 1991*

Topas Ecolodge, Bungalow 208

It's dusk, and as you step out on your private balcony to take in the majestic view, the hills are alive with the sound of . . . Wait, these are not those hills, but the verdant Hoang Lien Mountains (known as the Tonkinese Alps since French colonial times). Nevertheless, this region in northern Vietnam is euphonious, from the birdsong of the 150 species found around these peaks to the melodious dialects spoken by ethnic minorities including the Tay, the Ban Ho, and the Black Hmong, all of whom reside around the former hill station of Sapa, 11 miles away. The harmony between centuries-old traditions and current trends like this ecolodge makes Sapa a gem of a destination. Sensitive to its surroundings, the Topas Ecolodge has solar-powered bungalows constructed with indigenous materials by local builders and is staffed by villagers from the rice-terraced valley below. *June 2006*

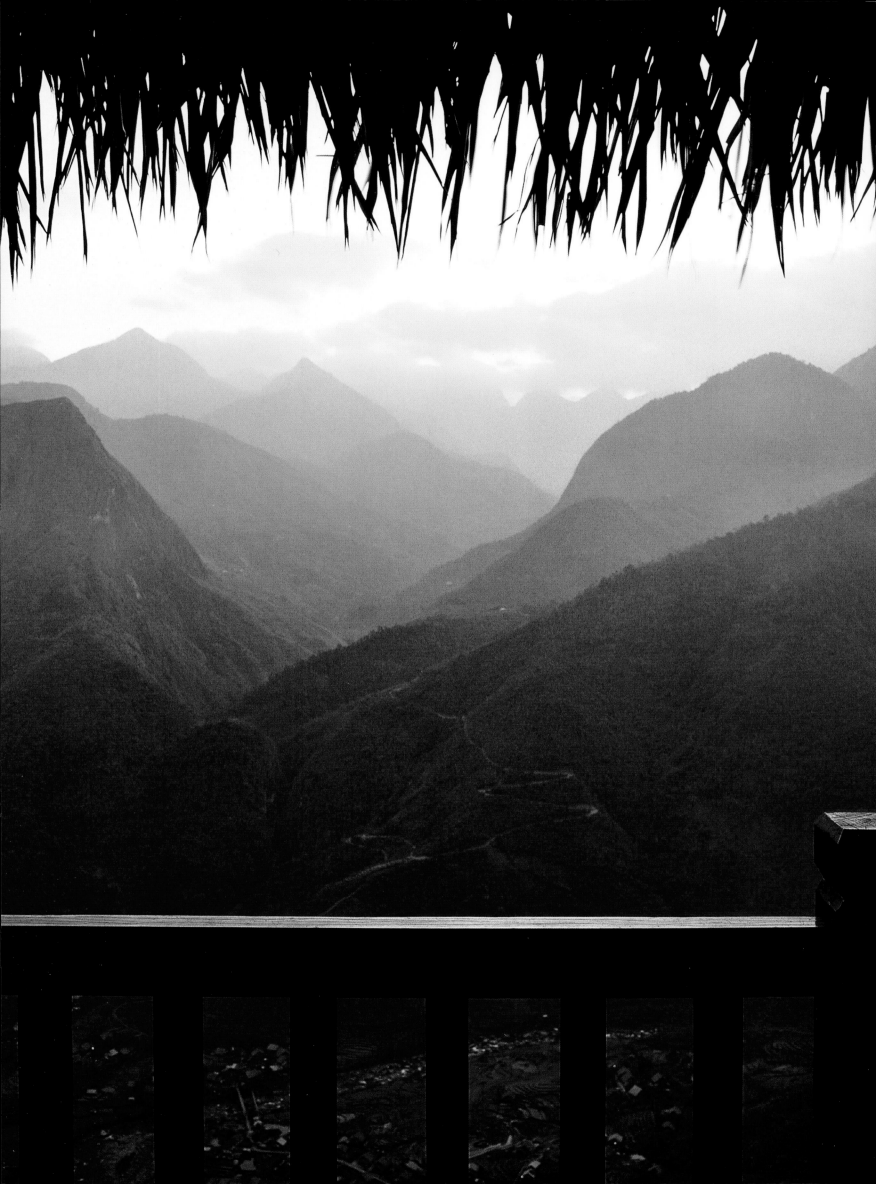

Al Qasr, Room 546

Everything old is new again at the island-resort of Madinat Jumeirah, whose 100 man-made acres are, in effect, a faux village of traditional emirate architecture. Of the resort's three hotels, Al Qasr is the grandest—*qasr* means "palace," after all. With its labyrinthine canals, where dhows transport guests through the complex, this opulent Old Arabia–style property (life-size gilded horse statues and all) rises several stories above its sand-colored sister hotels. Your view encompasses the iconic sail-shaped Burj Al Arab hotel jutting into the gulf, the first Dubaian foray into modern extravagance, as well as the resort's waterside souk, below, a collection of touristy cafés, restaurants, galleries, and shops designed to evoke an Arabian bazaar of yore. *November 2006*

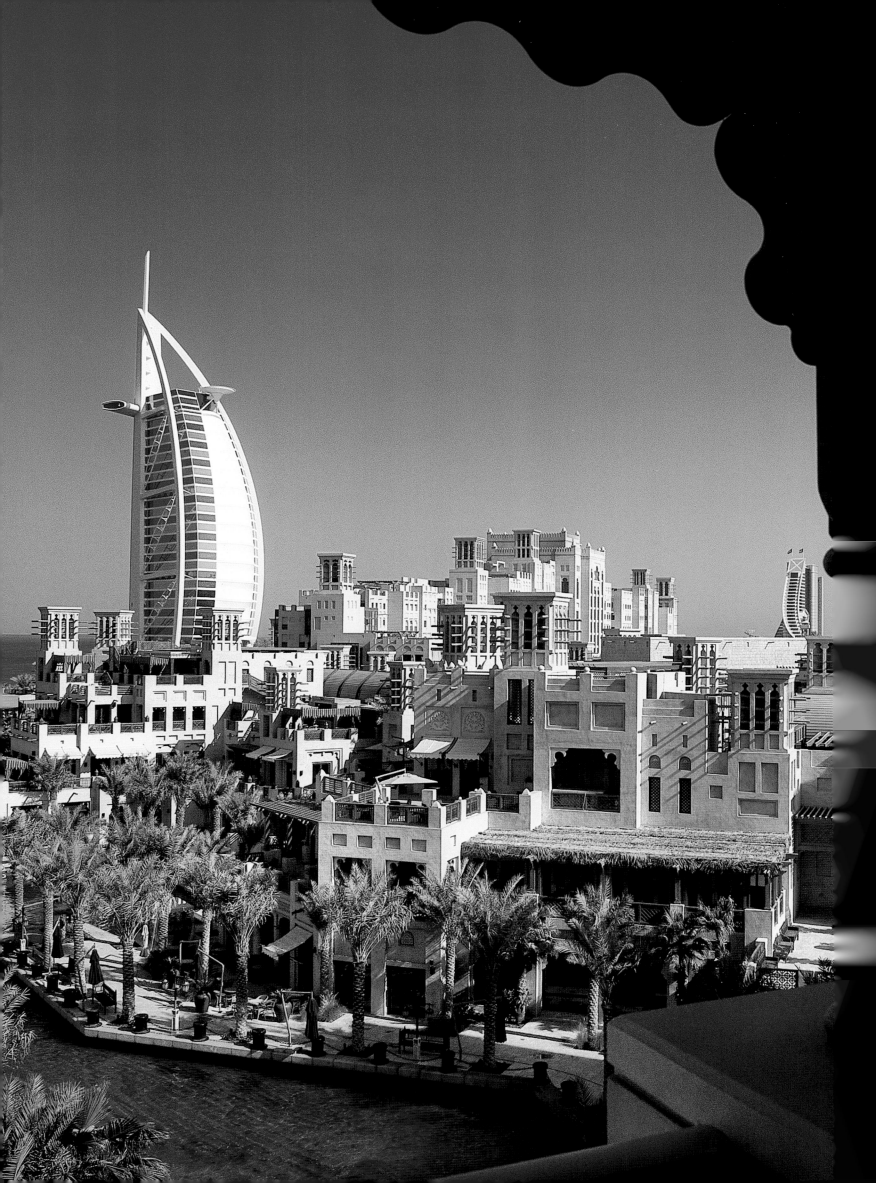

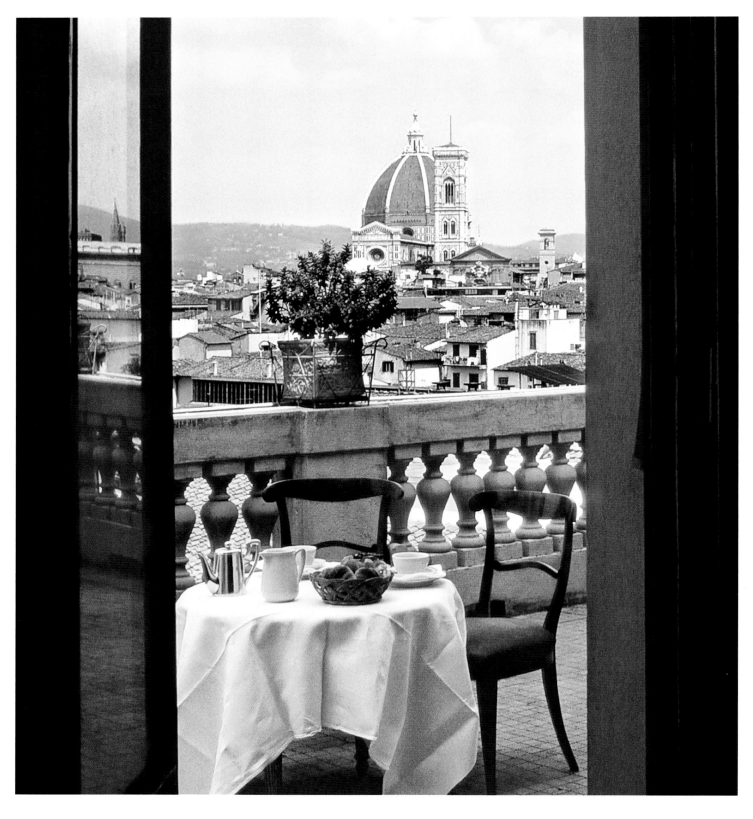

FLORENCE, ITALY

Westin Excelsior, Room 558

You're not the only one looking at Il Duomo. Hundreds of monitors, from plumb lines to lasers, are being used to scrutinize the cathedral's famous soaring dome. Brunelleschi's redbrick cupola is endangered, evidently because portions of it were cemented over during recent restoration. Absorb the bustle of the city over morning *caffe latte* and *pane fresco* or an afternoon bottle of young Chianti. Beside Il Duomo is Giotto's Campanile. The view of these landmarks is as good as the view from them. In the distance beyond the rooftops, the Tuscan hills invite exploration. *April 1988*

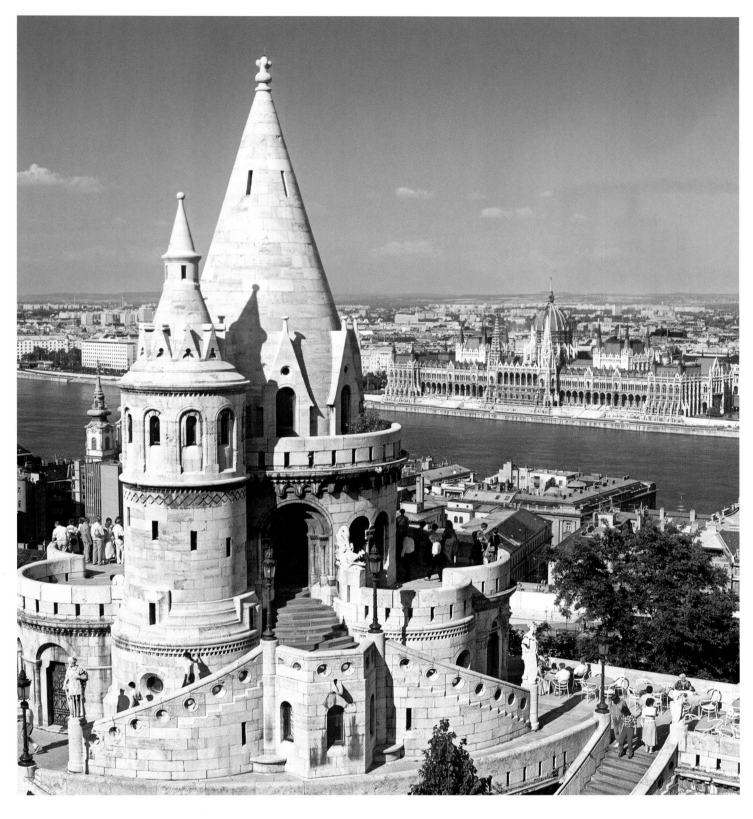

BUDAPEST, HUNGARY

Hilton Budapest, Room 516

Forty years of failed communism have had at least one accidental benefit: skylines unbroken by capitalist towers. Though Budapest was pulverized in the final battle between the Soviets and the Nazis in the winter of 1944–45, its original Hapsburg scale survives. The Hilton Budapest was plunked on top of the ruins of a thirteenth-century abbey on Castle Hill in Buda, granting this superb vista of the Danube, the city, and the sweeping Hungarian plain of Pest. If you step outside to the Disneyesque turrets of Fisherman's Bastion, a late-nineteenth-century confection (foreground), you'll get one of the city's most Instamatic views. Across on the south bank, the dominant building is the Parliament, the focus of the 1956 uprising, now the emblem of future freedom. Castle Hill itself, once a royal redoubt, has been restored to Baroque splendor. One caveat: The Danube is not blue; more an opaque putty. *March 1990*

Albergo Domus Mariae, Room 206

"Siracusa knows no day without sun," Cicero once observed, and your empyreal view facing the emerald waves of the Ionian Sea certainly supports the Roman orator's effusive claim. Both its climatic and geographic merits helped ancient Syracuse—its borders then limited to Ortygia Island, off Sicily—become one of Greece's most important cities some 2,200 years ago, even rivaling Athens in beauty and cosmopolitanism. (Remnants of Syracuse's legacy can be found a few blocks from your hotel, in the duomo built from the ruins of a Greek temple to Athena.) So celebrated was their city that before it ultimately fell to the Romans, the Siracusans had to fight off the Carthaginians in many a battle on these waters. On sleepy present-day Ortygia, you'll experience far more tranquillity than unrest—starting in your room at the Domus Mariae, which is run by nuns of the Ursuline order. *March 2004*

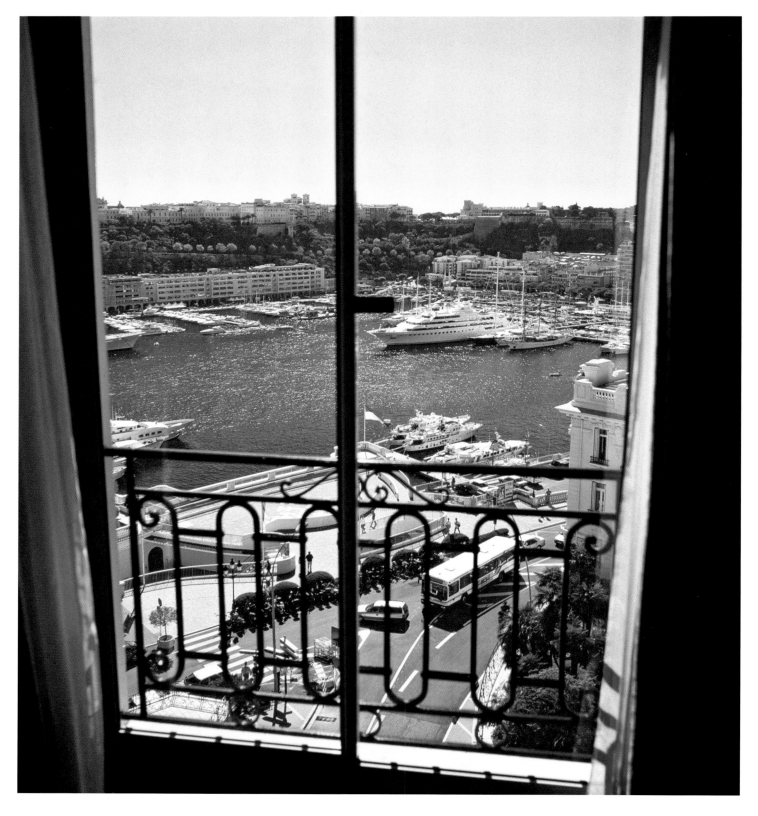

MONTE CARLO, MONACO

Hôtel de Paris, Room 610

The multitude of yachts docked in the sun-drenched harbor reflects the order of life at this requisite Riviera stop. The Grimaldis may have reigned for 700 years, but leisure is king in this tiny principality (it's less than half the size of Central Park) that only a century and a half ago was home to olive groves, lemon trees, and little else. Monte Carlo is now synonymous with playing hard and sleeping well, fulfilling the aim of the town's developer and namesake, Prince Charles III. To the left of your view is the Monte Carlo Casino, around which this 1864 hotel and the rest of the quartier were built on a hunch. It was one gamble that paid off. *February 2000*

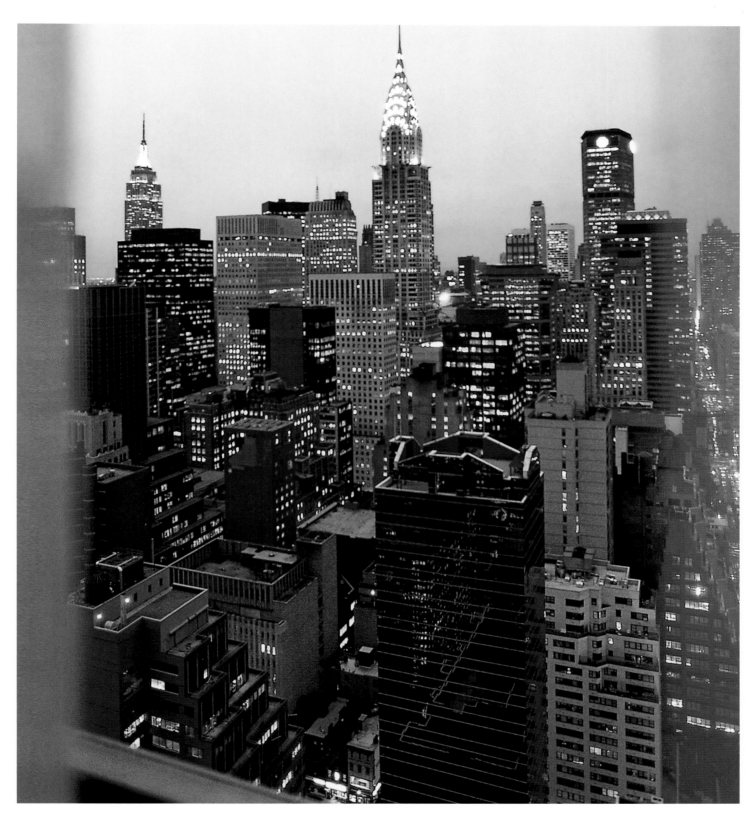

NEW YORK, NEW YORK, USA

Millennium U.N. Plaza Hotel, Room 3736

Dead ahead is the Chrysler Building, whose silvered crown was once home to the Cloud Club, the fabled gentlemen-only nightspot. Even more fabulous is the never-used airship station in the theatrically lit Empire State Building. It's easy to imagine the glowing youth of these architectural elder statesmen. Ambitious new skyscrapers cluster around them, but they stand proud in the Manhattan skyline, their romance undimmed. You're watching from a much newer edifice on the East Side, the Millennium U.N. Plaza Hotel. Before you, twilight envelops midtown Manhattan, the heart of New York. Behind you, the East River flows in from the harbor (it's actually an estuary), past the General Assembly and the 185 flags of its member states. And tonight you'll sleep above the worries of the world—United Nations offices fill the first 28 floors of the hotel's twin towers. *March 1998*

Las Mañanitas, Room 21

When it came time for stout Cortés to hang up his suit of armor and think about his retirement home in Mexico, where did the ultimate conquistador go? To Cuernavaca, *naturalmente*. This lush view from Room 21 of Las Mañanitas gives you some inkling of what it was that attracted him to the City of Eternal Spring. The climate is perfect year-round in this pre-Columbian resort that was known for its thermally heated springs long before the Spaniards arrived in 1521. One of the first things they did was change the unpronounceable Aztec name Cuauhnáhuac to the more prosaic Spanish for "cow's horn." As the sun goes down, sit back at a table in the garden, ask for the perfect margarita—straight up, with salt—and drink to Cortés's impeccable taste. *February 1991*

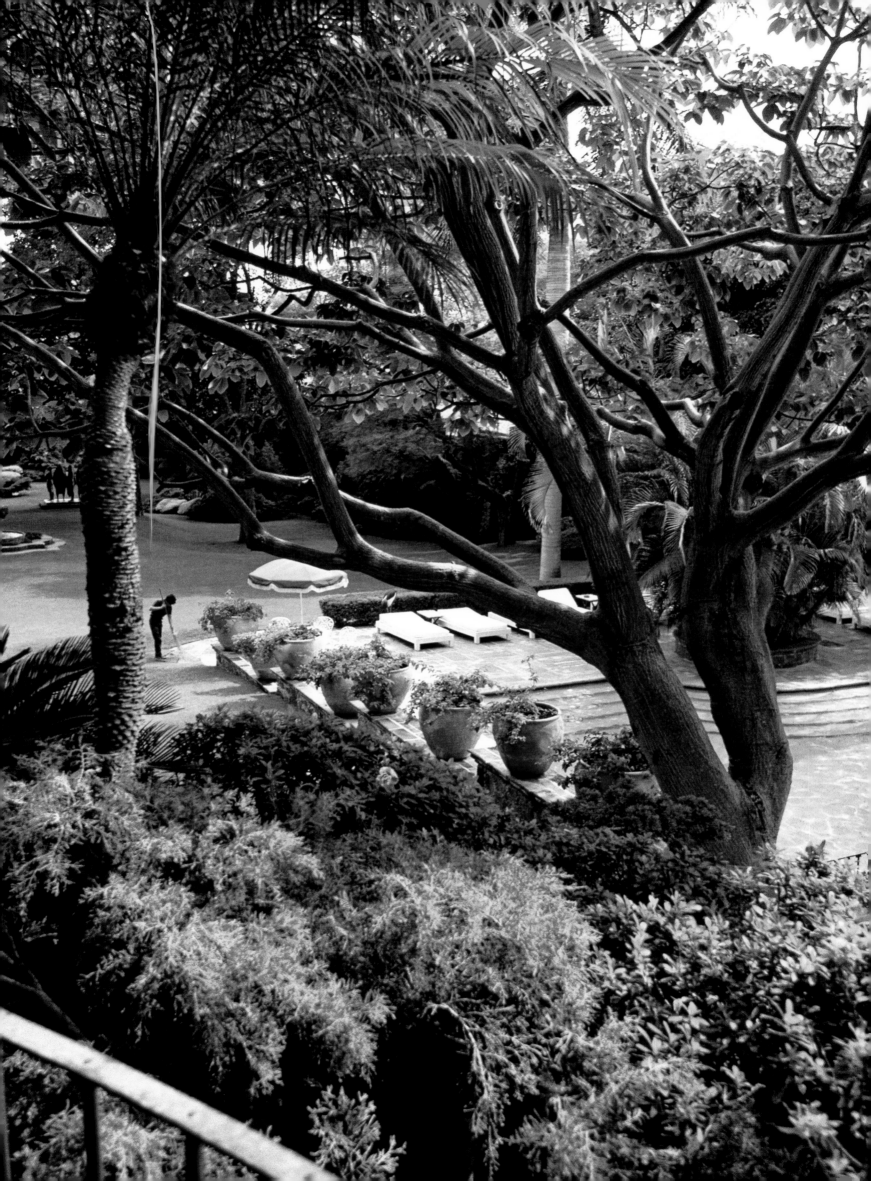

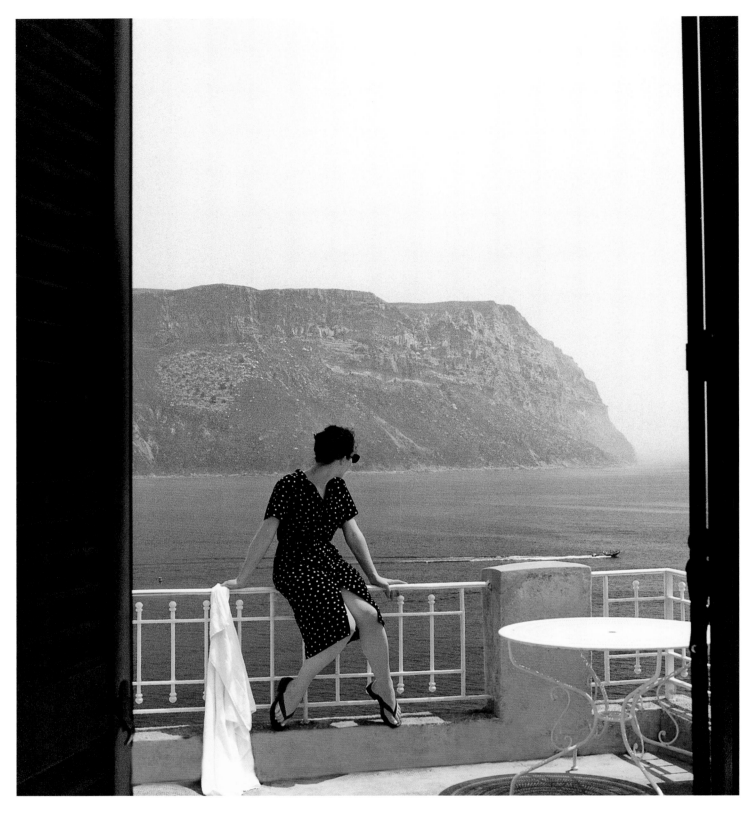

CASSIS, FRANCE

Les Roches Blanches, The Iris Suite

Bits of the rock that you and the lady in black are looking at have, in one of the odder quirks of fate, ended up lining the Suez Canal. It is your good fortune that this niche in the Côte d'Azur has not changed much since its quarrying days—which were also its heyday. You are in Cassis, a small port between Toulon and Marseilles that looks like St. Tropez used to and is famous for the amazingly high quality of its wine and its white rock. Cassis does not allow cars, which will leave you practicing the bygone arts of strolling, lingering, and poking aimlessly about the harbor's shops and cafés on the town's slender streets. Even more aimless pleasures are at hand back at your private terrace at the day's end, when you need only a glass of chilled rosé (another superb local blend) to go the lady in black one better. *February 1997*

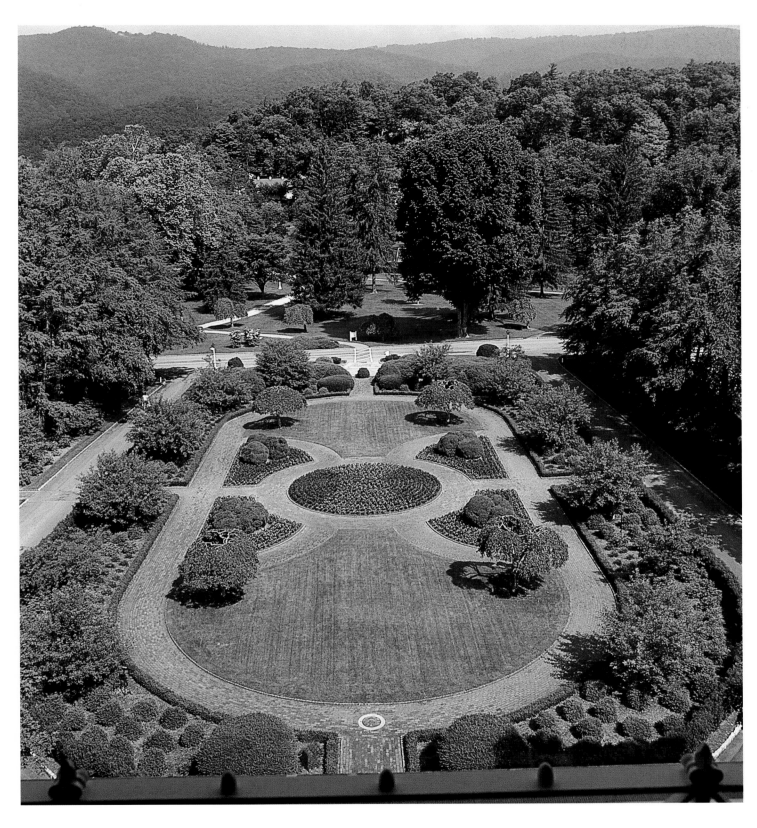

WHITE SULPHUR SPRINGS, WEST VIRGINIA, USA

The Greenbrier, Carleton Varney Suite

Consider yourself in esteemed company. Ever since James Monroe first stayed at this National Historic Landmark in 1815, 26 former and sitting U.S. presidents have followed suit, helping to dub this grand white house the "summer White House." Drawn to The Greenbrier's strategic Allegheny Mountains location and the restorative sulfur springs within its 6,500 acres, the government—in more politically charged times—used the resort as a military HQ, a hospital, an internment center, and the home of a top secret bunker designed for the relocation of Congress in the event of a Cold War crisis. Its existence made public in 1992, the 112,000-square-foot subterranean shelter is now open for tours. *September 2001*

Hotel de Londres y de Inglaterra, Room 322

A lot of money has changed hands here over the years. Basque fishermen still drop their lines off piers, but San Sebastián began the shift from picturesque hamlet to fashionable resort in the 1880s, when Queen María Cristina transformed the beachy real estate into a getaway for wealthy Spaniards. They in turn kept her entertained in her summer retreat by getting wet by day in the surf and fleeced by night at the casino, now the double-spired city hall to the right out your window. San Sebastián is a more democratic playground these days, with vendors hawking peeled shrimp and cold Coca-Cola along the wide Playa de la Concha, which stretches for nearly a mile outside the stately Hotel de Londres. In high season, you're as likely to hear accents from Newcastle as from Castille. Regardless of whose subjects keep the town lively, María Cristina would still be amused. *February 2003*

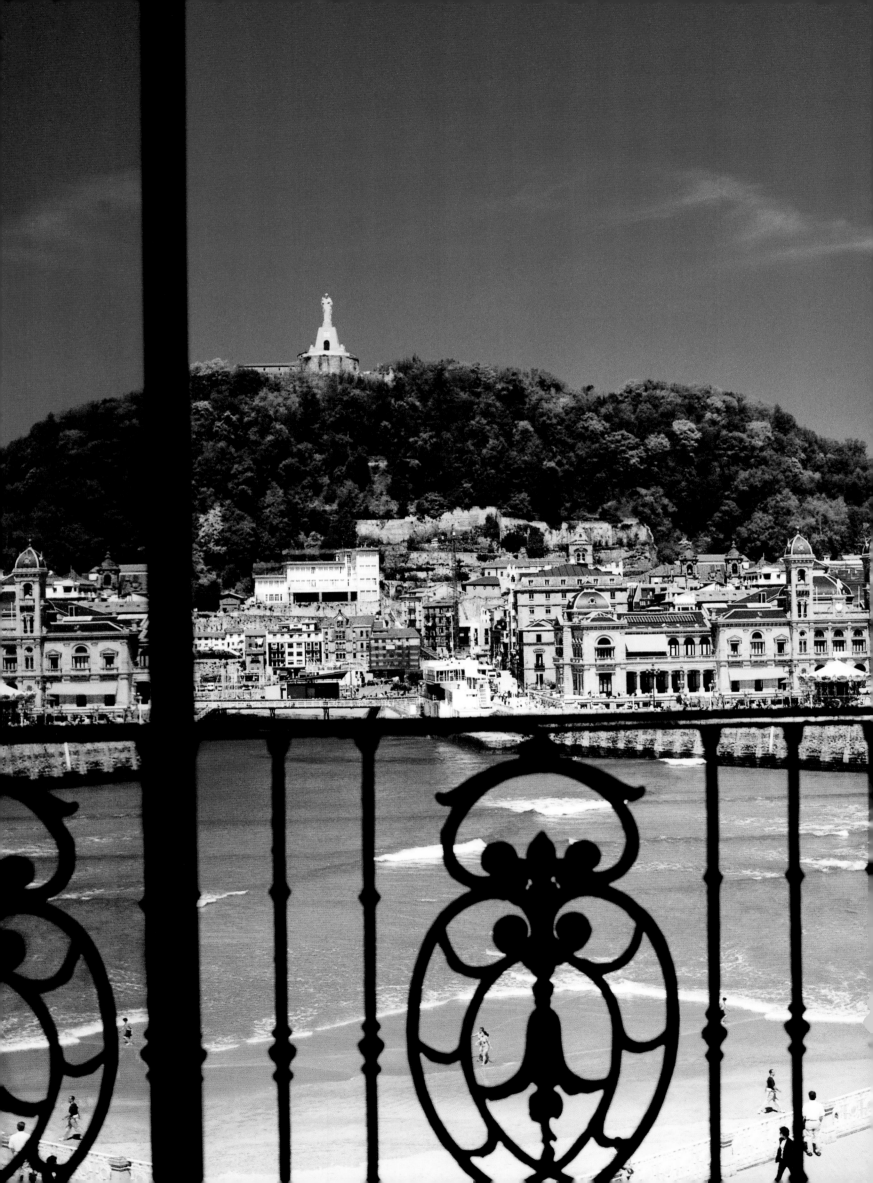

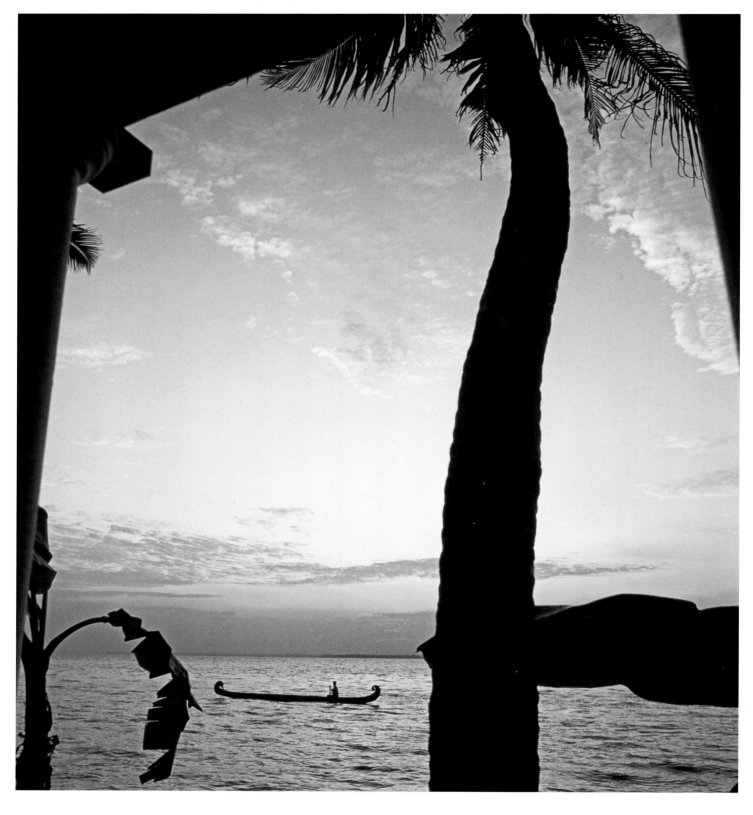

KERALA, INDIA

Coconut Lagoon, Koorali Room 1

A warrior created this serenity. Parasurama, a Hindu god, threw a battle-ax into the ocean and ordered the waters to recede, and the land that emerged was Kerala. A tropical region of inland waterways, rivers, and lakes (such as Vembanad, above), it has unique beauty and—no less so—unique character. The world's first democratically elected Marxist state (1957), it has free education, with literacy rates almost double the national average; free health care, stubbornly committed to the Hindu medicinal system of Ayurveda; and a matrilineal society that is only slowly disappearing. Guests at Coconut Lagoon stay in *tharavads* (traditional wooden cottages) and can travel by *kettuvallam* (rice boat) in these parted backwaters. Few warriors, or even gods, aim for peace so well. *August 1999*

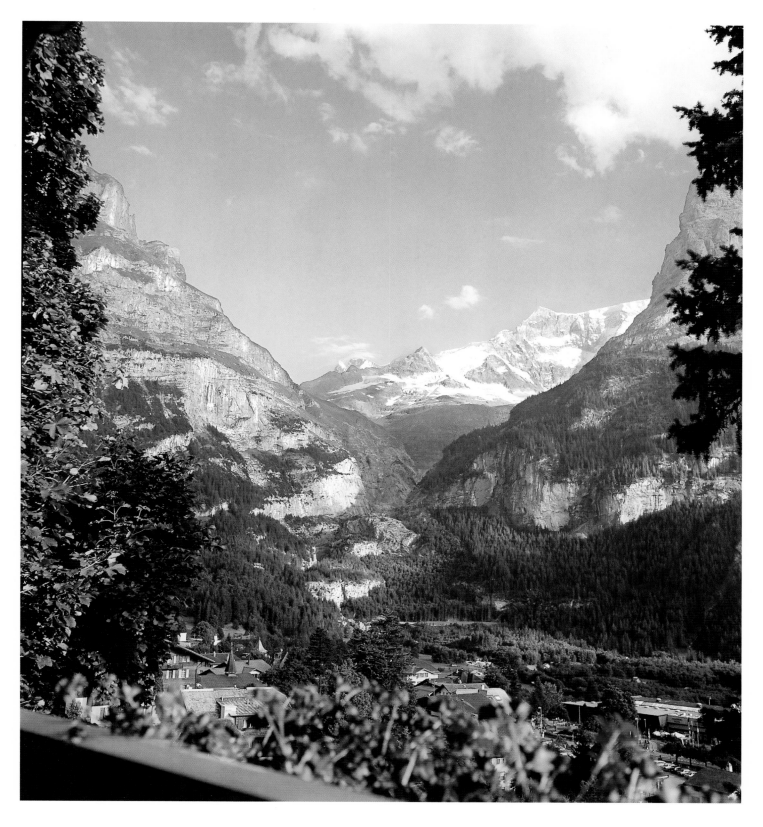

GRINDELWALD, SWITZERLAND

Hotel Sonnenberg, Room 105

You might want to stay put. Out there is the Eiger Mountain's North Face, notorious for walls of ice and forebodingly named landmarks like White Spider and Death Bivouac. You can see plenty from here, off a balcony at the Hotel Sonnenberg. And apart from the church bells, the cowbells, and the boisterous laugh of Mrs. Candolo, the hotel's proprietress, everything around Grindelwald is on a grand scale. Brightly painted cable cars climb snowy peaks. The Piz Gloria restaurant revolves on the 9,718-foot summit of the Schilthorn. The Jungfraubahn's final stop is the highest railway station in Europe—so high that some rubbernecking passengers claim they can see all the way to Russia. Clearly, they're missing the point. Even if you could see only as far as Poland, why aim beyond this horizon? *January 1998*

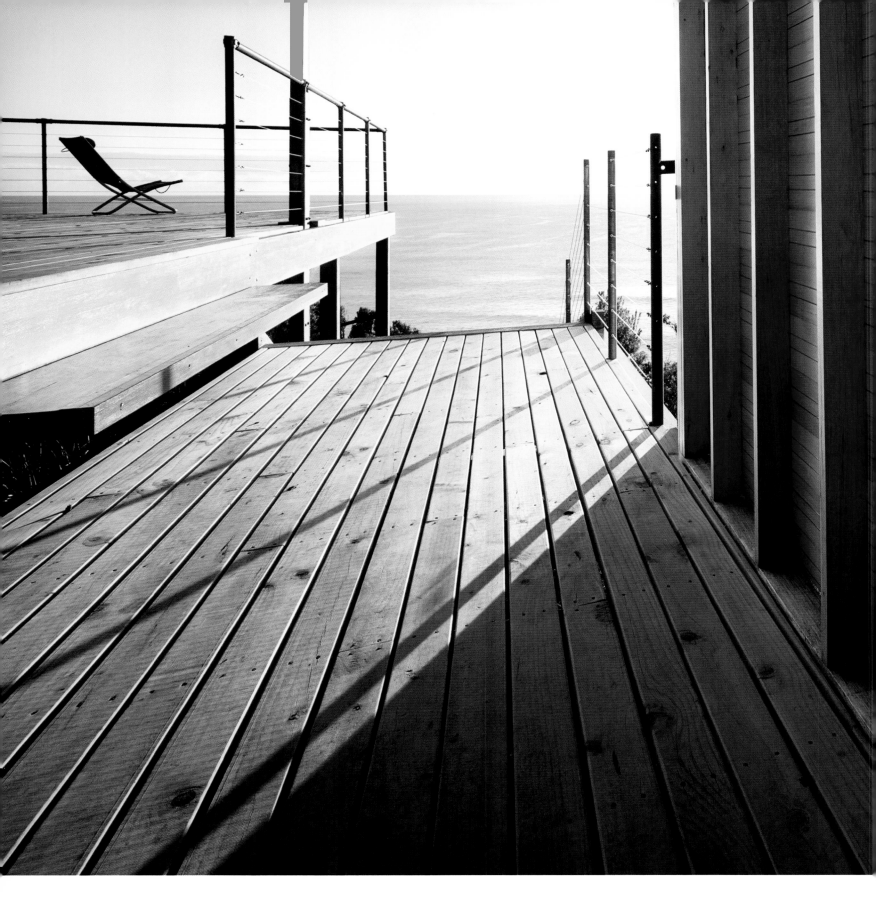

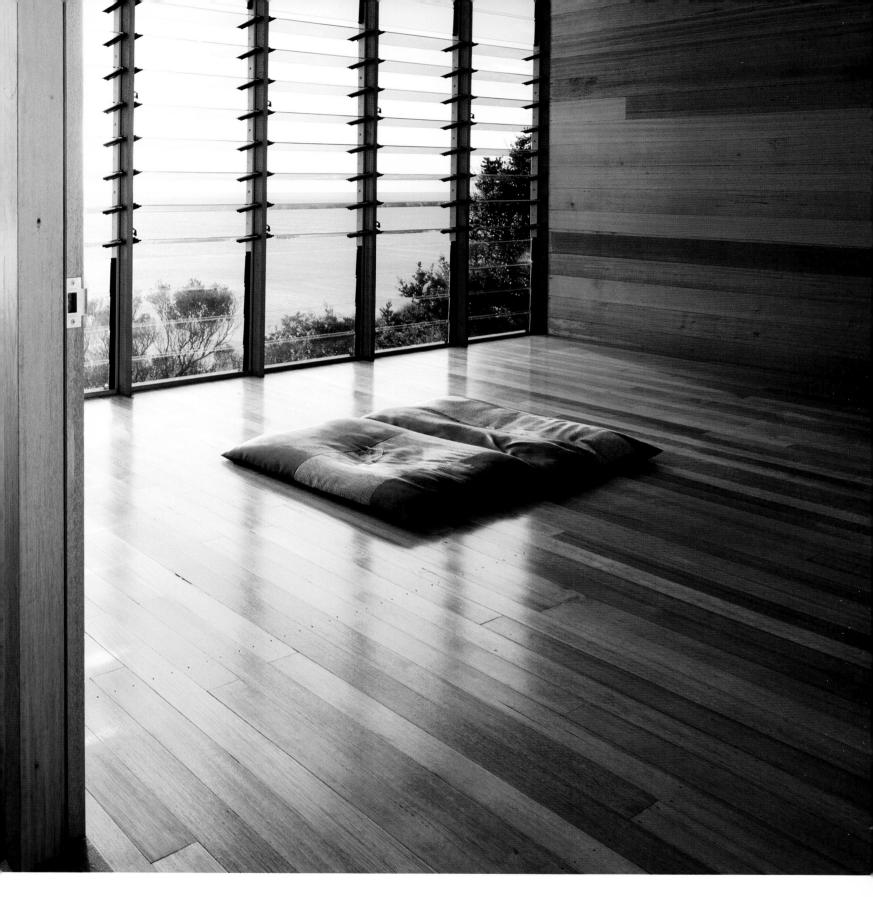

MOUNT WILLIAM NATIONAL PARK, TASMANIA, AUSTRALIA

Bay of Fires Lodge

Inside and out, the lodge—nicknamed "The Sheds"—is as pure as a retreat can be. But its rewards are not for the indolent: The sole structure within this 13-mile stretch of Tasmania's northeast coast and balanced roughly 150 feet above the Pacific, it's accessible only via a two-day hike through Mount William National Park. The area is home to such uniquely Australian species as the eastern gray kangaroo and the Tasmanian devil. During the trek, you'll pass huge middens of discarded shells left by Aboriginal tribes from centuries past. The Sheds is a tour de force of earthy architecture, both environmentally (just three trees were felled to build its two timber-and-glass pavilions) and aesthetically (louvered windows allow uncompromised views). But its charms are ephemeral, too: In a coup of eco-sensitive construction, the lodge can be entirely dismantled, leaving behind virtually no imprint of where it stood. *January 2003*

InterContinental Paris Le Grand, Room 2332

On May 5, 1862, Empress Eugénie inaugurated this grand hotel to orchestral strains from *La Traviata* and *Giselle*—the beginning of its ties to the arts. Business at the hotel was slow in its early years due to the construction of the opera house across the plaza. Completed in 1875 the Opéra was designed by Charles Garnier, the winner of a competition held by Napoléon III, who ordered a new performance hall built after an attempt was made on his life in another theater. Eugénie was unimpressed with Garnier, believing his style too forward-thinking. The architect retorted: "Old styles have had their day. This is the Napoléon III style, and you complain?" The now-fabled Palais Garnier, which gained attention from Gaston Leroux's story *Fantôme de l'Opéra*, is today one of the premier venues for the performing arts. *February 2001*

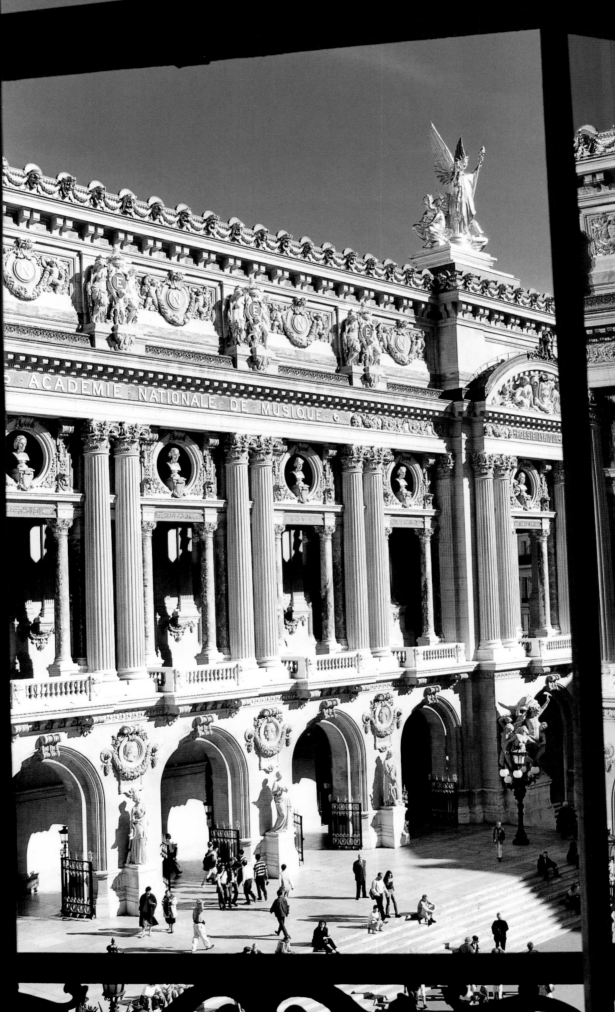

Las Balsas Hotel, Suite El Muelle

When the setting involves eternally snowcapped mountains, rolling green forests, and the blue waters of Nahuel Huapi Lake at your feet, it's easy to set yourself adrift and literally float away. Las Balsas Hotel ("The Rafts"), in Villa La Angostura, is true to its name, providing boats so you can explore the waters of Patagonia's mostly untouched wilderness. From the rustic-nautical Suite El Muelle ("The Wharf," another apt translation), the lake is but a short stroll across a private beach. If the view isn't enough to set you daydreaming, perhaps a visit to the spa followed by one of the 2,500 bottles from the wine cellar will do the trick. But remember, nothing lasts forever. The past decade has seen a crop of new hotels springing up around the lake—so take a good long look before these views are only the stuff of dreams. *December 2007*

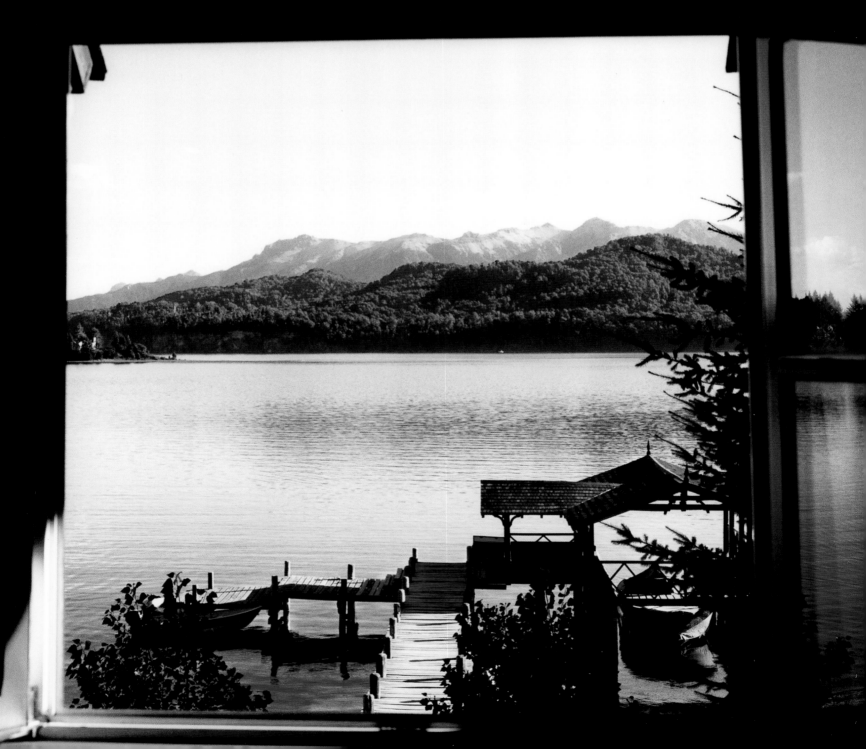

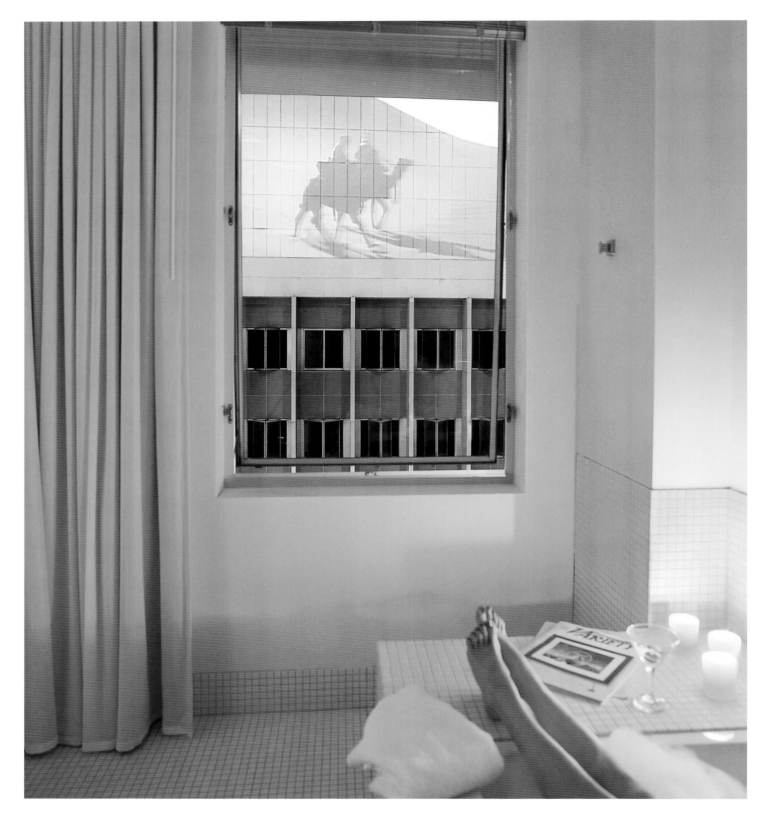

LOS ANGELES, CALIFORNIA, USA

The Standard Downtown L.A., Big Penthouse

The vision out your window is no mirage. That's Peter O'Toole (a.k.a. Lawrence of Arabia) trekking across you-know-where, companion in tow, in David Lean's 1962 classic. And, naturally, you're soaking up this desert drama from the bubbly tub of your penthouse at Los Angeles's Standard Downtown. Every night, films are projected onto a neighboring high-rise, which becomes the hotel's own celluloid canvas. (A decidedly more public viewing can be enjoyed one floor up, at the rooftop bar, where revelers enjoy the evening's movie pick against the backdrop of the city skyline.) In addition to screening Hollywood favorites, the hotel has plans for film festivals with delightfully esoteric themes: experimental, Italian neorealist, French New Wave, and—for the truly *précieux*—silent. High atop the Standard Downtown, God(ard)-worshipping cineasts will surely feel a little closer to the stars. *September 2002*

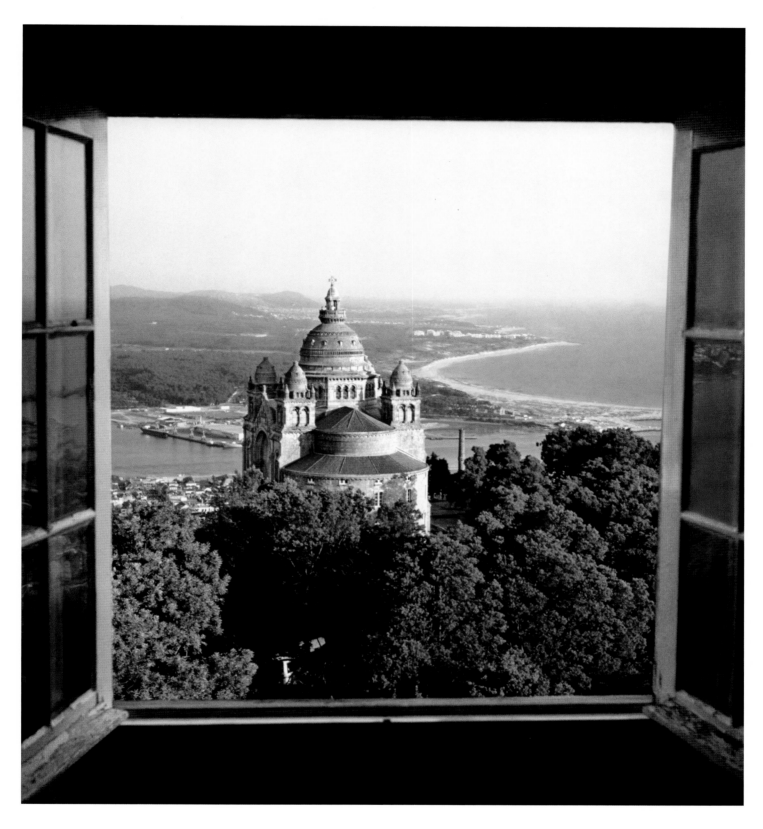

VIANA DO CASTELO, PORTUGAL

Pousada do Monte Santa Luzia, Room 302

"Wet or fine, the air of Portugal has a natural happiness in it," said H.G. Wells. One has merely to fling open the shutters of Room 302 at the Pousada do Monte Santa Luzia and gaze out over Viana do Castelo to agree with him completely. In the immediate foreground is the neo-Byzantine Church of Santa Luzia, built at the turn of the century, and beyond lies the port through which much of the country's wine exports were shipped to Renaissance England. Although it was once northern Portugal's merchant hub, Viana became a sleepy fishing hamlet three centuries ago, which is pretty much how visitors will find it today. It's an easy stroll through the Rococo chapels and abandoned convents that still cast their shadows on the town. And it is only once a year, in August, that Wells's "natural happiness" bursts into downright euphoria—ironically enough, during the festival of Our Lady of Agony, when the streets are filled with color and light. *March 1993*

Hotel Orbis Francuski Kraków, Room 401

If it's true that things keep better on ice, then winter is the perfect season for Kraków. Rare among Poland's cities, it was spared destruction during the war, only to be marinated in some of the highest levels of pollution in Europe in the following decades. The result was an architecturally intact Old Town in such a state of decay that the world wondered if its glories would be tarnished forever. But Poland took action. Preservation became a priority. Now St. Mary's Church and the Town Hall Tower are scrubbed clean, and centuries-old houses are attracting Polish gentry. The Rynek Główny, one of Europe's largest and liveliest town squares, is lined with cafés and shops and has an underground warren of vaulted brick cellars that buzz as restaurants and nightclubs. This 1912 hotel, reborn in 1991, is as clean and quiet as your view toward the wooded Planty, the encircling park that replaced the original city walls. *February 1999*

Bora Bora Lagoon Resort, Bungalow 205

You might be looking out over Bora Bora's famously blue lagoon from behind the eyelid, fringed with lush lashes, of some Polynesian god. In fact, your divine view is from a resort perched on an islet called Motu Toopua, a remnant of an ancient volcano. Across Poofai Bay is Mount Otemanu, the heftiest remaining shard of the volcano's rim. The 2,385-foot-high Otemanu is named for a sacred bird that mysteriously vanished from its vegetation-smothered slopes. Just 18 miles around, Bora Bora is a perfect example of a middle-aged South Pacific island, midway from mighty volcano to thin bracelet of coral. This is French Polynesia at its most glamorous, the place James Michener calls the world's most beautiful island. Discovered by Captain Cook in 1769, Bora Bora later fell to the French, who never let it go. Considering the sensuous expanses of its white sand beaches, and, of course, sacred Mount Otemanu, who can blame them? *April 1994*

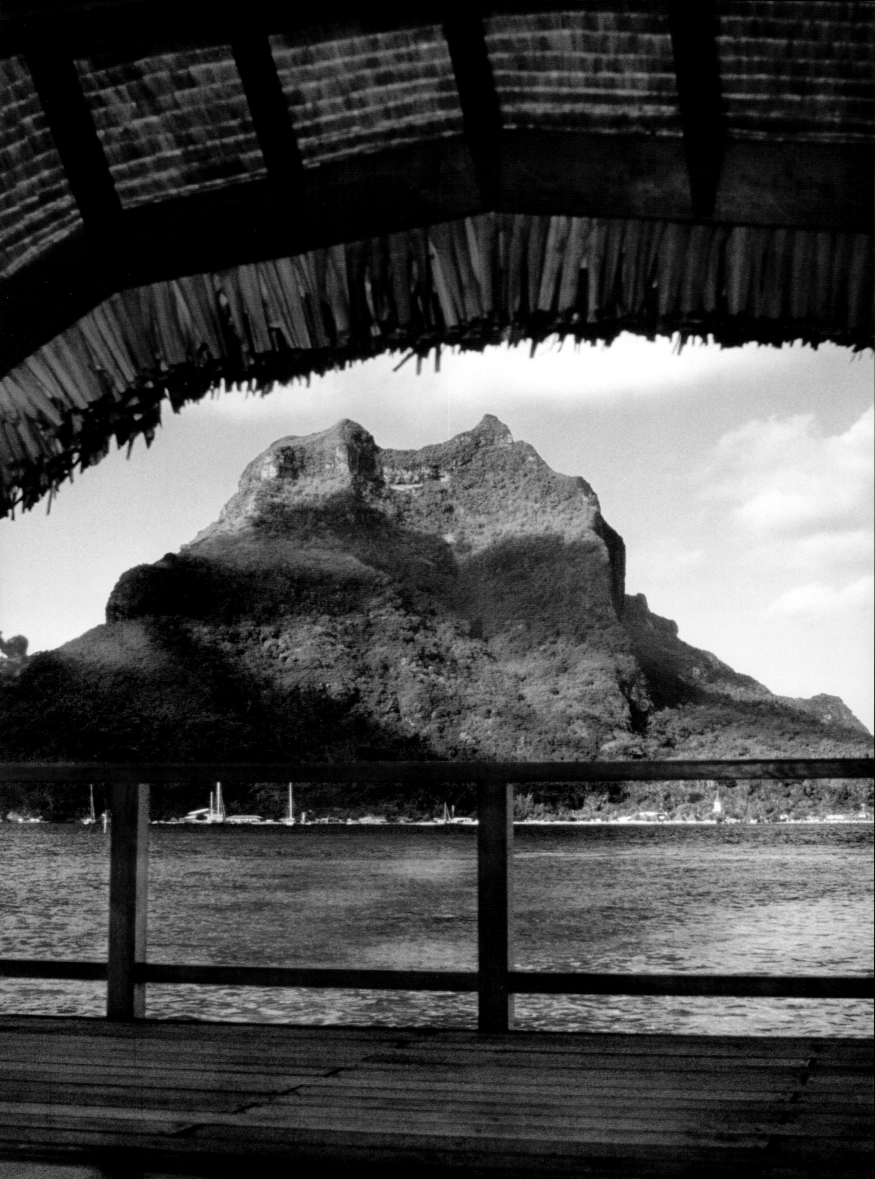

Red Rock Casino, Resort & Spa, The Cherry Suite

It may be a shock the first time you see those twinkling lights ten miles off: Yes, that's the Strip—and you're not on it. Thankfully, the floor-to-ceiling windows of the Cherry Suite, along with its sizable balcony, offer a panoramic perspective on the distant debauchery. The resort's gaming, restaurants, and pools are worthy of Sin City proper, but Red Rock's Adventure Spa is necessary in a city hewn from badlands. Choose from a daily menu of biking, horseback riding, and hiking the red rocks in the national conservation area just beyond the resort's grounds. Afterward, rejoin civilization in the suite's 4,400 square feet of opulence. Located on the twentieth floor, this ultimate party pad comes with all the trimmings: private butler service, a full bar with seating for 20, and a glass shower in the middle of the second master bedroom large enough for six—after all, what happens in Vegas stays in Vegas. *May 2007*

Albergo Barbara, Room 8

"Italians seem hardly able to look at a high place without longing to put something on top of it," Samuel Butler wrote. He might have been envisioning Cinque Terre, the five medieval villages dramatically perched on cliffs an hour south of Portofino. You can drive (perilously) to each town, but since no cars are allowed in, everyone arrives by train, by boat, or on foot. You will work hard on the footpaths, and be rewarded by miles of panoramas of one of Italy's most stunning, secluded coasts. But why sweat? If this perfect little view is the payoff for nothing more vigorous than flinging open your casement windows, we say head for Vernazza and let fling. *April 2000*

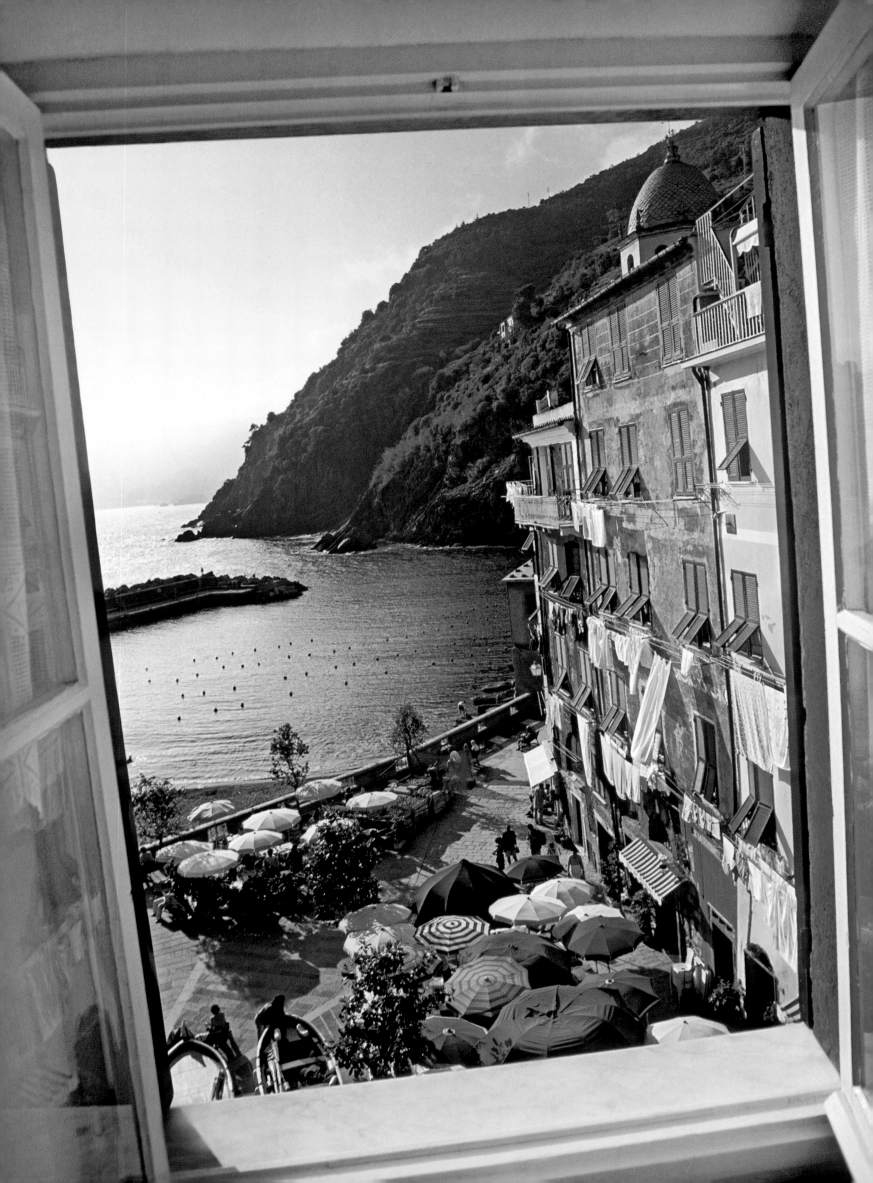

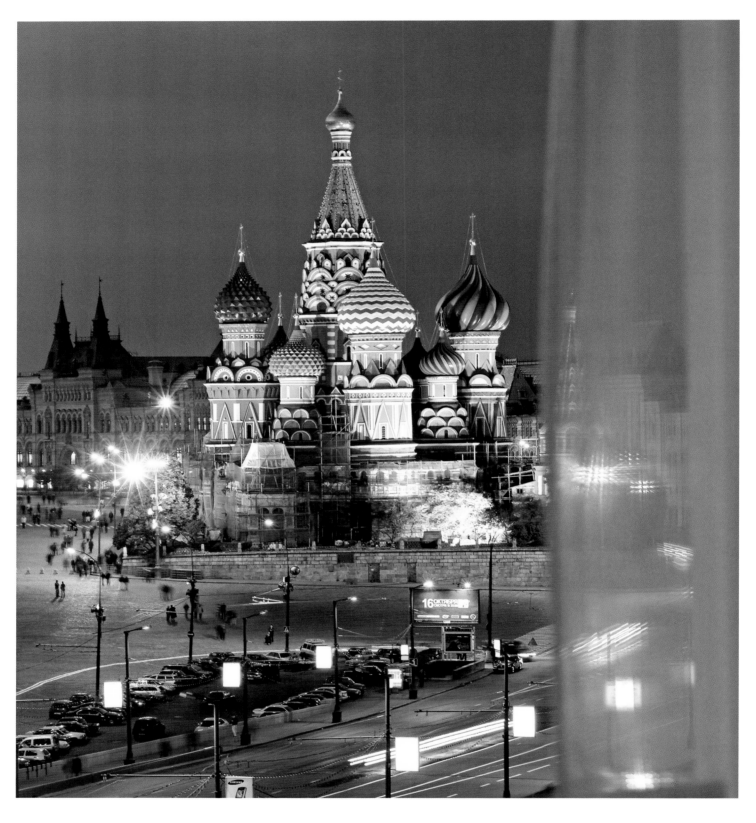

MOSCOW, RUSSIA

Hotel Baltschug Kempinski, Presidential Suite

On the south side of Red Square, near the Kremlin's gate, St. Basil's Cathedral is Russia's Taj Mahal—and the focal point of your view. Ivan the Terrible erected the bulbous edifice in 1560 to celebrate his victory over the Tatars in Kazan. Legend has it that the czar was so enamored of the finished structure that he poked out the eyes of its architect, Postnik Yakovlev, to prevent him from ever again creating anything as beautiful. The nine uniquely patterned onion domes, each housing a chapel, were originally gold—the fanciful hues were added a century later. Red Square, like Russia itself, is feverishly modernizing from its days of solemn marches past Lenin's tomb. Visible on the left is GUM, the state's massive department store, which now sells Levi's and Christian Dior. *March 2005*

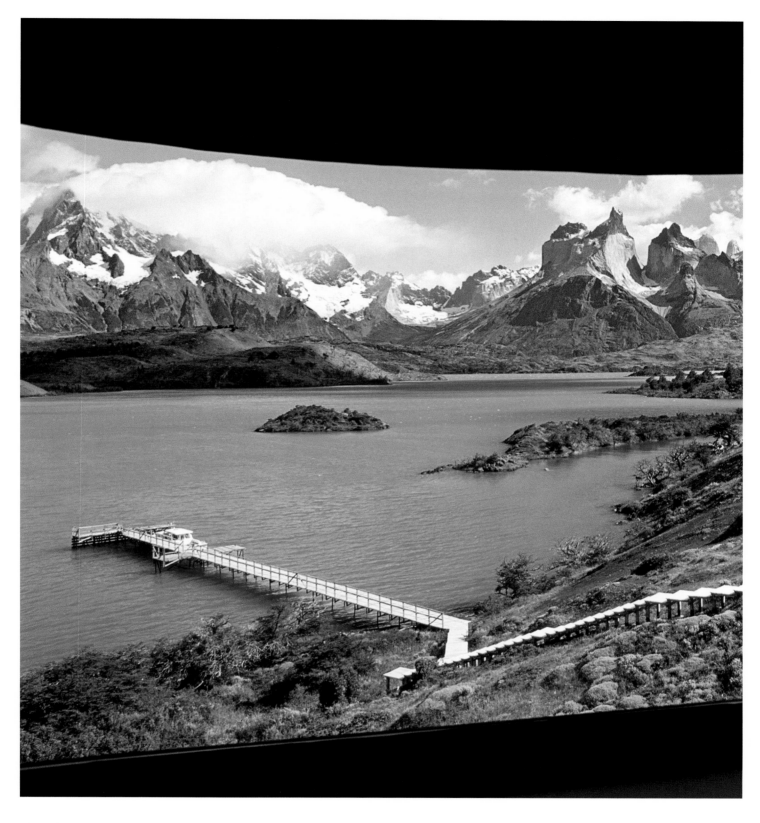

TORRES DEL PAINE NATIONAL PARK, CHILE

Hotel Salto Chico, Room 19

Rising above Patagonia, the horned 9,840-foot Los Cuernos del Paine resemble something otherworldly. No surprise. After all, you're in the province of Última Esperanza—Last Hope—in the shadows of the Macizo del Paine massif. Your home in this UNESCO biosphere reserve is the seven-acre Hotel Salto Chico (named after a nearby waterfall). A motorboat (or one of Salto Chico's two dozen horses) carry guests to campsites. But the 50-mile Torres del Paine hiking circuit awaits really rugged adventurers. After a week or so of trekking past calving glaciers and through forests and bogs, Salto Chico will beckon again. In the hotel's *quincho*, or barbecue area, gauchos will reinvigorate you with spit-roasted lamb and maté tea. Later, a soak in the outdoor sauna at Casa de Baños del Ona will soothe muscles, and you'll be dreaming long before you make it back to your suite. Massif dreams. *January 2010*

New York Marriott Marquis, Room 1834

Who could mistake this neon canyon for any other place on earth? Then again, could this dazzling view really be of the same Times Square that had, not so long ago, slumped into seediness? When the Marriott Marquis opened in 1985, it had to lure cabbies with free lunches. Today, Times Square burns brighter than ever, with flashy new tenants—megastores and media giants—lining the streets and filling the sky. Landmark buildings are getting face-lifts, and Broadway shows are playing to packed houses. In the event that you, dizzy form the light, color, and multilingual masses, forget what brought on this transformation, NASDAQ's eight-story sign, displaying stock prices in 16 million colors, should remind you. *May 2000*

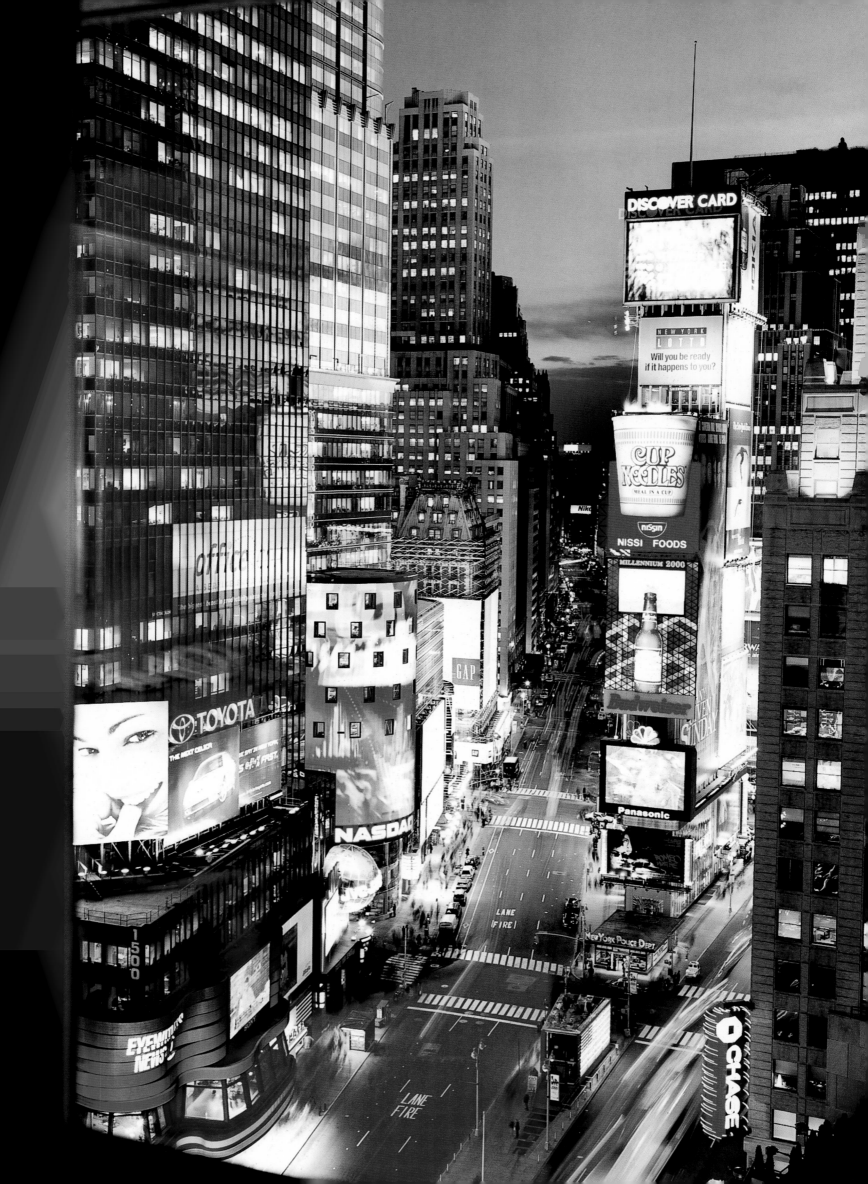

Hotel Colón, Room 406

The view across the Plaza Avenida de la Catedral of the Gothic cathedral, Santa Eulalia, has been good enough for some fairly discriminating eyes: Joan Miró, one of the most celebrated artists of the twentieth century, often stayed in Room 406 when he visited the city that displays so many of his works. The architect José Luis Sert stayed here; and Tennessee Williams also liked what he saw. The hotel is in the Barrio Gótico, the oldest quarter, and it's the only one there that has history and charm. Michelin rates it "top-class comfort," its second-highest rating. Room 406 has sound as well as vision (maybe too much for some people). A brass band plays sardana dances on the cathedral steps every Sunday from noon until 2 P.M. and on Wednesday and Saturday evenings. *December 1988*

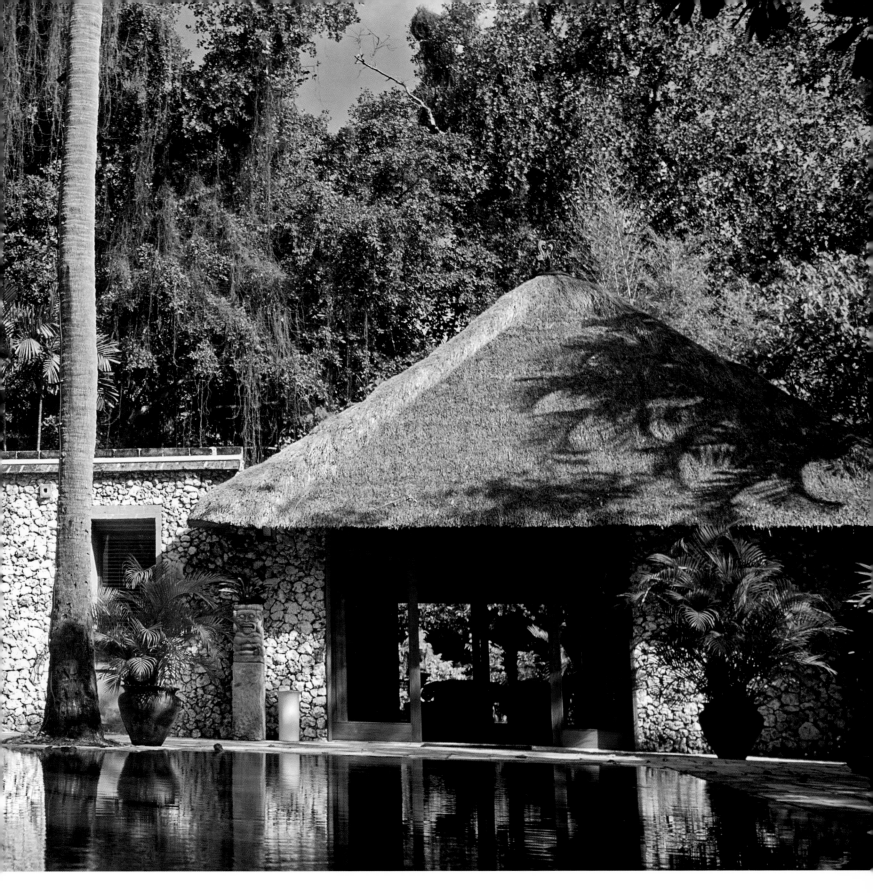

SEMINYAK, BALI, INDONESIA

The Oberoi, Lotus Villa

Propped up on your chaise longue next to your 600-square-foot private pool, you can easily cocoon yourself in these Edenic surroundings, even though the heart of Seminyak, Bali's trendiest beach town, is just beyond your thatched-roof accommodations and the high stone walls. Before it became a hotel in 1978, this 15-acre beachfront property was the exclusive club Kayu Aya, a smattering of bungalows that sheltered the glitterati. As the island upped its glamour quotient, The Oberoi followed suit (poolside massage, anyone?). However, the resort's raison d'être—R and R—needed no improvement. *October 2006*

CONTACTS

Argentina

- LAS BALSAS
 54-2944-494-308
 lasbalsas.com

Australia

- AVALON COASTAL RETREAT
 61-428-250-399
 avaloncoastalretreat.com.au

- BAY OF FIRES LODGE
 61-3-6392-2211
 bayoffires.com.au

- DESERT GARDENS HOTEL
 61-8-8957-7714
 ayersrockresort.com.au/desert

- INTERCONTINENTAL SYDNEY
 61-2-9253-9000
 sydney.intercontinental.com

- LANGHAM MELBOURNE
 61-3-8696-8888
 melbourne.langhamhotels.com.au

Austria

- DO & CO HOTEL
 43-1-24188
 doco.com

- HOTEL IMPERIAL
 43-1-501-100
 hotelimperialvienna.com

- HOTEL SACHER SALZBURG
 43-662-88-977-0
 sacher.com

Azerbaijan

- HYATT REGENCY BAKU
 994-12-496-1234
 baku.regency.hyatt.com

Barbados

- COBBLERS COVE
 246-422-2291
 cobblerscove.com

Belgium

- DUC DE BOURGOGNE
 32-50-33-20-38
 ducdebourgogne.be

Brazil

- RIO OTHON PALACE
 55-21-2122-5900
 hoteis-othon.com.br

British Virgin Islands

- ROSEWOOD LITTLE DIX BAY
 284-495-5555
 littledixbay.com

Burkina Faso

- TANGA SSUGO SETTLEMENT
 510-594-6000 ext. 6025
 mtsobek.com

Canada

- FAIRMONT EMPRESS RESORT HOTEL
 250-384-8111
 fairmont.com/empress

- FAIRMONT JASPER PARK LODGE
 780-852-3301
 fairmont.com/jasper

- KING PACIFIC LODGE
 604-987-5452
 kingpacificlodge.com

- PARK HYATT TORONTO
 416-925-1234
 parktoronto.hyatt.com

- SIMPSON'S NUM-TI-JAH LODGE
 403-522-2167
 num-ti-jah.com

- WESTIN OTTAWA
 613-560-7000
 starwoodhotels.com

Chile

- HOTEL PORTILLO
 56-2-361-7000
 skiportillo.com

- HOTEL SALTO CHICO
 866-750-6699
 explora.com

China

- GRAND HYATT SHANGHAI
 86-21-5049-1234
 shanghai.grand.hyatt.com

- MANDARIN ORIENTAL HONG KONG
 852-2522-0111
 madarinoriental.com

- PENINSULA HONG KONG
 852-2920-2888
 hongkong.peninsula.com

Costa Rica

- LUNA LODGE
 888-409-8448
 lunalodge.com

Ecuador

- KAPAWI ECOLODGE & RESERVE
 593-2-600-9333
 kapawi.com

Egypt

- MENA HOUSE OBEROI
 20-2-3377-3222
 oberoimenahouse.com

- SALAH EL-DEEN VILLAGE
 20-69-922-0003

England

- THE RUBENS AT THE PALACE
 44-20-7834-6600
 rubenshotel.com

- ST. MARTINS LANE
 44-20-7300-5500
 st.martinslane.com

- THE TOWER
 44-845-305-8335
 guoman.com

France

- CHÂTEAU DE LA TREYNE
 33-5-65-27-60-60
 chateaudelatreyne.com

- HÔTEL CROIX-BLANCHE
 33-4-50-53-41-28
 bestmontblanc.com

- HÔTEL PLAZA ATHÉNÉE PARIS
 33-1-53-67-65-99
 plaza-athenee-paris.com

- INTERCONTINENTAL CARLTON CANNES
 33-4-93-06-40-06
 ichotelsgroup.com

- InterContinental Paris Le Grand
 33-1-40-07-32-32
 ichotelsgroup.com

- Les Roches Blanches
 33-4-42-01-09-30
 roches-blanches-cassis.com

- Ritz Paris
 33-1-42-16-30-30
 ritzparis.com

French Polynesia

- Bora Bora Lagoon Resort
 689-60-40-00
 boraboralagoon.com

- Hotel Kia Ora
 689-93-11-11
 hotelkiaora.com

- Sofitel Bora Bora Marara Beach
 689-60-55-00
 sofitel.com

Germany

- Hotel Adlon Kempinski
 49-30-2261-0
 hotel-adlon.de

- Hotel Rübezahl
 49-8362-8888
 hotelruebezahl.de

- Lindauer Hof
 49-8382-4064
 lindauer-hof.de

Greece

- Electra Palace Hotel
 30-210-33-70-000
 electrahotels.gr

- Villa Rose Hotel
 30-22860-24564
 villarose-santorini.com

Hungary

- Hilton Budapest
 36-1-889-6600
 hilton.com

India

- Bangaram Island Resort
 91-484-301-1711
 cghearth.com

- Coconut Lagoon
 91-484-301-1711
 cghearth.com

- Oberoi Amarvilas
 91-562-223-1515
 amarvilas.com

Indonesia

- The Oberoi, Bali
 62-361-73-0361
 oberoibali.com

Israel

- St. Gabriel Hotel
 972-4-657-2133
 rannet.com/gabriel

Italy

- Albergo Barbara
 39-0187-812-398
 albergobarbara.it

- Albergo Domus Mariae
 39-0931-24858
 sistemia.it/domusmariae

- Bauer Il Palazzo
 39-041-520-7022
 ilpalazzovenezia.com

- Hotel Bigallo
 39-055-216-086
 hotelbigallo.it

- Hotel Pescille
 39-0577-940-186
 pescille.it

- Hotel Raya
 39-090-983-013
 hotelraya.it

- Hotel Splendido
 39-0185-267-801
 hotelsplendido.com

- Hotel Villa Athena
 39-0922-596-288
 hotelvillaathena.it

- Palazzo Sant'Angelo
 39-041-241-1452
 palazzosantangelo.com

- Relais Vignale
 39-0577-738-300
 vignale.it

- Terre di Nano
 39-0578-755-265
 terredinano.com

- Westin Excelsior
 39-055-27151
 starwoodhotels.com

Japan

- Yokohama Royal Park Hotel
 81-45-221-1111
 yrph.com

Kenya

- Giraffe Manor
 254-20-891-078
 giraffemanor.com

- Ol Donyo Wuas Lodge
 254-20-600-457
 oldonyowuas.com

- Ol Malo
 254-62-32715
 olmalo.com

Malaysia

- Mandarin Oriental Kuala Lumpur
 60-3-2380-8888
 mandarinoriental.com

Mexico

- Casa de Sierra Nevada
 52-415-152-7040
 casadesierranevada.com

- Hotel Los Juaninos
 52-443-312-0036
 hoteljuaninos.com.mx

- Hotelito Desconocido
 52-33-3611-1255
 hotelito.com

- Las Mañanitas
 52-777-362-0000
 lasmananitas.com.mx

- Playa Mambo
 52-984-803-5989
 playamambo.com

Monaco

- Hôtel de Paris
 377-98-06-30-00
 hoteldeparismontecarlo.com

Mongolia

· HOGNO HAN GER CAMP

609-860-9008
nomadicexpeditions.com

Morocco

· AUBERGE KASBAH DERKAOUA

212-5-35-57-71-40
aubergederkaoua.com

Myanmar

· POPA MOUNTAIN RESORT

95-2-69168
woodlandtravels.com

Niger

· PENSION TELLIT

227-20-440-231

Norway

· HOLE HYTTEUTLEIGE

47-7026-3030
holehytter.no

Peru

· MACHU PICCHU SANCTUARY LODGE

51-84-984-816-956
machupicchu.orient-express.com

Poland

· HOTEL ORBIS FRANCUSKI KRAKÓW

48-12-627-37-77
orbis.pl

Portugal

· POUSADA DO MONTE SANTA LUZIA

351-258-800-370
pousadas.pt

Russia

· HOTEL BALTSCHUG KEMPINSKI

7-495-287-2000
kempinski-moscow.com

· RITZ-CARLTON

7-495-225-8888
ritzcarlton.com

Scotland

· HOTEL MISSONI EDINBURGH

44-131-220-6666
hotelmissoni.com

Seychelles

· PATATRAN VILLAGE

248-29-43-00
patatranseychelles.com

Slovenia

· VILA BLED HOTEL

386-4-575-37-10
vila-bled.com

St. Lucia

· JADE MOUNTAIN

758-459-4000
jademountain.com

St. Vincent and the Grenadines

· PETIT ST. VINCENT RESORT

954-963-7401
psvresort.com

South Africa

· SINGITA LEBOMBO LODGE

27-21-683-3424
singita.com

Spain

· HOTEL COLÓN

34-93-301-1404
hotelcolon.es

· HOTEL DE LONDRES Y DE INGLATERRA

34-943-44-07-70
hlondres.com

Suriname

· METS AWARRADAM RESORT

597-477-088
surinamevacations.com

Switzerland

· BADRUTT'S PALACE HOTEL

41-81-837-10-00
badruttspalace.com

· HOTEL BELLA VISTA

41-27-966-28-10
bellavista-zermatt.ch

· HOTEL SONNENBERG

41-33-853-10-15
sonnenberghotel.ch

· HOTEL ZUM STORCHEN

41-44-227-27-27
storchen.ch

· THE OMNIA

41-27-966-71-71
the-omnia.com

· TSCHUGGEN GRAND HOTEL

41-81-378-99-99
tschuggen.ch

Tanzania

· NGORONGORO CRATER LODGE

255-27-253-7038
andbeyondafrica.com

Thailand

· ARUN RESIDENCE

66-2221-9158
arunresidence.com

· FOUR SEASONS RESORT CHIANG MAI

66-53-298-181
fourseasons.com/chiangmai

· FOUR SEASONS RESORT KOH SAMUI

66-77-243-000
fourseasons.com/kohsamui

· MANDARIN ORIENTAL DHARA DHEVI

66-53-888-400
mandarinoriental.com

· ZEAVOLA

66-75-627-024
zeavola.com

Turkey

· SEVEN HILLS HOTEL

90-212-516-9497
hotelsevenhills.com

· TYPIQUE MAISON TURQUE

90-384-219-2100

United Arab Emirates

- AL QASR
 971-4-366-6711
 jumeirah.com

United States

- BELLAGIO
 702-693-7405
 bellagio.com

- ENCHANTMENT RESORT
 928-282-2900
 enchantmentresort.com

- FOUR SEASONS HOTEL
 212-758-5700
 fourseasons.com/newyorkfs

- FONTAINEBLEAU MIAMI BEACH
 305-538-2000
 fontainebleau.com

- THE GREENBRIER
 304-536-1110
 greenbrier.com

- HOTEL 71
 312-346-7100
 hotel71.com

- HOTEL VITALE
 415-278-3700
 hotelvitale.com

- JUST INN
 805-238-6932
 justinwine.com

- LOONSONG MOUNTAIN LAKE CAMP
 907-235-8910
 kachemakbaywildernesslodge.com

- MANDARIN ORIENTAL SAN FRANCISCO
 415-276-9888
 mandarinoriental.com

- MILLENNIUM BOSTONIAN HOTEL
 617-523-3600
 millenniumhotels.com

- MILLENNIUM U.N. PLAZA HOTEL
 212-758-1234
 millenniumhotels.com

- MIRROR LAKE INN
 518-523-2544
 mirrorlakeinn.com

- NEW YORK MARRIOTT MARQUIS
 212-398-1900
 marriott.com

- OMNI SAN DIEGO HOTEL
 619-231-6664
 omnisandiegohotel.com

- RED ROCK CASINO, RESORT & SPA
 702-797-7777
 redrocklasvegas.com

- RITZ-CARLTON NEW YORK, BATTERY PARK
 212-344-0800
 ritzcarlton.com

- SPRING CREEK RANCH
 307-733-8833
 springcreekranch.com

- ST. REGIS ASPEN
 970-920-3300
 stregisaspen.com

- THE STANDARD DOWNTOWN L.A.
 213-892-8080
 standardhotels.com/los-angeles

- THE STANDARD NEW YORK
 212-645-4646
 standardhotels.com/new-york-city

- THE TIDES, SOUTH BEACH
 305-604-5070
 tidessouthbeach.com

- TRUMP INTERNATIONAL HOTEL
 917-210-4776
 trumpintl.com

- WIND RIVER PACK GOATS' ESCALANTE CANYON GOATPACKING CAMP
 307-332-3328
 goatpacking.com

U.S. Virgin Islands

- CANEEL BAY
 340-776-6111
 caneelbay.com

Vietnam

- BAO DAI'S VILLAS
 84-58-3590-148
 vngold.com/nt/baodai

- TOPAS ECOLODGE
 84-20-387-1331
 topasecolodge.com

Zambia

- CHONGWE RIVER HOUSE
 260-211-278-248
 chongwe.com

Zimbabwe

- VICTORIA FALLS HOTEL
 263-13-44751
 africansunhotels.com

ABOUT *CONDÉ NAST TRAVELER*

Condé Nast Traveler is the most trusted name in travel journalism. Since its launch in 1987, the magazine has been committed to its unique philosophy of "Truth in Travel." It is independent of the travel industry; this means its correspondents do not accept free or discounted trips or accommodations and, as far as possible, travel anonymously. By doing so, they experience the world the way its readers do—good and bad—and their reports and recommendations are fair, impartial, and authoritative. *Condé Nast Traveler* has been nominated for 24 National Magazine Awards, 7 of which were in the General Excellence category, and has won 6 awards in numerous categories, including Special Interest, Design, Photography, and General Excellence.

ACKNOWLEDGMENTS

I would like to thank all of the photographers and writers who have contributed to *Condé Nast Traveler*'s "Room with a View" feature over the past twenty-two-plus years. Their work has helped us to create this most satisfying of magazine end pages—and often the very first page our readers turn to. Were it only possible to include each and every one of their inspiring perspectives—but that book, alas, would require a podium to support it.

My gratitude goes to my predecessors as editor in chief of *Condé Nast Traveler*: Sir Harold Evans, the founding editor, and Thomas J. Wallace, who recognized a good thing and brilliantly and steadily ran with it. Thanks as well to senior consulting editor Clive Irving, our invaluable sounding board and presiding sage for countless magazine endeavors, including this one. On behalf of all of us, I would like to thank S. I. Newhouse, Jr., chairman of Condé Nast Publications, for so staunchly supporting *Condé Nast Traveler* and for recognizing the value and imperative of its Truth in Travel philosophy.

I am immensely appreciative of the energy and attention to detail of deputy editor Hanya Yanagihara, the organizing force behind this volume, and of the vision and enterprise of photography director Kathleen Klech and associate picture editor Jocelyn Miller. My thanks, too, to the magazine's publisher, Chris Mitchell, and his associates William Li and Susan Harrington, for helping to make this project a reality, and to managing editor Dee Aldrich for her assistance.

I would also like to thank my friend and longtime *Condé Nast Traveler* contributor André Aciman for his introductory essay on the magic and meaning of what we travelers perceive through windows—on the importance, if you will, of the windowsill—as well as features editor Gully Wells, who worked with him. My thanks, too, to deputy research editor Sylvia Espinoza for her fact-checking, Eimear Lynch and Claire Willett for their work on the manuscript, and Beata L. Santora, Kathryn Maier, and Michael D. Cassidy.

Last but by no means least, I am immensely grateful to Prosper Assouline—and to editorial director Esther Kremer, designer Camille Dubois, and editor Sarah P. Hanson, the members of his team—for loving our "Room with a View" pages and saying, "You have a book here!"

—K.G.